THE MODERN ART OF THE PRINT:
Selections from the
Collection of Lois and Michael Torf

Roy Lichtenstein. *Industry and Melody*, 1969 (cat. no. 133)

THE MODERN ART OF THE PRINT:

Selections from the Collection of Lois and Michael Torf

Exhibition organized by the Williams College Museum of Art

in collaboration with the Museum of Fine Arts, Boston

Coordinated by Deborah Menaker

Essays by Clifford S. Ackley, Thomas Krens, and Deborah Menaker

Williams College Museum of Art
Williamstown, Massachusetts

Museum of Fine Arts
Boston, Massachusetts

Contents

Cover: **Emil Nolde.** *Junge Dänin* (Young Danish Woman),
1913

Exhibition Itinerary:
Williams College Museum of Art
May 5 – July 16, 1984

Museum of Fine Arts, Boston
August 1 – October 14, 1984

Copyright © 1984 by Museum of Fine Arts
Boston, Massachusetts

ISBN: 0-87846-239-2

Library of Congress Catalogue Card Number: 84-60501

Printed in U.S.A. by Acme Printing Co.
Medford, Massachusetts

Bound by Mueller Trade Bindery
Middletown, Connecticut

Foreword

The Torf collection offers a survey of twentieth-century graphic art of a range, depth, and quality that any Museum in the world would welcome. It has the distinction of exploring the most important directions in twentieth-century art and, at the same time, affirming the creative role of printmaking in the unfolding of the story of modern art. For the past quarter century printmaking has flourished, both technically and conceptually, to a degree unimagined in the previous history of art. In the inventive hands of contemporary artists the printed image has emerged from the shadow of painting and sculpture to assume the position of a unique form of artistic expression. Lois Torf's acquisitions document that development with extraordinary sensitivity and insight.

It is altogether fitting that this project had its roots in an academic setting. Lois Torf has always been exceedingly generous with her time and energy to anyone with an interest in printmaking, and numerous scholars, students, and potential collectors have spent many pleasant hours exploring the treasures in her collection. Thus in 1978, when it was first suggested that a group of graduate art history students from Williams College make the Torf collection the source for a modest exhibition of contemporary prints in the context of their course work, the idea immediately had her enthusiastic endorsement. Work began on a complete documentation of all the prints that had been assembled, and it quickly became apparent that their extraordinary range and quality could not be served by an exhibition of less than sixty works. There were simply too many superlative images to justify imposing artificial restraints at such an early stage in the planning. As the cataloging work progressed, and as new acquisitions were added to the collection, the framework of an exhibition of substantial dimensions emerged – one that simultaneously demonstrated the achievement of twentieth-century printmaking and the unique character of the Torf collection.

As the scale of the project expanded, the prospects for circulating the exhibition increased. Given the close associations between Lois and Michael Torf and the Boston art community, as well as Mrs. Torf's long-standing relationship with the print department of the Museum of Fine Arts, the participation of the Museum was arranged with the counsel and guidance of the Museum's administration and of Eleanor Sayre, Curator of Prints, Drawings, and Photographs; Clifford Ackley, Associate Curator; and Barbara Shapiro, Assistant Curator.

The exhibition would not have been possible, of course, without the continuous support and encouragement of Lois and Michael Torf. The prints stand as a measure of their devotion to the fine arts.

Thomas Krens
Director, Williams College Museum of Art

Jan Fontein
Director, Museum of Fine Arts

Acknowledgments

In its initial stages, the conception and organization of this catalogue and exhibition were undertaken by Thomas Krens in the context of his courses in the history of printmaking at Williams College. Rafael Fernandez, Curator of Prints and Drawings at the Sterling and Francine Clark Art Institute, collaborated on the course and provided early advice on the definition of the exhibition project. Vivian Patterson and Edward Hawkins were the first two graduate students to participate, and they diligently worked at cataloguing the entire collection through the spring and summer of 1979. Plans for a small show were postponed when the Williams College Museum of Art was closed in 1980 for the construction of a new addition, and the showing was subsequently scheduled for the first year after the museum reopened in 1983. In the interim, Lois Torf agreed to a more comprehensive presentation — one that reflected the depth of the three main segments of the collection.

In 1981, Deborah Menaker, Assistant Curator at the Williams College Museum of Art, assumed primary curatorial responsibility for the exhibition. During the past year, as the project has become a true collaboration between the Williams College Museum of Art and the Museum of Fine Arts, Clifford Ackley of the Museum of Fine Arts has played a major role, contributing an essay and extensive rewriting of the catalogue of the exhibition. Nancy Green and Michael Morgan Floss, students in the Williams College Graduate Program in the History of Art, have compiled the checklist of the collection and contributed, along with Nancy Spector and Steven High, catalogue entries on selected works. At the Museum of Fine Arts, Eleanor Sayre, Barbara Stern Shapiro, Sue Welsh Reed, David Becker, and Clifford Ackley have also written entries.

A number of art historians and knowledgeable individuals have generously offered their time and counsel on the catalogue text. Professor Robert Rosenblum of the Institute of Fine Arts in New York; Eleanor Sayre, Curator of Prints; Kathryn Greenthal, Assistant Curator of American Paintings and Sculpture at the Metropolitan Museum of Art; Valerie Cook; and Marian Goodman provided numerous insights. Others with special knowledge of the prints assembled here supplied information, including: Brooke Alexander, Peter Blum, Riva Castleman, Ruth Fine, Bill Goldston of U.L.A.E., and the staffs of Gemini G.E.L. and Tyler Graphics Ltd.

Deborah Menaker is grateful for the support provided by David Rothschild, Ann Menaker, and Joan Zappula. Professor Sara Suleri, of Yale University, read Mr. Krens's manuscript in its early stages, and her suggestions are reflected in its final form. At Williams College, Russell Panczenko, Assistant Director; Vivian Patterson, Assistant Curator; Lise Holst, Assistant Curator and Registrar; along with Joseph Thompson, Charles Sheppard, Hanne Booth, Edith Leu, and George Abbott, contributed their talents and energies to the various organizational tasks associated with the project. Judith Tiernan and her staff at Commonwealth Print Conservation framed many of the large prints.

At the Museum of Fine Arts, George Peabody Gardner III and Kathy Duane were helpful with administrative details relating to the scheduling of the exhibition. Within the Department of Prints, Drawings, and Photographs, David Becker coordinated final checking of the list of the exhibition; Drew Knowlton and Heather Northway checked, collated, and typed the manuscript; and Roy Perkinson, Elizabeth Lunning, and David Ross of the conservation staff assisted in the preparation of many of the prints for exhibition.

We are indebted to Charles P. Parkhurst, Co-Director of the Williams College Museum of Art, and Ross Farrar, Associate Director of the Museum of Fine Arts, for negotiating arrangements between the two institutions. The catalogue is the handsome design of Carl Zahn; it was skillfully and efficiently edited by Judy Spear; and Mary Bachmann produced the photographs.

It is to Lois and Michael Torf that we owe the deepest gratitude. Lois Torf has participated in every aspect of the organization of the exhibition. Her understanding and enthusiasm for twentieth-century art is an inspiration.

The Genesis of a Collection

Thomas Krens

I

The most profound enchantment for the collector is the locking of individual items within a magic circle in which they are fixed as the final thrill, the thrill of acquisition, passes through them.

(Walter Benjamin, *Illuminations*)

Modern prints have been the focus of collectors' energies to an extraordinary degree in recent years, but few have succumbed to the "profound enchantment" of print collecting more completely than Lois Torf. Initiated in 1961 with the purchase of a minor Japanese woodcut for less than twenty-five dollars, the Torf collection has steadily grown to nearly 1,000 impressions and now includes many of the finest images in twentieth-century graphic art. With concentrations ranging from the Cubist prints of Picasso and Braque to the current international neo-expressionists, the history of the collection is an absorbing illustration of an incidental interest that developed into a consummate involvement with the language and commerce of contemporary printmaking. Like other distinguished collections, it has a separate identity that is more than just the sum of its parts.

The invisible lines that bind these objects together in a collection are as much the subject of the catalogue as are the inherent qualities of the works of art themselves. To consider this entity as a collection, it is important to recognize that as objects pass into collections, they are inevitably measured against an intuitive set of criteria of which even the collector may be unaware. The nature of the criteria, which is ultimately interchangeable with the concept of the quality of the collection, emerges only gradually in the course of its development to reveal a specific identity. A collection is, furthermore, almost by definition, a dynamic entity that embodies the dialectical paradox: each object added to it reinforces its previous character as it challenges and redefines the collective identity. It is, therefore, hardly surprising that collections exist in finite time, reach maturity, change their shapes, and generally display the transitory attributes of an organic process.

The vitality of the Torf collection is evident here on at least two important levels: it remains intrinsically linked to the unconscious as well as conscious dynamics of the collector, on the one hand; it extrinsically expresses the patterns of the age it inhabits, on the other. Where, by comparison, the focus of a given collection is on the art of distant ages, or on a class of objects that are numerically rare, the opportunities for forceful expression through the act of collecting are perhaps less dramatic. In practical terms, for example, the possibilities for a modern collector of Renaissance painting are limited. The works of art that best express the age will very likely have been established already in museums or private collections; those that remain on the market are usually of negligible quality or of extraordinary price. In effect, the collection of these objects is necessarily restricted to the occasional work of distinction that surfaces, and the process of collection takes on the qualities of a hunt for exotic game – a one-time chance wherein the judgments or skills of the hunter may matter less than the fact of the capture of particular quarry.

With contemporary prints, unlike Renaissance painting, the supply of new material is constantly being replenished; the prices at one stage or another of the market processes are relatively reasonable, and the objects of quality are abundant. The contemporary collector, therefore, has the unique opportunity to reflect the morés and structures of an artistic age by exercising the option of choice before the market has tightened and before the academic word is pronounced by critics and art historians. That is not to imply that only inexpensive or accessible works have found their way into the Torf collection. On the contrary, its extraordinary quality is a function of the fact that Lois Torf has played all aspects of the game so well. The acquisition of rare prints like the Gabo woodengravings, Nolde's *Junge Dänin*, and Picasso's *Nature Morte: Trousseau de Clefs* (cat. nos. 55-77, 165, 174) demanded patience, persistence, and good fortune; and they beautifully complement the main thrust of the collection.

It must be remembered that the patterns of an age revealed by works of art are not measured only in aesthetic terms. That the growth of the Torf collection coincided almost exactly with a renascent social and artistic interest in prints in America only emphasizes the importance of collecting to the creative dynamic of contemporary printmaking. Among

the factors that reflect the extraordinary expansion since 1960 are the increase in the number of professional printmaking workshops, print publishers, and fine art print programs at American academic institutions; the number of artists more familiar with other media who have expanded into printmaking; and the scale, complexity, originality, and technical virtuosity that has become the signature of recent graphic work. However extraordinary these developments may be by themselves, it remains a fundamental intuition of political and social economy that artistic enterprise – like business enterprise – flourishes in times of economic expansion. This hypothesis could not be more elegantly demonstrated than by our present concern: without a broad-based consumer demand and a strong market for prints, it is highly unlikely that the extraordinary images assembled here could have come into existence in the first place; if the development of the field had not coincided with Lois Torf's abilities to acquire, the collection might not have materialized either.

The equation between patronage and art-making, between the object and the collector, has not been sufficiently explored on either a practical or a theoretical level, though its impact on culture has been far from negligible. Art historical scholarship has remained more comfortable with biography, chronology, and the inherent formal qualities of the object by itself, to the exclusion of the political and social economy of the object's function in the world. As a result, collecting as an activity and as an aesthetic is generally viewed as if it were somehow an *a priori* constant that naturally and automatically reflects the inherent, inspired tastes of the acquisitor. A case for uncovering the active role that collecting exercises in the art-making dynamic and the implications of the gradual development of the collector's expertise, with specific reference to the Torf collection, will be explored below.

II

We can forgive a man for making a useful thing as long as he does not admire it. The only excuse for making a useless thing is that one admires it intensely.

(Oscar Wilde, *The Picture of Dorian Gray*)

What constitutes a print is not the medium or the technique of the image, but an aggregate of aptitudes to which it must answer.

(Michel Melot, *Prints: History of an Art*)

For the last century or so, the pecuniary aspects of collecting have been segregated from consideration of the object, as if the vitality of a work of art was dependent on a myth of practical isolation to protect it from contamination in the world at large. Moreover, the mechanics of the separation between object and context is a function of a more fundamental schism that took place at the end of the nineteenth century, when the priorities of rational analysis and the benefits of specialization established the methodology that is at the foundation of modern academic thought.

Art history has remained, to a remarkable degree, the progeny of the era from which it first emerged as an academic discipline; the strange contradictions of the nineteenth century continue to influence our most widely held scholarly assumptions and exercise considerable control over how we perceive the status of a work of art in the present day. From the Renaissance to the post-Enlightenment period, the art object enjoyed a diverse range of secular and religious functions, of which its position as a metaphor for wealth was by no means the least significant. For more than 400 years a tacit collusion between the intellectual, religious, and economic elite maintained control over the art object and its commerce, but the variety of its functions was freely acknowledged. As late as 1860, no less a moral aesthete than John Ruskin was eloquently demonstrating the thesis that art originates from utility and ethical functionality.[1]

Paradoxically, it took the industrial age to make the connection between art and wealth an issue of discomfort, and ultimately to develop an academic discipline based on the dissociation of art and economy. If the extensive social changes wrought in the late nineteenth century threatened the permanent control of the economic elite, the intellectual elite responded by evolving a complex denial of the fact that art could ever be influenced by the commerce and technology of modern times. Artists as well as aesthetes were disposed to protest the disruptive arrival of a proliferating middle class to the scene of contemporary aesthetics by striving to protect philosophically the boundaries of the territory they had traditionally inhabited with uncontested impunity. Thus, the language of culture came to be dominated by a hitherto unraised issue, which was nothing less than the question of how art should function and where it should properly be placed. Should it be considered a delightfully superfluous item of adornment designed to grace the lives and homes of the rich and tasteful, as the aesthetic movement would have it, or should it be treated with the reverential awe of a Matthew Arnold for whom the custodial climate of the museums – the secular churches of a new age – provided a properly august home? As it happened, neither school of thought was able to maintain influence. The implicit and powerful consensus that was forming at the end of the century concluded that wherever the art object was located in fact, it had become the property of interpretation alone.

If the Age of Enlightenment gave birth to the science of interpretation with respect to culture, the nineteenth century established its academic methodology along the lines of the categorical tendencies toward specialization and compartmentalization that were ideally suited to the analytic priorities of science. By encouraging the separation (rather than the union) between interpretation and object, these tendencies frequently run counter to the normative impulses that lie behind the artistic experience. Over the past 100 years, the distinction between the object and its understanding has been institutionalized and coded as a cultural norm in both the fine and the performing arts. With estimable accuracy, Roland Barthes succinctly describes the transition with reference to music: "There was a time when 'practicing' music lovers were numerous (at least within the confines of a

1. John Ruskin, "The Relation of Art to Youth," *Lectures on Art: The Complete Works of John Ruskin*, Illustrated Cabinet Edition (Boston, n.d.).

certain class), when 'playing' and 'listening' constituted an almost undifferentiated activity. Then two roles appeared in succession: first, that of the interpreter, to whom the bourgeois public delegated its playing; second, that of the music lover who listened to music without knowing how to play it."[2] In art the makers, no less than the collectors, may likewise have been excluded from an important part of the process of experience.

Concurrent with the nineteenth-century conviction that aesthetics requires the mediation of an interpretative analysis were the anxieties of a materialistic ethos incapable of a spontaneous act of appreciation. The experience of art became self-conscious and, in the process, revealed the paradoxical tensions that governed the age. The industrial era was defined by materialism, but felt compelled to cleanse its aesthetics of material content. Furthermore, objects of technology so seized the insecure imagination of wealth and power that the ancient allegiance between wealth and art was not only superseded but vigorously denied as a fiction in the first place. Operating on an even more over-determined level, the industrial ethos of the nineteenth century literalized money as an object of interest in itself, but denied the inherently artful qualities of this interest. As a consequence of these tensions, what used to function as an emblem for wealth was noiselessly segregated from its traditional function and given as compensation the dubious value of a religious object in a secular age.

Lionel Trilling wrote in the early part of this century that "the idea of money exercises great fascination – it is the fascination of an actual thing which has attained a metaphysical ideality or of a metaphysical entity which has attained actual existence.[3] With respect to art, the denial of this fascination has contributed to the emasculation of the object; art became equated with beauty, consigned to the rarefied air of aesthetic discourse, and dissociated from an explicit relationship to power. The selfless objectivity of the analyst replaces the utilitarian modes of less sophisticated times with the assumption that the authenticity of any alternative discourse on art is circumspect.

The depth to which such attitudes have been established in the modern Western psyche is reflected by the degree to which the exclusivity of the object and its dependency on the mediation of interpretation have been implicitly and completely absorbed by modernist analysis. If the new bourgeoisie in the nineteenth century relinquished a possessive relation with the object out of fear of interpretive inadequacy, the radical avant-garde in the twentieth confirmed the division with its complicit mystification of the object. Thus, going back to James McNeill Whistler, who serves as a paradigm of the American intellectual aesthete of the 1890s, we see the pernicious influence of commerce being strenuously resisted. Whistler, asserting the aristocratic inviolability of the art object, claimed that art transcends and eludes the ill-bred interest of the world at large and suggested that the middle class were victims of an aesthetic they could not understand, or ever wanted to in the first place: "The people have been harassed with Art in every guise, and vexed with many methods as to its endurance. They have been told how they shall love Art, and live with it. Their homes have been invaded, their walls covered with paper, their very dress taken to task – until, roused at last, bewildered and filled with doubts and discomforts of senseless suggestion, they resent such an intrusion, and cast forth the false prophets, who have brought the very name of the beautiful into disrepute, and derision upon themselves."[4] His classist assumptions notwithstanding, Whistler illustrated a fundamental doctrine of the industrial age that has remained entrenched for roughly a century: that the domain of art is immune from influence by the world of commerce.

If the motivation of the late nineteenth century was predicated on the denial of property, it sought to repress the compelling pleasure of the fact of ownership with regard to art. Walter Benjamin's observations in the 1920s, however, that "ownership is the most intimate relationship that one can have to objects" emphasizes the actuality of the collection and challenges the intellectual

imperialism of the interpretive priority.[5] But this is a minority view. In the minds of the great art historians such as Focillon, Burckhardt, Fry, Panofsky, and Gombrich, stylistic analysis and iconographic reference still determined the parameters of the discipline. The separation between art and economy, or between the object and its culture, has persisted with great force in recent years, no doubt as a result of the power of their scholarship.

The nineteenth century bequeathed to the twentieth an exclusive claim with regard to the interpretation of the object, and to participation in the artistic process, that is predicated on its ideological isolation. Dadaist populism and Warhol's soup cans notwithstanding, the twentieth-century avant garde, by and large, draws its strength from the same well that nourished the nineteenth-century establishment – a style of criticism in which aesthetics commands a world unto itself. As a result, despite an endless fascination with the subject of money and power in general, the twentieth-century academic attitude toward art is handicapped by its inability to admit art as an object of purchase, consumers as part of the process, or aesthetics as a viable form of economy. The present proliferation of dealers in Soho and on both sides of 57th Street and Madison Avenue testifies not so much to the availability or affordability of paintings and sculpture as much as it does to the fact that major art remains in the elitist territory of major museums and wealthy collectors – surrounded by, yet discreetly cut off from, the machinery from which it was produced in the first place.

Prints have always provided, on several levels, a fundamental challenge to such notions. Their inherent characteristics of reproducibility and transportability are *designed* to bring creative content into the public domain; since the fourteenth century they have played the role of widely disseminated surrogates or substitutes for more sophisticated, unique, or fragile art forms. Their derivation from goldsmith's work and association with bookmaking, printing, cabinetmaking, embroidery, and tapestry reinforced the position of the print in the world of commerce. From the sixteenth to the nineteenth century, prints were important

2. Roland Barthes, "From Work to Text," *Textual Strategies*, ed. Harari (Ithaca, 1979), p. 80.

3. Lionel Trilling, *The Liberal Imagination* (New York, 1940), p. 258.

4. James Abbott McNeill Whistler, "Mr. Whistler's Ten O'Clock," rpt. in *Victorian Poetry and Poetics*, ed. Walter Houghton (Boston, 1959), p. 898.

5. Walter Benjamin, *Illuminations*, ed. Hannah Arendt (New York, 1963), p. 67.

international commodities of trade and fertilized the economic development of Europe by acting as a technological carrier between the worlds of commerce and art. Michel Melot has observed that the "rise of the print was conditioned, on the one hand, by the new ways of producing and distributing goods and the new purposes to which they were put, and, on the other, by the traditional use that was to be made of it in the ideology of art."[6] He makes the pertinent observation that the print played a crucial role in shaping the concept of the artist as one who was simultaneously "creator" and "craftsman," which can be seen as a union of the creative and economic in a single presence. But the most distinctive quality of prints may be that they are, in their particular manifestation, designed to be owned. If other works of art and architecture indulge the priority of their religious, iconographic, social, or formal functions and waive the question of possession as inconsequential, ownership is the *raison d'être* of prints.

On another level, writing about prints has opened the exclusive territory of historical scholarship to a style of analysis that engages the social, political, and economic realities that lie behind the formation of particular attitudes about art. Prints reflect society perhaps more than any other art form: they are intimately bound to a utilitarian technology that dominates the commerce of information, and their images invoke an absorbing contextual history. Knowledgeable print historians like Hyatt Mayor and William Ivins were the first to direct intelligent attention to the attributes of the graphic media that indulged the very qualities of aesthetic diffusion that Whistler argued against. Mayor's tracking of the development and impact of the print in all its forms – from the invention of paper to its role in the refinement of playing cards, from the earliest illustrated books to large-scale publishing in seventeenth-century Rome for the production of tourist souvenirs, from Rembrandt's inventive experimentation with etching technique to Picasso's complete command of the language of printmaking – relentlessly unfolds the practices and traditions that embody the sociological history of

the print.[7] His interest in the social, economic, and technological history of the printmaking processes fully acknowledges the context in which the print has developed and flourished; to achieve a complete understanding of a work, he sought to describe both the circumstances and the dynamic that have conspired to produce a given image. Art for Mayor becomes fully comprehensible in the context of its culture.

Ivins performed a similar function with regard to technique. The implicit assumption of his modest volume *How Prints Look*, first published in 1943, is that a full conceptual understanding of prints is dependent on a thorough grasp of the principles and processes of manufacture.[8] Relying on exceptionally detailed photographs far more than on verbal description, he argued that the power and potential of prints can be fully appreciated only with an awareness that approaches that of the maker. His interest in placing technical information at the service of critical commentary has expanded the basis upon which prints are understood and interpreted.

The ground that Mayor and Ivins share with respect to art in general, of course, is the belief that product is intimately tied to context. The sophistication of their approach is a direct challenge to the complicated circumlocutions of a Whistler, who seeks to create a special protected and exclusive territory to maintain the aesthetic purity of the object. The irony of the latter universe is that the argument for the excellence of the object is also the very instrument whereby control is exercised and access to its organic source is cut off. In such a world, the complex impulse of the collector – the physical appropriator of the object and therefore a force in the circumstances of its manufacture – readily assumes the shape of a threat by bringing into protected territory the will to spend and control. To carry out this mandate effectively is to direct attention to the process and structures that support the object, not to the exclusion of interpretive aesthetics but, rather, as part of a complex web of relationships and distinctions that attend to our understanding of the object and its place in our culture.

III

...inside him there are spirits, or at least a little genie, which have seen to it that for a collector – and I mean a real collector, a collector as he ought to be – ownership is the most intimate relationship that one can have to objects.

(Walter Benjamin, *Illuminations*)

Wealth never emerges without generous demands on its attention; the acquisition of art, therefore, should be seen as an energy that is somewhat more complex than the simple act of getting and spending. Whether art is considered, as in Ruskin's early nineteenth-century thought, as the logical extension of utility, or, as in Whistler's an industrial revolution later, as a secret power that eludes economy, the fact remains that special passion adheres to great collections that is nourished by a symbiotic relationship with the processes of both production and acquisition. For collectors are indeed inspired by more than money: they create a science of possession, they convert object into desire, and they fertilize the creative process of imagination. In fiction, the homing impulse of the collector is replayed in fine detail by Henry James in *The Spoils of Poynton*, who describes Mrs. Gereth's lifetime as a collector with generous strokes: "What she had achieved was indeed an exquisite work; and in such an art of the treasure-hunter, in collection and comparison refined to that point, there was an element of creation, of personality."[9]

The powerful fascination that impels the will to collect is even more closely examined by Walter Benjamin, who writes that "collectors are the physiognomists of the world of objects, and turn into interpreters of fate."[10] Benjamin's understanding of the impulse to collect is complete enough to recognize its root in the morés of social and personal power; he argues that "the phenomenon of collecting loses its meaning as it loses its personal power. Even though public collections may be less objectionable socially and more useful academically than private collections, the objects get their due only in the latter." If Benjamin's insight is

6. Michel Melot, *Prints: History of an Art* (New York, 1981), p. 63.

7. A. Hyatt Mayor, *Prints and People: A Social History of Printed Pictures* (New York, 1971).

8. William Ivins, *How Prints Look* (Boston, 1958).

9. Henry James, *The Spoils of Poynton*, 1897 (New York, 1963), p. 18.

10. Benjamin, op. cit. p. 60.

accurate, then the objects in the Torf collection resonate with a dual signficance; they are remarkable for their individual intrinsic value as well as the context of their collective presence.

The particular power of this collection is a function of Lois Torf's developing maturity, experience, and intelligence as a student of cultural objects on a practical rather than a theoretical plane. Her first purchases were motivated less by scholarly advice or an informed perception of the print market than by intuitive curiosity and personal attraction to image. They were noteworthy primarily for their affordability and availability. To understand the mechanics of the formation of the collection, it is useful to imagine the circumstances in which Mrs. Torf found herself in the early sixties. Tamarind and Universal Limited Art Editions were in their infancies, and the attractions they generated had barely taken hold. Yet, there was a relatively high general art consciousness that was undoubtedly part of the residue of the international notoriety of Abstract Expressionism. The third generation of the American avant-garde, manifested in the personalities and the work of the likes of Robert Rauschenberg, Jasper Johns, Frank Stella, Robert Irwin, Claes Oldenburg, Allan Kaprow, Jim Dine, and Andy Warhol, was beginning to assume center stage, and the work carried with it a palpable air of excitement and challenge. *Time*, *Life*, and *Newsweek* ran feature stories on the bohemian existence of the new New York painters, and galleries began to proliferate on Madison Avenue and 57th Street in unusual numbers. The new bastions of blue chip contemporary art – the Leo Castelli Gallery and Pace – were in the process of establishing their territory, and museums were showing a renewed interest in presenting contemporary work to the public.

But even at that time, the cost of acquiring paintings reserved serious collecting for the very wealthy. Print collecting, as a more modest alternative to satisfy the impulse to own art (a new painting by a younger artist might cost $2,000, whereas a print by the same hand would be priced at $100), was a slightly esoteric enterprise separated from the mainstream by the fact that few of the prominent newer painters expressed any interest at all in printmaking. Except for Picasso, who was regarded by the new painters with a kind of reverential indifference, contemporary printmaking was dominated by a few graphic craftsmen like Stanley Hayter, Mauricio Lasansky, and Leonard Baskin, who, while consummate technicians and influential teachers, generated little of the excitement of the international mainstream.[11]

The prints that were available in the early 1960s were generally modest in price, and the beginning collector thus had the opportunity to obtain the work of established artists for reasonable sums. (Indeed, the affordability of reproductive idioms has been a factor in the popularity of prints ever since the respective technologies were invented.) Lois Torf followed her initial purchase of a Shiko Munakata woodcut in 1961 with the acquisition of a Lyonel Feininger, *Auf der Quaimauer*, and Pierre Bonnard's *Le Bain*. Perhaps one could look for an aesthetic connection between the Japanese print and the Bonnard and conclude that she might have been inspired to look more closely at the potential opportunities in the print market – thus being stimulated with a restless curiosity about prints in all their forms. The reality was undoubtedly more prosaic. Feininger and Bonnard were closer to the major currents in western art than Shiko Munakata. They were recognized artists whose contributions to cultural aesthetics were certified academically by art historical scholarship. Thus was established very quickly the dynamic that is at the foundation of the Torf collection. Its first component was reflected in the fact that when Lois Torf began to collect seriously, she intelligently limited her potential field to those twentieth-century artists whose credentials were established by generally accepted standards, and for whose graphic work there already existed a reasonably vigorous market of sustained supply and demand. To this predisposition she joined a complementary and equally instinctive propensity for visual images of surpassing power. If it is possible to characterize the definitive attributes of the Torf collection with a single phrase, that phrase would inevitably invoke the descriptive language of graphic strength and dramatic visual impact. Finally, the catalyst in this equation, at least with reference to the evolution of the collection, has been nothing less than Lois Torf's progressively informed perception of printmaking that gradually developed over the past two decades.

Once she began to acquire in earnest, Mrs. Torf repeated the experience that is the hallmark of all great collectors: she gradually became expert in all aspects of her subject. She became aware of the range of available prints at the major auction houses and thus the potential for more competitive prices. In early 1967, after a string of unsuccessful bids, she met success with the acquisition of one of Kandinsky's *Kleine Welten* series (cat. nos. 102-113), and from that point on, she never looked back. Over the next sixteen years, she traveled extensively in the U.S. and to Europe in quest of prints, and became a familiar and widely respected figure at Sotheby's in New York, Los Angeles, and London; at Christies's in New York and London; at Lempertz in Cologne; Kornfeld and Klipstein in Berne; Hauswedell and Nolte in Hamburg; and Karl and Faber and Ketterer in Munich. She developed a network of suppliers that included most of the prominent dealers and publishers in Boston, New York, and Los Angeles – a group that kept her current and informed on the latest developments in the print world. She frequented artists' studios, traveled to the print workshops in New York and the west coast, and attended major print exhibitions wherever they occurred in museums and galleries throughout the world. In short, Lois Torf worked on her collection. Its development fortunately coincided with an astonishing growth in printmaking activity and the practical means to indulge her interest, and her efforts illuminate the times as much as, if not more than, the artifacts

11. Indeed, there were a few dealers in the 1960s who specialized in prints, such as the late Peter Deitsch in New York and Robert Light in Boston, but their interest was anchored in a very special kind of connoisseurship that was unlikely to engender the enthusiasm necessary for a strong and vibrant market. It must also be said that the bread and butter of the handful of dealers that concentrated on prints was generated by old master, rather than by contemporary, works. A dealer like Peter Deitsch, for example, handled only prints and drawings of interest to museums and established "serious" collectors. In addition to Deitsch and Sylvan Cole's Association of American Artists, the only New York galleries to specialize in prints were Gordon's Fifth Avenue Gallery, Lucien Goldschmidt, David Tunick, William Schab, the FAR, and the AFT Galleries. Their interests were concentrated on late nineteenth-century French modernists, German Expressionists, Picasso (who was a category unto himself as far as printmaking was concerned), and the old masters.

she has managed to assemble. On those terms alone, the Torf collection demonstrates the inspired creativity of the passionate collector.

At present the Torf collection seems to form itself naturally into three distinct divisions. The first can be succinctly described as early twentieth-century masters, including the prints of the German Expressionists; Picasso, Braque, Villon, Delaunay, and the Cubists; and the Constructivists Lissitzky, Rodchenko, Gabo, and Moholy-Nagy. Her collecting energies were devoted to this group until roughly 1969. The second period focused on the "contemporary masters" – principally the American painters who inspired the extraordinary expansion of the contemporary art world in New York in the 1960s.[12] The third group comprises prints by younger, less well-known contemporary artists from Europe and America. This aspect of her collection reflects the point in Lois Torf's development as a collector when her knowledge and understanding of the nuances of the graphic image became complete enough to warrant an ambitious attempt to determine cultural attitudes before they were established. Clearly she felt confident enough of her judgment and experience to pronounce her opinions, and she possessed the means to make them felt among the fraternity of dealers and artists in the contemporary art world.

Perhaps Lois Torf's greatest strength as a collector is a sharply critical perspective that forces a new concept to reveal itself thoroughly before an almost grudging acceptance is transformed into passionate advocacy. Her initial preference for the German Expressionists and reluctance to embrace contemporary art gave way to a wave of enthusiasm for Johns, Rauschenberg, Dine, Lichtenstein, Rosenquist, Twombly, and Oldenburg, among others. This second period, however, was still an intermedi-

ate phase with respect to her powers of collecting. The attitudes she held toward artists remained subordinated to a critical word that was already pronounced in the journals of art history and criticism. Her selection of imagery within that range of artists was, if anything, growing stronger, but she aspired to the final and perhaps most satisfying role of the collector: to be the determinant of a particular brand of cultural aesthetics, rather than its recipient.

By the time her consuming interest in the "contemporary masters" gave way to a riskier involvement with artists who were not yet well known, Mrs. Torf had become a major player in the international print world. She was well aware of her knowledge and the strengths of her collection to date, and was intrigued by the possibility of having a formative role in the careers of younger artists whose work she respected. She also understood the dialectical nature of progress in the world of art, and prepared herself for new and different imagery with an openmindedness that more formal academics would do well to emulate. Her current interest in the prints of artists like Jennifer Bartlett, Jonathan Borofsky, Anselm Kiefer, Bryan Hunt, Aaron Fink, Susan Rothenberg, A.R. Penck, Georg Baselitz, Lois Lane, and Mags Harries testifies to her adventurousness and independence as much as it does to a sense of power and insight that is bred of the depth of her experience as a collector.

The identification of three stages in the Torf collection is not meant to imply that one stage has superseded and excluded another. Perhaps the greatest pleasure allowed a collector is the sense of accomplishment and fulfillment that accompanies a definitive collection. But the process can never be truly completed. As one phase of the collection has naturally given way to another, Lois Torf has remained vigilant for superlative impressions that enhance an earlier concentration: the Gabo woodcuts, Picasso's *Nature Morte*, and Miro's *L'aigle, la femme, et la nuit*, were all works that she acquired at a relatively late date, when the primary thrust of her energies was focused in other directions.

As a collector, Lois Torf's persistence, intelligence, and commitment to process have left an indelible mark on the print world. Artists, dealers, students, and scholars have all been included in the elaborate exchange that has

taken place in the physical territory of her collection. The story of the Torf collection thus triumphantly links object with process, as it projects a domain of contextual practicality into the field of aesthetic exclusivity; it demonstrates how the acquisition of art is simultaneously the acquisition of knowledge. The objects in this catalogue, therefore, represent a felicitous union between art, resource, and active expertise in the complex dynamic of art-making. As a consequence, it provides a refreshing alternative to the greater objectivity of academic analysis by drawing attention to the creative elements in the will to possess. The passion of the object is complemented by the passion of the collector, which, by rendering the object safe and interpretable, releases the energy of discovery and artistic change.

12. As Mrs. Torf tells the story, she was introduced to this new wave of contemporary printmaker-artists by the dealer Alice Adams, who had worked with Kornfeld in Switzerland, but at the time was director of the graphics division of the Frumkin Gallery and based in Chicago. It was Ms. Adams's habit to bring her inventory to clients located in various cities, and Lois Torf was one of her prime customers for early twentieth-century master prints. On one of her trips to Boston in 1967, Ms. Adams tried to interest Mrs. Torf in a Rauschenberg lithograph, but the sale was not made. In 1969, however, with her initial reluctance only partially dispelled, Rauschenberg's *Landmark* entered the collection through Ms. Adams. As the Frumkin Gallery became more involved with contemporary prints, Mrs. Torf became more aware of its attractions. Her contact with Alice Adams was reinforced by the growing popularity of prints in the art world, and the Rauschenberg prints marked a change in Lois Torf's primary interest.

The Early Twentieth Century: A Prism Reflecting the Work of Master Printmakers

Deborah Menaker

The comprehensiveness and consistent high quality of the Torf collection make it possible to illustrate major themes of the twentieth century with some of its most compelling printed images. The early years of the century witnessed rapid changes as well as an unparalleled diversity of styles; within a matter of months groups and movements would form, disband, and reassemble again. Scientific, philosophic, and psychological discoveries fueled artistic investigations and led artists to concentrate on a number of new issues that were international in scope.

Expressionism and its Roots

Eugène Carrière's *Sleep* (cat. no. 34) and Edvard Munch's *Vampire* (cat. no. 158) of the 1890s lead us into the new century – a century born under the signs of revolution, uncertainty, and longing for the primal and instinctual. Both artists show a nascent interest in states beyond reason so common in *fin de siècle* arts and letters; in Carrière's Symbolist milieu, the dream was viewed as a key to unlocking primal instincts and mysteries of the subconscious. (Indeed, as he sleeps, Carrière's son, Jean-René seems to regress to a primordial state.) Similarly, Munch's *dramatis personae* appear to be in a hypnotic trance, involuntarily obeying unseen forces. In both works linear rhythms sweep hair, arms, and faces into undulating masses, and a lack of precise description gives the figures an unformed look.

Munch's association of love with death – the act of creation as destruction, filled with pleasure and pain – sets off a chain of contradictions that links the art of the next nine decades. Modern dilemmas and maladies such as loss of faith, feelings of alienation, and psychological suffering are common in his work, where universal dramas often have their source in personal experience. Thus, it is likely that *Vampire*, which was originally titled *Love and Pain*, recalls an unhappy affair, perhaps referred to in a passage written by Munch in 1889:

She had bent her head over mine – the blood red hair had entwined itself around me. It had twisted itself around me like blood red snakes – its finest threads had entangled themselves into my heart.[1]

Hair is often an instrument of entrapment in Symbolist literature and the vampire's enveloping tendrils identify her with the quintessential *femme fatale* of that movement – the woman whose sexuality is a deadly weapon.

In 1892 members of the Verein Berliner Künstler voted to close an exhibition of Munch's work on the grounds that it was degenerate. This endeared him immediately to the avant garde, for whom, virtually overnight, he became a hero. His frankly erotic subject matter, as well as his way of working the block – flat masses broken by rough strokes of the knife and his use of the wood grain as an integral part of the composition – made him particularly relevant to a group of anti-establishment architecture students from Dresden. In 1905 these students – Ernst-Ludwig Kirchner, Erich Heckel, Fritz Bleyl, and Karl Schmidt-Rottluff – founded *Die Brücke* (The Bridge). (Later members included Emil Nolde and Max Pechstein.) From the beginning, graphic media were vital to them, as they considered the multiple original the best way to reach a large public and to promote their anti-elitist platform.

Erich Heckel and Emil Nolde took Munch's innovations a step further (see cat. nos. 84 and 162): while Munch's woodcut of a young woman (cat. no. 159)[2] leaves the figure's face intact, Heckel and Nolde vigorously excavate their subjects' faces from the block, lending a boldness to otherwise innocuous subjects. Riva Castleman has written of *Die Brücke*: "Direct unedited attack upon the wood or other medium in which they worked conveyed a primal energy that transformed subjects as banal as reclining nudes or street scenes into complex psychodramas.... They plunged their chisels into blocks with the uninhibited vigor of uncivilized natives releasing spirits from the wood."[3]

1. Quoted in Sarah G. Epstein, *The Prints of Edvard Munch: Mirror of His Life* (Oberlin College, Ohio, 1983), p. 39.

2. Cat. no. 159 may be a portrait of the artist's sister Inger. She is also the somber child in the painting *The Sickroom* (1893; Oslo Kommunes Kunstsammlungen). She is presented in the same self-contained way in *Sister Inger* (1892; Nasjonalgalleriet).

3. Riva Castleman, *Prints from Blocks* (New York, 1983), unpaginated.

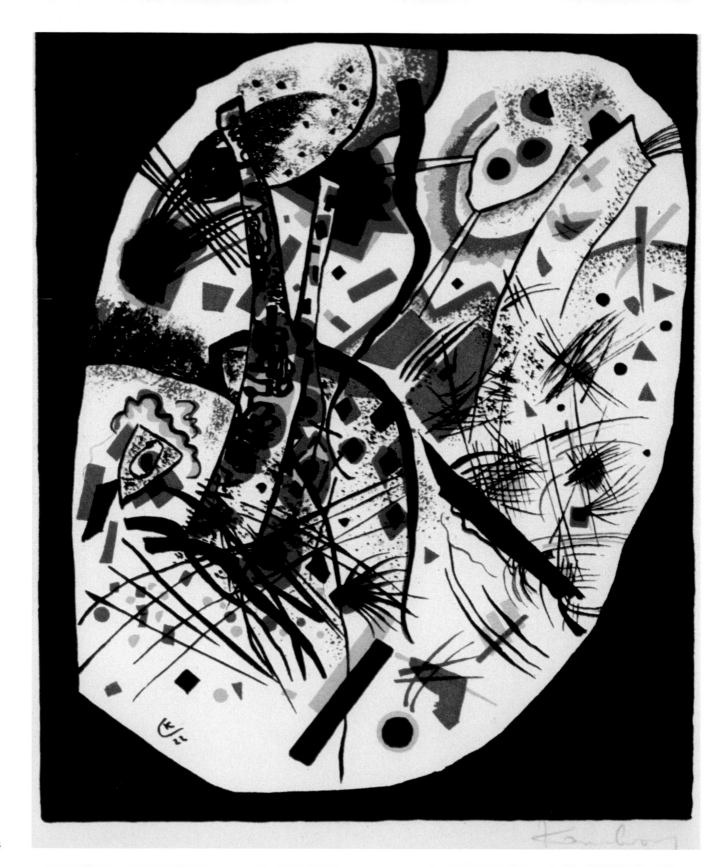

14

Of all *Brücke* members, Emil Nolde seems to have been possessed of the most "primitive" temperament. Born of peasant stock, Nolde was already an accomplished etcher when he joined the *Brücke* group in 1905 and 1906 for a brief eighteen months. In exchange for etching lessons, his new colleagues introduced him to the woodcut medium and, in the space of a year, he produced about thirty woodcuts, of which *Young Priest* (cat. no. 162) is one. The dour piety of Nolde's native North Germany is evoked as much by the harsh marks carved from the block as by the priest's stern face.

In 1910 Nolde visited Hamburg, where he was stimulated by the bustling port, and he produced ink drawings, woodcuts, and etchings of the harbor. The nineteen etchings he made (two of the finest being cat. nos. 163 and 164) reveal a sensitivity to atmosphere that allies him with Turner and Monet. Like them, Nolde was attentive to the multitude of vapors, natural and man-made, that hover over an industrial port city. Different types of etched lines, some double-bitten into the rough steel plates, suggest steam, rain, and smog. Peter Selz has given an account of Nolde's working method: "During the day he sketched and drew in a small boat and at night, in his sailors' hostel, he etched his plates with furious speed, placed them in the acid, lay down to sleep for a few hours and awoke in time to remove them from the bath."[4]

Nolde's *Young Danish Woman* (cat. no. 165) is one of a series of thirteen color lithographs that has been described as "the climax of German Expressionist graphic art."[5] A few months before setting sail for the South Seas in 1913, he was allowed free run of the lithography studio in Flensburg. There he created prints that were, for the time, large in scale, and he used them to experiment with different states and color variations. *Young Danish Woman*, possibly a primitivizing portrait of his wife, Ada, at once captures the fresh-faced vitality of the rural Dane while anticipating the bold physiognomies of the South Sea islanders Nolde would soon encounter.

Ernst-Ludwig Kirchner, who was the driving force behind the *Brücke* association, was also its most complete graphic talent. Woodcut, etching, and lithography were of prime importance to him and often, in times of crisis, he set oil paint aside in favor of the graphic media. Nineteen-fifteen, the date of *Lovers in the Morning* (cat. no. 117), was one such year for the artist. (He suffered a breakdown while serving in the army and was declared unfit for duty; for the rest of the year he shuttled between Berlin and a sanatorium in Königstein.) The lovers' thin angular bodies, cloaked in a web of darkness by the scrawled lines that zigzag across the lithograph's surface, serve as a metaphor for an undernourished spirit. In their emotional indigence, they recall Kirchner's statement that "Our times are so frightfully poor in sensuousness, i.e., love aroused for anything outside of us at all...."[6]

Like Kirchner's lovers, Egon Schiele's *Mädchen* of 1918 (cat. no. 197) suggests — through her scrawny frame, knobby joints, and listless air — a diseased social order. Undermining a centuries-old tradition of the voluptuous nude, she is rendered with a nervous line that expresses the artist's personal anxiety. Schiele's penchant for erotic studies of children and adolescents led to his imprisonment when authorities of the provincial town of Neulengbach charged him with "immoral conduct and the seduction of a minor."[7] His incarceration was symptomatic of his ongoing failure to conform to bourgeois society. As *Mädchen* indicates, imprisonment did not chasten him and he continued to employ child models until the end of his brief life. *Mädchen* was the last print in Schiele's graphic production, which numbers seventeen works in woodcut, etching, and lithography, all commissioned.[8] He submitted it in 1918 in response to an invitation from Dr. Arpad Weixlgärtner, editor of *Die graphischen Künste*, who was seeking color lithographs for an annual portfolio. Weixlgärtner wrote the artist on June 19, 1918: "I would be very glad if your work turned out to be especially good and characteristic as

the print in black already promises. I hope the somewhat overemphasized genitals of the girl will not be considered offensive. I wonder if you could tone that down a little."[9] On June 28, before Schiele could respond, the design was rejected on the grounds that "the subject after all is less suited to the taste of the majority of our members than for a small circle of collectors and amateurs."[10] Schiele died five months later, not having realized a color lithograph of the subject.

Like Kirchner and Schiele, Max Beckmann held up a mirror to society's ills. In 1915, he was discharged from the military after suffering a breakdown and it is likely that the events he witnessed in his capacity as a medical corpsman contributed to the unflinching candor of his vision. *Two Women Dressing* and *Group Portrait: Eden Bar* (cat. nos. 14 and 15), representative of a rare venture into woodcut, are typical of his acerbic style. They describe a decadent Berlin, where "...sex was the business of the town...."[11] In *Two Women Dressing* (probably a depiction of prostitutes) the sense of disquiet is enhanced by presentation of the top half of the image from below and the bottom half from above — a device Beckmann appropriated from the fifteenth-century German paintings he studied while living in Frankfurt from 1915 to 1935.[12] The worldly patrons of the Eden bar are "crowded together, yet no human contact seems possible between them," as each gazes in a different direction.[13]

Beckmann did not spare himself in his biting commentaries on modern manners. His many searching self-portraits document the change from confident youth to disillusioned maturity. In the drypoint *Self-Portrait with Bowler* of 1921 (cat. no. 13) the artist peers out from jaded eyes. A sense of timeless mystery provided by the lamplit interior and the idol-like cat is counterposed against such contemporary trappings of middle-class fashion as a cigarette, a stiff collar, and a bowler hat.

4. Peter Selz, *Emil Nolde* (New York, 1963), p. 52.

5. Ibid., p. 56.

6. From Donald E. Gordon, *Ernst Ludwig Kirchner* (Cambridge, 1968), p. 25.

7. See Arthur Roessler, ed., *Egon Schiele in Gefängnis* (Vienna, 1922).

8. *Mädchen* and not *Paris van Gütersloh*, as Roessler had claimed, was Schiele's last graphic work. See Otto Kallir, *Egon Schiele, das druckgraphische Werk* (Vienna, 1970), p. 41.

9. Ibid., p. 42.

10. Ibid., p. 43.

11. The actress Louise Brooks, who filmed *Pandora's Box* in Berlin in the 1920s, virtually described Beckmann's two woodcuts in this statement and in what follows: "At the Eden Hotel where I lived in Berlin, the café bar was lined with the higher-priced trollops. The economy girls walked the streets outside." (From *Lulu in Hollywood* [New York, 1982], p. 97.)

12. Peter Selz, *German Expressionist Painting* (Berkeley, 1957), p. 286.

13. Ibid., p. 286.

The prints of Kirchner, Schiele, and Beckmann confront a bankrupt society; on the other side of the coin is a desire to escape from civilization. Several of the rural landscapes by Heckel and Schmidt-Rottluff (see cat. nos. 84 and 199) are part of the impulse to return to a natural way of life, and many works of the period demonstrate a need to explore beyond the frontiers of familiar culture: following in the steps of Paul Gauguin, both Emil Nolde and Max Pechstein sailed to the South Seas. The *Hunting of the Roast for the Feast* of 1911 (cat. no. 168), made three years before Pechstein's departure for Palau, shows native women sitting in unselfconscious nudity beneath a tree harboring two birds, while a hunter clad in a loincloth stalks the birds with bow and arrow. A response to naive folk art as well as to the sophisticated experiments with arbitrary color conducted by the French Fauves and other artists, the scene is economically rendered. The center figure has no mouth, nose, or ears – only a large, semicircular eye. The hair of the side figures is subsumed within flat masses of black that bisect the composition and the hand-applied flat colors extend beyond the outlines of the objects they describe.

The woodcut was one of the first works by a *Brücke* member to appear in Herwarth Walden's controversial literary journal *Der Sturm*, serving as the cover illustration for the issue of January 21, 1912. Kirchner, Heckel, Schmidt-Rottluff, and Nolde also became frequent contributors.

Der Blaue Reiter (The Blue Rider)

Herwarth Walden also promoted a group of artists, based in Munich, who banded together in December of 1911 to produce the *Blue Rider Almanac*. Cofounded by Franz Marc and Wassily Kandinsky, its regular contributors included Gabriele Münter, Heinrich Campendonk, Paul Klee, and Lyonel Feininger. Like the anti-bourgeois *Brücke*, the *Blaue Reiter* was dedicated to fighting "like disorganized savages against an old established power."[14] In general, they were more utopian and metaphysical in their philosophy than the *Brücke* artists, believing that art could bring a spiritual renewal to society, and sharing a

romantic vision of primal harmony with nature. They encouraged diversity of style among the contemporary artists from various groups they invited to show with them, stipulating only that works be outside the post-Renaissance western European tradition. A glance through the *Almanac* reveals a penchant for juxtapositions showing the relationship between favored contemporary artists and medieval, folk, or exotic art. Thus, a Kirchner lithograph is seen next to a wood carving from Borneo, or a Campendonk is paired with a Bavarian folk painting.

Heinrich Campendonk's *Adam and Eve* (cat. no. 33), although created some ten years after his affiliation with the *Blue Rider*, is nonetheless faithful to their precepts. Like Pechstein's color woodcut, it depicts a pastoral theme in a deliberately naive way; flat planes, stylized forms, and unmodulated colors bely sophistication. The anomaly of finding Adam and Eve in a village with a thatched hut and a peasant woman is compounded by other mysteries: the snake and ram hover in midair, as does Adam, who has no limbs from his knees down. Moreover, it remains unclear whether the crosses on the buildings are intended as Christian symbols or are merely structural elements – an ambiguity that is typical of Campendonk.

Both the *Brücke* and the *Blaue Reiter* artists were influenced by Friedrich Nietzsche's writings in their quest for a closer relationship between the human being and his biological instincts. Nietzsche wrote in the *Antichrist*: "Man is not the crown of creation. Relatively speaking, he is the most bungled of the animals and the sickest. Not one has strayed more dangerously from its instincts. The animal lives in unity with nature, a unity that man has forsaken."[15] Franz Marc took Nietzsche to heart, eliminating the human figure from his work in the belief that only animals were worthy of salvation. By 1912 Marc arrived at the conclusion that his dream for pastoral regression could be realized only through total annihilation of the existing order, and welcomed the declaration of World War I as a sign that the cleansing apocalypse was at hand. He soon realized, however, that war would not be the cure-all he expected; several months

before he died at Verdun, he abandoned hope, writing: "I no longer envision death as destruction; it is absolute deliverance – Death where is thy sting!"[16]

Creation II (cat. no. 143) is one of four woodcuts Marc executed for a joint project involving Kandinsky, Klee, Heckel, Alfred Kubin, and Oskar Kokoschka, each illustrating a different book of the Bible. Marc chose the Book of Genesis and Kandinsky the Apocalypse, thereby framing the beginning and the end of time. The first two woodcuts Marc made for the project, the *Birth of the Horses* and the *Birth of the Wolves*, represent the respective genesis of good and evil. *The History of Creation I and II*, continuing this theme, shows the presence of both benevolent and malignant forces at the birth of the world. At the bottom is a menacing embryonic snake; a half-evolved cat-like animal with a horse's mane and hooves rushes in from the right, and a fully described horse's head (usually a symbol for purity in Marc's lexicon) appears at the upper left. Against a background of cataclysmic forces that cause trees to bend and rocks to tumble, the sun and moon are shown simultaneously – another indication of light and dark agents present at the beginning of the world.

Marc's yearning for primitive regression and for the apocalypse needed to achieve it were shared by Wassily Kandinsky, whose abstractions of 1910-1914 were based on Last Judgment, Deluge, and Resurrection imagery.[17] Like Marc, he believed that a better age would emerge after a great struggle, and always strove to reconcile opposing forces. He would transform a galloping rider, a toppling tower, or an angel trumpeting Judgment Day into highly personal hieroglyphs obscure to the uninitiated eye.

It is clear from his writing that Kandinsky took keen delight in every aspect of printmaking and had a sensuous feeling for graphic tools and materials. He described the woodcutting

14. From "Savages of Germany," by Franz Marc in *The Blaue Reiter Almanac*, Klaus Lankheit, *The Documents of Twentieth Century Art* (New York, 1974), p. 61.

15. Friedrich Nietzsche, "The Anti-Christ," in *Twilight of the Idols and The Anti-Christ*, transl. R. J. Hollingdale (Harmondsworth, 1978), p. 117.

16. Franz Marc, *Briefe, Aufzeichnungen und Aphorismen* (Berlin, 1920), pp. 74-75. From a letter to his wife, Maria, dated June 23, 1915.

17. The representational basis for Kandinsky's abstract innovations in apocalyptic imagery was first put forth in Klaus Brisch's dissertation for the University of Bonn in 1955. More recent publications include Sixten Ringbom, " 'Art in the Great Spiritual,' Occult Elements in the Early Theory of Abstract Painting," *Journal of the Warburg and Courtauld Institutes* 29 (1966), pp. 386-411; and Rose-Carol Washton Long, *Kandinsky: The Development of an Abstract Style* (Oxford, 1980). See the preface in Washton Long for state of research and further bibliography.

process as a dramatic event "as the cold metal moves against the warm wood," the drypoint needle "bores voluptuously into the plate," and in etching the "plate devours the paper...a passionate process which results in a complete fusion of paper and ink."[18] Kandinsky's utopianism was compatible with the newly founded Bauhaus, and in 1922 he accepted the invitation of Walter Gropius to teach at the Weimar design school. In the same year he produced his best-known graphic work of the Bauhaus period, the portfolio *Kleine Welten* (cat. nos. 102-113), consisting of twelve woodcuts, etchings, and lithographs. Although *en route* to the precise geometries of his later years, *Kleine Welten* is still predominantly in the expressive style Kandinsky invented in 1910. Many of the plates contain vestiges of mountain ranges and walled cities rent asunder by cosmic conflicts, echoing Kandinsky's view that "Art is like a thundering collision of different worlds that are destined in and through conflict to create the new world called the work. Technically every work of art comes into being in the same way as the cosmos — by means of a catastrophe which ultimately creates out of the cacophony of various instruments that symphony that we call the music of the spheres."[19]

Lyonel Feininger was also a subscriber to the Bauhaus dream of interdisciplinary collaboration and communal living; he fully endorsed its goal of improving general aesthetic standards through the application of modern technology and mass production to fine design. Preceding Kandinsky, Feininger joined the Bauhaus as Master of Form, and was placed in charge of the graphic workshop, which began operation in the fall of 1919.[20] Slowly, over a period of years, Feininger arrived at a spatial structure similar to that of the Cubists and Futurists. His wife, an art student at the time they met, introduced him to lithography and etching. His passion for woodcut began during the war, when a shortage of oil paint, and of metal or stone plates for etching and lithography,

encouraged him to turn to woodcut. In a single year he carved over a hundred blocks.

The woodcut entitled *The Gate* of 1920 (cat. no. 53) is a reworking of a motif that continually absorbed Feininger. A medieval city is dominated by a massive gate and its superstructure. The dynamism of the black sun whose rays radiate through the village seems to cause the buildings to totter on their foundations, a sensation augmented by the cubistic fragmentation of forms.

A sense of precariousness also informs Paul Klee's Bauhaus print *Tightrope Walker* (cat. no. 119). Both Klee and Feininger were preoccupied with formal structures that they believed to be derived from their musical training. Klee's and Feininger's parents were professional musicians and the two artists were accomplished amateurs (they often performed together at the Bauhaus, which Klee joined in 1920). They used satire and caricature in order to break free from academic tendencies, and struggled over many years to find their own styles.

The lighthearted whimsy on the surface of *Tightrope Walker* draws attention away from its carefully considered formal structure. The work is divided by a cross into four pink zones. A network of vertical, horizontal, and perspectival lines provides an armature upon which the scene is enacted. The lightly spattered black ink on the top and bottom edges of the stone has a fine gray texture that adds depth and atmosphere to the print. Like his tightrope walker, Klee was constantly performing a balancing act — reconciling free imagination with premeditated structure. As early as 1902 he wrote with admiration of Titian: "But this man knows how to lose and control himself at the same time. ..."[21] It was a condition to which Klee always aspired.

Cubism and its Satellites

Nearly every post-1910 image discussed thus far has somehow taken into account the pioneering collaboration between Pablo Picasso and Georges Braque known as Cubism. The

prismatic faceting of planes in Feininger's *Gate* and Heckel's *Park Lake*, the shuffled perspectives in Beckmann's woodcuts, and the submerged grid in Klee's *Tightrope Walker* — all are predicated upon Cubist innovations.

Although printmaking was less important for the Cubists than for the Expressionists, it formed an equally original means of artistic communication.[22] Obliged to rethink in graphic terms revolutionary concepts they had developed in painting and sculpture, Picasso and Braque sought graphic correspondences for painterly qualities such as overlapping and dissolving planes, ambiguous space, and shifting perspectives. The bounty of Cubist prints in the Torf collection charts the development of the movement from its birth through the so-called high Analytic phase, including its many offspring.[23]

Georges Braque's nude study of 1908 (cat no. 24) represents the artist's first essay in printmaking. With Cézanne's achievements fresh in his mind (a major Cézanne retrospective was held in 1906), Braque tried his hand at the simultaneous rendering of two and three dimensions; his cross-hatchings not only model form but serve as flat decorative markings upon the plane surface of the plate. In the areas of the hair and shoulder, left side, and thigh, these hatchings are a graphic counterpart to Cézanne's painterly *passage* (the linking of near and far through bleeding close-valued tones).

Picasso's discovery of Cézanne, whom he later called "my one and only master,"[24] paralleled his exploration of tribal art. It is possible that in *Two Nude Figures* of 1909 (cat. no. 171), the audacious displacement of the seated woman's right arm is indebted to the example of African carvings, in which anatomical parts have a freedom unknown in Western art. Like so many of his contemporaries, Picasso first looked to "primitive" art in the years around 1905 to help him break away from stagnant European conventions. *Still Life, Compote* of 1909 (cat. no. 172) repeats the angular configu-

18. From Wassily Kandinsky, *Point and Line to Plane*, transl. Howard Dearstyne and Hilla Rebay (New York, 1947), p. 48.

19. Wassily Kandinsky, "Reminiscence" (1913), in Kenneth C. Lindsay and Peter Vergo, eds., *Kandinsky, Complete Writings on Art*, vol. 1 (Boston, 1982), p. 373.

20. Carl Zaubitzer, the master craftsman, deserves credit for the uniformly high quality of Bauhaus prints and portfolios from 1919 to 1924. See Hans Wingler, ed., *Graphic Work from the Bauhaus* (Greenwich, 1965).

21. Félix Klee, ed., *The Diaries of Paul Klee* (Berkeley, 1964), p. 109, no. 403 (April 18, 1902).

22. Burr Wallen and Donna Stein, *The Cubist Print* (University Art Museum, Santa Barbara, 1981), p. 13.

23. Douglas Cooper and Gary Tinterow, *The Essential Cubism 1907-1920. Braque, Picasso and their Friends* (Tate Gallery, London, 1983). The authors argue that only the works of Braque, Picasso, Juan Gris, and Fernand Léger qualify as "pure" Cubism.

24. Dore Ashton, *Picasso on Art: A Selection of Views* (New York, 1972), p. 162.

rations found in *Two Nude Figures* but moves further toward the analytic style. In three states or stages, Picasso progressed from a sharply contrasted image, similar to *Two Nude Figures*, to a light and subtly nuanced treatment that is the graphic equivalent of the monochrome Cubist palette.

After the two drypoints of 1909 Picasso did not venture into printmaking again until the summer of 1910, when he was commissioned by his dealer, Daniel Henry Kahnweiler, to illustrate Max Jacob's autobiographical prose-poem *Saint Matorel*. Picasso created four etchings that constitute his "first true Cubist prints in the Analytical style."[25] One of them, *Mademoiselle Léonie* (cat. no. 173), represents the poem's love interest – a character based upon an acrobat whose performances Picasso and Jacob attended at the Cirque Medrano. The etched figure's dislocated shoulder, hip, and knee are amusingly appropriate to someone "double-jointed." And, in a general way, the acrobat's feats of agility and balance parallel the artist's creative nimbleness.[26] Mademoiselle Léonie undoubtedly had a special hold on Picasso, for two years later he traced her name on an overlay drawing for the unpublished drypoint *Still Life, Bunch of Keys* (cat. no. 174).[27]

Picasso's success with *Saint Matorel* apparently inspired his co-conspirator Braque to make a series of still-life etchings with dry-point, a group of which form the shimmering cluster of images included here. In the still-life *Paris* (cat. no. 25), etched the same year as *Mlle. Léonie*, the only clearly readable elements are the letters that spell out "Paris" and the letters identifying a cigarette box with the brand name "Murad Cairo." The rest remains tantalizingly difficult to decipher as the Parisian environment intermingles with the objects on the tabletop.

The next year Braque continued his graphic explorations with a series of masterful still lifes. It has recently been discovered that *Still Life I* and *Still Life with Glasses* (cat. nos. 29

and 30) were originally intended as a single image.[28] (Apparently dissatisfied with a large horizontal format, Braque cut the plate in two.) The more elaborated half, *Still Life I*, represents high analytic Cubism at its most hermetic. On the brink of total abstraction, it is difficult for the viewer to find his bearing amid the myriad shaded planes, partly modeled forms, and transparent elements that allude to the look of three-dimensional reality, yet confound any such reading.

Prodigious concentration was involved in creating works of such complexity in which, within a shallow relief space, layer upon layer of observed reality is transformed into metaphysical abstraction. The ambiguity at the heart of Cubism announces a distinctly modern world view – one that accepts the relative, the partial, and the uncertain and acknowledges the limits of man's ability to know.

Still Life I and *Still Life with Glasses* represent Cubism at a crossroads. Instead of taking the final plunge into total abstraction, Picasso and Braque began to introduce more signs referring to reality – words, numbers, and descriptive details (see *Job*, *Fox*, and *Bass*; cat nos. 26-28). The typography of Cubism is rife with off-color puns and schoolboy humor:[29] gamesmanship and duplicity, inherent in the Cubist ethic, are referred to in *Job* – French slang for duping someone[30] – and in *Fox* – a Parisian bar catering to the turf set (also a synonym for "sly" in English). The words "gin" and "old Tom" in the latter connote flirting and coupling in French argot.[31]

The Cubism that Picasso and Braque created in relative isolation was, by 1910, spawning numerous satellites. Among the most original and skillful creators of Cubist-inspired art were Robert Delaunay and Jacques Villon. Early in his career, in 1912, Delaunay abandoned Cubist dependence on reality and became one of the pioneers of pure abstraction. By 1925 his interest in representation was renewed: *Window on the City* (cat. no. 40) presents a flickering bird's-eye view of his beloved Paris. Light and the Eiffel Tower – two phenomena

for which the city is famous – dominate the composition.

Jacques Villon achieved perhaps the greatest mastery of Cubist intaglio process. The graphic medium was his primary discipline, and the works included here demonstrate the technical perfection and sensitivity to linear structure for which he is so highly esteemed. *Chessboard* (cat. no. 213) was the first print Villon executed after World War I. In it he explored a new method of layering planes derived from D'Arcy W. Thompson's theoretical treatise *On Growth and Form* of 1917.[32] The plate of *Chessboard* was covered with closely parallel or cross-hatched lines of the utmost refinement. It was then re-etched a number of times in order to create a wide variety of tonal values.

Villon's etching demonstrates an interest in sequential motion that brings to mind the Cubist-related movement of Futurism. However, it was the Italian Futurists who used a Cubist vocabulary to express the noisy and frenetic pace of contemporary life. Umberto Boccioni's *Forward Movement*, printed posthumously at the Bauhaus from a 1913 sketch (cat. no. 20), exemplifies the Futurists' fascination with speed. Adopting Cubist fragmentation and multiple or partial views for kinetic ends, the artist compressed successive moments of a single action as the cyclist hurtles across the page. Unlike the Cubist subject, which remains static while the viewer's point of view changes, Futurist objects move swiftly before a stationary viewer.

Futurist Gino Severini's *Cubist Figure: Woman* of 1915 (cat. no. 203) may relate to Picasso's images such as *Mlle. Léonie*.[33] However, Severini replaced the analytic facture and open contour with hard-edged planes and flat cut-out forms. Whereas Picasso's etching was a search for the structure that underlies the changing face of reality, Severini's elegant lady is more about surface pattern.

Like the works of Severini, Albert Gleizes's *Cubist Composition* of 1921 (cat. no. 78) seems inspired by the simplified collages of Cubism's later Synthetic phase, rather than by the less easily comprehended Analytic works. Gleizes

25. Wallen and Stein, op. cit., p. 26.

26. See Richard Axsom's discussion of the Acrobat from the ballet *Parade* (with set, décor, and costumes by Picasso) as a symbol of the artist's facility. In *"Parade": Cubism as Theater* (Outstanding Dissertations in the Fine Arts, New York, 1979), pp. 70-72.

27. Bernhard Geiser, *Picasso Peintre-Graveur: Catalogue illustré de l'oeuvre gravé et lithographié 1899-1931* (Berne, 1933), no. 30.

28. Wallen and Stein, op. cit., p. 66. Burr Wallen made the discovery in 1981.

29. Robert Rosenblum, "Picasso and the Typography of Cubism," in *Picasso in Retrospect* (New York, 1973), pp. 49-76.

30. Wallen and Stein, op. cit., p. 67.

31. Ibid., pp. 67-68.

32. From Daniel Robbins, ed., *Jacques Villon* (Cambridge, 1976), pp. 19-21. For *Chessboard* and the 1919 oil painting from which it derived, *Jeu*, see p. 89, nos. 68-69.

33. Wallen and Stein, op. cit., pp. 79-80.

wrote in collaboration with Jean Metzinger a book on Cubism (*Du Cubisme*, 1912) that attempted to codify and explain "the very untheoretical pictorial intuitions of Braque and Picasso";[34] his lithograph, likewise, imposes order and formulae upon the Cubist idiom. The diagonal play of flat patterns – with its satisfying contrast of light and dark, stippling, and striation – is closer to Bauhaus design than to the original values of Cubism.

Utopian Constructivism and Dada

The Bauhaus was one of many international groups that, in the years around World War I, focused its attention upon balancing free-floating abstract forms in space. Generally lumped under the heading of Constructivism, artists in France, America, England, Germany, Holland, and Russia devoted themselves to creating abstract visual structures based on geometric shapes. Perhaps responding to scientific and philosophic advances that were "in the air" (such as Einstein's theory of relativity or Henri Bergson's investigations into the nature of time), artists looked beyond representation in order to discover the basis of reality. "Space and time are the only forms on which life is built and hence art must be constructed," declared Naum Gabo in the "Realistic Manifesto" published in Moscow in 1920.[35]

Russian Constructivism was the official art of the 1918 Revolution. Though short-lived, it was one instance wherein artistic revolt played a part in political upheaval. "The aesthetics developed from the Revolution will not merely be a facet of the Revolution, but a revolution in itself," claimed the text of a 1922 exhibition catalogue commissioned by the People's Commissariat for Art and Science.[36] Like the Bauhaus artists, Russian Constructivists aimed at raising standards of mass production and public taste through the integration of art, craft, and technology. El Lissitzky's mechanistic personages from the 1923 portfolio of costume designs for the opera *Victory over the Sun*, of which *Gravedigger* (cat. no. 136) is one, attest

to the zealous faith with which the possibilities of technology were embraced.

El Lissitzky's *Proun 2 B* (cat. no. 135) and Alexander Rodchenko's linocut *Composition* (cat. no. 193) are rare examples of Russian Constructivist graphics. Both achieve a dynamic equilibrium as abstract shapes slowly move backward and forward or rotate in space. In part, this sense of motion results from the interpenetration and overlapping of the variously textured elements, as well as from their implied extension beyond the frame.

Naum Gabo was a pioneer in creating an art based on space, time, and structure, rather than volume, mass, and representation. In his first attempt at printmaking, begun in 1950 (see cat. nos. 57-77), he produced wood engravings that possess the same transparent weightlessness as the constructions he fashioned from plastic and wire many years earlier. Like the prints of his countrymen, Gabo's geometrically derived configurations seem to move slowly through space. However, his work possesses a grace and lyricism foreign to the more architectonic Constructivism of Lissitzky and Rodchenko.[37] Some of the engravings suggest celestial bodies, others primordial life forms drifting underwater.

The prints by Bauhaus masters Josef Albers, László Moholy-Nagy, and Oskar Schlemmer (cat. nos. 2-6, 152, and 198) share the Constructivists' enthusiasm for the vocabulary of the engineer and architect. Outwardly cool and impersonal, this style was fueled by passionate revolutionary beliefs – such as the rejection of Expressionism as being romantically bourgeois and embarassingly personal, or the idea that art should be useful and directed toward the general populace. Often there are undercurrents of ambiguity in the seemingly clear and rational Constructivist style. For example, Albers's *Grey Instrumentation* (cat. nos. 4-6), part of his extended Homage to the Square series begun in 1949, challenges visual assumptions as it explores the relativity of color through subtle juxtapositions.

Similarly, Oskar Schlemmer's dancer (cat. no. 198) sends out a contradictory message as the figure's gesture halts the viewer, while the plunging orthogonals pull him into the picture space. The dancer is based on "the Abstract," a

character in Schlemmer's *Triadic Ballet*, which was first performed in September of 1922 in Stuttgart during a week-long Bauhaus celebration.[38] "The Abstract" embodies Schlemmer's view of the dancer as a special human being gifted with an intensified feeling for his body and a heightened awareness of space. The figure of the dancer is duplicated in an oil painting, a watercolor, an ink sketch, and a stage costume.[39] In all of its embodiments the figure retains an aloof bearing as it spans the distance from near to far with pinpointed precision.

In 1921 Theo van Doesburg, one of the founders of the Dutch Constructivist movement known as *De Stijl* (The Style), moved to Weimar in the hope of being appointed a Master at the Bauhaus. He was opposed to the medieval handicraft ideal of the original Bauhaus program as promulgated by the mystic Johannes Itten (and to a lesser extent by Kandinsky), championing instead the use of the machine in the mass-production of well-designed goods. After lecturing independently on typography and design, van Doesburg left Weimar in 1922 and began a collaboration with the Hanover Dadaist Kurt Schwitters. Although the pairing might seem incongruous, both Constructivists and Dadaists were anti-materialist (i.e., dedicated to a "radical cleansing of social and artistic life") and both artists carried out this objective in their work. For years van Doesburg led a double life as the Dadaist poet I. K. Bonset,[40] while Schwitters's seemingly haphazard arrangements of collaged refuse are, in fact, ordered by a rigorous formal structure (cat. no. 201).

During the first three months of 1923 van Doesburg and Schwitters conducted a Dada campaign through Holland. *Kleine Dada Soirée* (cat. no. 200) announces their opening night performance at the Hague Artists Association. The flyer loudly proclaims, "Dada, Dada, Dada" in red, while the program of the evening's events (as well as some Dada asides) are printed helter-skelter in various black typefaces. The poster announces Schwitters's recitation of his absurdist poem "Cause

34. Robert Rosenblum, *Cubism and Twentieth Century Art* (New York, 1976), p. 180.

35. Published in *Gabo* (introduction by Sir Herbert Read and Sir Leslie Martin (London, 1957), p. 152.

36. Lissitzky designed the cover for the catalogue. See Sophie Lissitzky-Küppers, *El Lissitzky, Life Letters, Text* (London, 1968), p. 12.

37. Michael Mazur, "The Monoprints of Naum Gabo," in *Print Collector's Newsletter* 9, no. 5 (Nov.-Dec., 1978), p. 151.

38. In Karin von Maur, *Oskar Schlemmer* (Spencer A. Samuels and Co., New York, 1969), p. 12.

39. Karin von Maur, *Oskar Schlemmer* (Munich, 1982), nos. 36, 295, 402, 498, and 562.

40. Joost Baljeu, *Theo van Doesburg* (London, 1974), p. 39.

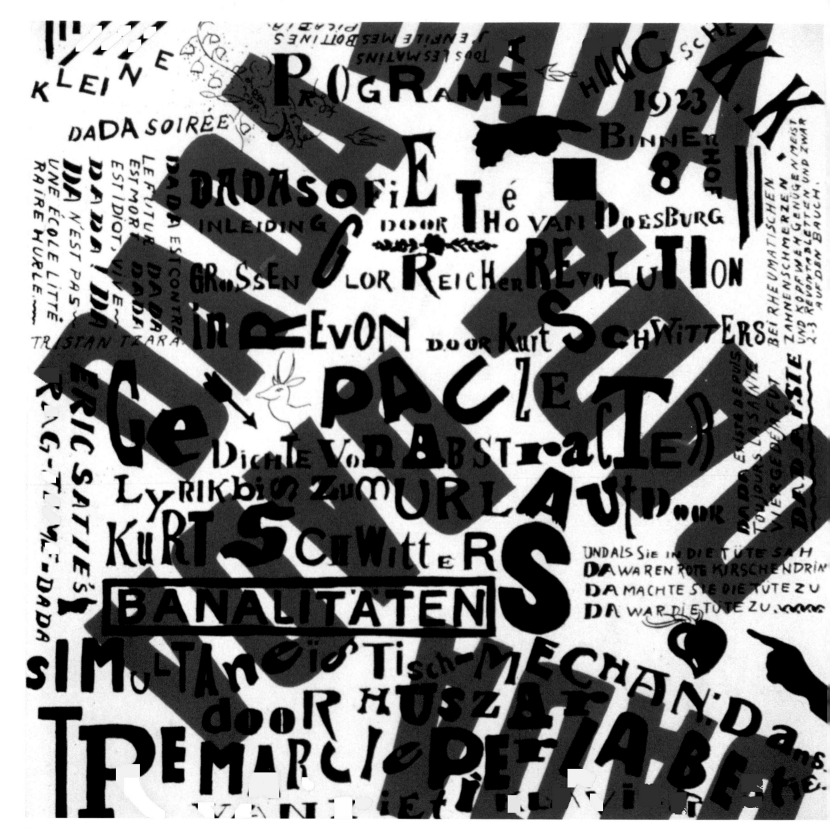

and Beginning of the Great and Glorious Revolution in Revon'' (Revon being the last five letters of Hanover in reverse). Also noted is his Poem of the Abstract (Gedichte von Abstracte) in which numbers were first shouted, then whispered.[41] The poster, intended as a mailer, but here seen in a rare unfolded example, exemplifies the interest in typography shared by so many of the modern movements that capitalized on the potential that letters and numbers have to combine the referential and the abstract.

In the Dada movement, contradiction and regression to the primitive – major factors in so much twentieth-century art – reached a climax. Dedicated to outraging the ever-beleaguered bourgeoisie, Dadaists used shock, paradox, and absurdity as a means of disorienting their public. Like the German Expressionists, they sought the *tabula rasa*: one Dada spokesman, Tristan Tzara, wrote, ''Honor, Country, Morality, Family, Art, Religion, Liberty, Fraternity had once answered to human needs. Now nothing [remains] of them but a skeleton of conventions….We must sweep and clean.''[42]

Unlike the *Blaue Reiter* or Utopian Constructivists, the nihilistic Dada artists had no idealistic plan for a better future. On the contrary, they were against anything systematized. The name ''Dada,'' evoking the sounds a baby makes, was perfectly suited to the movement's rejection of paternal values, as well as its regression to asocial infantile states.

Jean (Hans) Arp's primordial forms (cat. nos. 7 and 8) are in part a response to Dada's regressive impulses. His organic shapes are about the natural and instinctual rather than the man-made and intellectual; in their biomorphic aspect, they are akin to Dali's visceral forms (cat. no. 39), to the ameoboid personages of Miró's prints (cat. nos. 148-151), and to the floating semiorganic configurations seen in the wood engravings by Naum Gabo and Julius Bissier (cat. nos. 18 and 19).

Arp and Max Ernst were Dada companions who together staged subversive antics in Cologne. The title of Ernst's portfolio *Fiat*

modes, pereat ars or *Long live Fashion, Down with Art* (cat. no. 51) exemplifies Dada's nihilistic position. Inspired by the empty vistas and blank-faced mannequins of Giorgio de Chirico, Ernst's lithographs seem to vent his hostility toward the merchant class. His well-dressed tailor's dummies do not interact but stand isolated and idle, or dedicate themselves to meaningless tasks. While the dramatic spatial recession and robot-like figures echo the form of Oskar Schlemmer's dancer (cat. no. 198), the ideology is quite different from its positive utopian vision.

Following the upheavals of the first two decades of the century, the 1920s and 1930s were years of retrenchment and stabilization – a shift that seemed then as revolutionary as disruption and chaos had to the preceding generation. This conservative trend, which paradoxically called for both a return to order and a rejection of the status quo, counted many Constructivists among its adherents. Equally ironic was the transformation of anarchistic Dada into Surrealism under the dictatorship of André Breton. Thus, while retaining its provocative stance, Dada's spirit was codified – with manifestos and all – in much the same way that Gleizes and others had codified Cubism.

In the '20s and '30s the Surrealists, as well as independent artists, continued the investigations into man's subconscious – particularly the potency of his sex drives – begun by Edvard Munch and others before the turn of the century. Dali's *Mobilier Fantastique*, Miró's *Daphnis and Chloe* and *Eagle, Woman, and Night*, and Picasso's *Figures* of 1927 (cat. nos. 39, 148, 149, and 177) reduce eroticism to its biological essence, continuing further back on a retrograde course in search of primal beginnings.

During the second quarter of the twentieth century, avant-garde artists continued to rebel against the world of their fathers. In response the middle class had its retribution with the rise of Fascism in the '20s and '30s, and, by 1937, the work of most of the German-speaking artists discussed here was condemned as ''degenerate.'' The doors of the Bauhaus were permanently shut in 1933, and with the outbreak of World War II, many artists fled their homeland. In this way the visions of artist-printmakers such as Arp, Dali, Ernst, and Gabo were transplanted to America, contributing to a

process of cross-fertilization with artists on this continent. Emigré surrealists influenced the gestural lithographs by Willem DeKooning, Robert Motherwell, and Cy Twombly (cat. nos. 120, 156-157, and 208-211). Another seminal influence was Josef Albers, who passed on a lifelong preoccupation with problems of form and perception to a succession of students in Germany and America. The works included here by Dorothea Rockburne, Brice Marden, Robert Mangold, and Kenneth Noland indicate his success in conveying the endless possibilities of formal invention.[43] Through numerous permutations, they perpetuate this concern with precise construction and serial imagery into another generation.

41. Arturo Schwartz, *Almanacco Dada: Antologia letteraria artistica cronologia. Repertorio delle riviste* (Milan, 1976), pp. 637-639.
42. William Rubin, *Dada and Surrealism* (London, 1969), p. 10.

◁ **Kurt Schwitters** and **Theo van Doesburg.** *Kleine Dada Soirée,* 1922. (cat. no. 200)

43. George Heard Hamilton, *Josef Albers, Paintings, Prints, Projects* (Yale University, New Haven, 1956), p. 25.

The Contemporary Artist as Printmaker:
'Sixties to 'Eighties

Clifford S. Ackley

Although the Torf collection was not consciously assembled as a comprehensive survey of printmaking by the painters and sculptors of our time, a number of meaningful issues relating to American printmaking from the early 1960s to the early 1980s – as well as some related to recent European printmaking – can be illustrated by works in the collection.

Collaborative Printmaking

Without the existence of certain print workshops that made it possible for painters and sculptors to work with professional printers, the surge of printmaking by American avant-garde artists in the early 1960s would probably not have occurred; many of the artists had never produced serious work in printmaking before and had no access to presses. Two workshops, both of them lithographic, must be viewed as cornerstones of these developments: Universal Limited Art Editions, of West Islip, Long Island, founded by the publisher Tatyana Grosman in 1956, and Tamarind Lithography Workshop of Los Angeles, founded by the printmaker June Wayne in 1960. Tanya Grosman brought with her from Europe a devotion to the tradition of the artist-illustrated book with all its attendant emphasis on limited editions, fine hand craftsmanship, and the use of choice handmade papers. Perhaps her greatest accomplishment lay in the gentle persistence that enabled her to convince leading artists of the New York School to make a serious commitment to printmaking. Among these artists, Jasper Johns and Robert Rauschenberg rapidly developed into two of the most creative and influential printmakers of our time. The reluctance of Rauschenberg to attempt the traditional art of lithography is memorialized in his oft-quoted and now – many great lithographs later – wonderfully ironic statement that the second half of the twentieth century was no time to start "writing on rocks." Both Johns and Rauschenberg are prominent among the many artists of the 1960s whose reputations were considerably advanced by the acquisition of their original prints by museums and private collectors, here and abroad. Today, as in the past, artists have often first captured the art audience's attention through their prints rather than through their larger-scale, less portable, and more expensive works in other media.

Professional printmaking workshops, once established, have tended to spawn others and, in fact, one of Tamarind's primary goals was to train printers and personnel for such establishments. In the '60s and '70s their creative proliferation across the country can be clearly traced: Tamarind training led to Kenneth Tyler's founding of Gemini G. E. L. in Los Angeles, which in turn led eventually to the establishment of Tyler Graphics Ltd. in Bedford Village, New York. The increasing demand for access to printmaking media other than lithography encouraged lithographic workshops to diversify: Universal Limited Art Editions, for example, moved into etching in the second half of the '60s and into woodcut in the early '70s. Workshops that specialized in media other than lithography were also founded: for example, Crown Point Press in Oakland for etching, and Simca Print Artists in New York for screen printing.

A potentially negative aspect of collaborative printmaking is that it can sometimes generate reproductive rather than original art. The artist or the artist's publisher provides a drawing or painting that is then reproduced by the printer with little or no active participation on the part of the artist, the result being merely a signed reproduction rather than a fresh statement in a new medium of expression. At its best, however, collaborative printmaking makes available to the artist and publisher a range of technical resources and professional skills that no one artist's studio can contain. While this ultra-professionalism and technical wizardry can occasionally overwhelm the artist's message, substituting high-tech virtuosity for personal expression, it has made possible printed works of a complexity not otherwise conceivable; Jennifer Bartlett's *Graceland Mansions* (cat. no. 10) and Frank Stella's *Talladega Three I* (cat. no. 207) are examples of such ambitious prints. In Bartlett's five-part work the same theme of the primitive image of a house is stated in five different media and in five different vocabularies of stroke and line, employing four separate printmaking establishments to realize the idea.

Fabrication and the Impersonal Surface

In much of the "advanced" American art of the early '60s there is discernible a reaction against what was perceived as the all-too-personal handwriting and autobiographical excesses of Abstract Expressionist painting. The multiple image printed in an impeccably uniform edition is very much a part of a new interest in the precisely fabricated image and the cool impersonal surface that replaces the unique painterly gestures of Abstract Expressionism.[1]

In the quest for the more impersonal, fabricated look, the stencil medium of silkscreen came to the fore. Silkscreen lent itself readily to the production of the crisp, flat areas of unmodulated color that characterize much art of the '60s. Furthermore, the fact that it was a medium with strong commercial associations – customarily employed for printing of advertising posters and brand-name labels – gave it an additional usefulness to artists such as Warhol and Lichtenstein, who were playing with the ironies involved in imagery drawn from the mass media and popular culture. Their relatively cool approach to silkscreen is illuminated by a comparison with the sensuous buildup of surfaces in a screenprint of 1981 by Joel Shapiro (cat. no. 204) Printed on a piece of silky handmade Japanese paper, blacks of varying density, texture, and reflectivity combine to produce a distinctly painterly surface.

The Photographic Image

In 1962 both Andy Warhol and Robert Rauschenberg began transferring to their canvases, by means of photosensitized silkscreen stencils, photomechanical images drawn from newspaper and magazine sources. The silkscreen and the photomechanical image were to be one of the classic artistic marriages of the 1960s. Warhol was interested in the numbness and banality produced by the endless repetition of images in the mass media, whether the faces of cult icons such as Marilyn Monroe or Jackie Kennedy, or images of catastrophe and

dread such as electric chairs and car crashes. Warhol's repeated images were often screened unevenly onto the canvas, a means of achieving painterly variations while simultaneously referring to the debased quality of images in the popular media. Similar expressive ends are realized by the intentional off-register printing of screen prints on paper such as the set of ten Marilyn color variations (cat. no. 214), although here Warhol's images are crisper and more decorative. Apart from its allusion to the "silver screen," the black and silver version of Marilyn has a tarnished, ashen appearance that gives it a funereal air.

Rauschenberg's collage approach to the use of photomechanical imagery began with his transfer drawings of the late '50s in which, using a solvent, he made pencil rubbings from magazine and newspaper clippings, achieving simultaneously a pale translucent ghost of the photomechanical image and a gestural stroke that echoed and parodied the vocabulary of Abstract Expressionism. In the lithographs, which he began making in 1962, Rauschenberg transferred photomechanical images to the stones and plates by a variety of means, including photosilkscreens (as in *Breakthrough I*; cat. no. 189). The photosensitized screens encouraged him to manipulate through photographic enlargement or reduction the relative sizes of the images he had collected: a commonplace key becomes equivalent in scale to a life-size Houdon statue of George Washington. Exploring the ubiquity of images diffused via the modern mass media – the wallpaper of processed and reprocessed photographic imagery that continuously surrounds us in our waking lives – Rauschenberg has discovered his own kind of poetry. It is only in recent years that he has begun to use in prints and collages photographs taken by himself; the photographs in his earlier prints are all processed photomechanical images retrieved from the mass media. Rauschenberg often makes artistic capital of the banal language of mechanical screen and dot patterns in the latter, magnifying them and playing them off against each other, transforming them into textural passages of surprising beauty. His improvisatory inventiveness with modern photographic media is wittily demonstrated in the life-size x-ray self-portrait that dominates the lithograph *Booster* (cat. no. 190).

In contemporary printmaking from the 1960s onward the spectrum of attitudes to photographic and photomechanical imagery – and the uses to which it can be put – is extremely wide, with many artists making photographic "reality" part of a dialogue concerning art and illusion. In Jasper Johns's *Ruler* (cat. no. 96), a negative photoetching of an actual-size ruler appears to have scraped its way across the plate, leaving a track that resembles a bold stroke from the brush of an Abstract Expressionist painter. Poker-faced, Johns presents us with a confrontation between the abstraction of art and the literalness of the "real." A comparable conceptual use of the literalness that can be achieved with photoetching is seen in Vito Acconci's ambiguous statement on international politics titled *3 Flags...* (cat. no. 1) in which the overlapping flags of the contending powers are actual-size photoetchings of real flags.

In Cy Twombly's mushroom lithographs (cat. nos. 208-211) real tape and real collage overlays of tracing paper are teasingly juxtaposed with printed tape and printed collage in the best fool-the-eye tradition. The spontaneous graffiti-like drawings of mushrooms are played off against the reproductive textures of color illustrations of mushrooms from a traditional natural history publication. Similarly, Richard Hamilton's faceted, mirror-maze view in *Berlin Interior* (cat. no. 80) playfully shuttles back and forth between photoetched passages and the painterly, draftsmanly marks of the artist's hand.

Chuck Close toys with the relationship between the illusion of photographic reality and the mind and hand of the artist in his oversized head-and-shoulders portrait of Keith Hollingsworth (cat. no. 36). Beginning with a full-face frontal photograph of the impassive sitter, Close enlarged the image and transferred it to a plate that had been etched all over to roughen its surface. If the prepared, unworked plate had been inked and proofed at this stage it would have printed as a dark velvety rectangle (as in a mezzotint, the first print process to achieve a continuously graded tone). Working in the traditional mezzotint manner, Close then created the portrait by a process of subtraction, scraping the lights out of the dark field In the step-by-step execution of the image he was guided by a grid of lines he

1. This was not the first time in the history of twentieth-century printmaking that the impersonal, fabricated look had been consciously sought. A number of the prints by European Dada and Constructivist artists such as Kurt Schwitters, Moholy-Nagy, and El Lissitzky, produced between the wars, reveal a predilection for the precision of engineers' drawings and make use of mechanical patterns and textures employed by commercial printers (see, for example, Kurt Schwitters's lithograph of 1923; cat. no. 201).

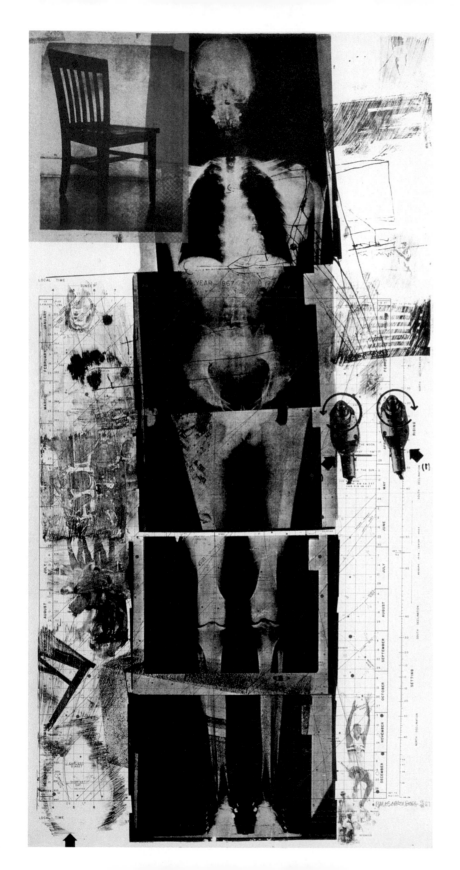

24

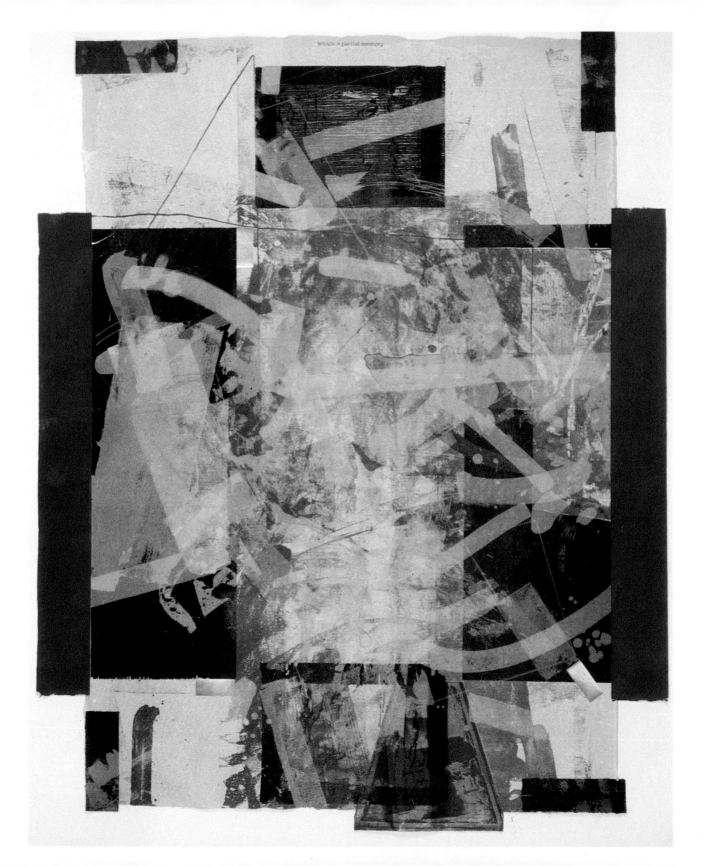

had imposed on it. The resulting checkerboard of individual squares that shift subtly in tone from square to square remains very much part of the final image – a net of rationality that the artist has cast over the optical illusion produced by photography.

Many contemporary artists make reference to photographic tones or textures in their prints. Robert Longo's lithograph *Frank* (cat. no. 137), while hand-drawn, alludes to photography in its tonal patterns and in its stop-motion gesture; indeed, Longo's point of departure for such works is often a stop-action slide made from a model in motion. But the silhouetting of this figure on a black ground – caught in his unexplained spasm or fall – works against photographic illusion, flattening volumes and creating pictorial tensions closely related to recent abstraction.

Wit and Irony

Much of the art produced in the United States in the 1960s is characterized by an ironic attitude to the culture from which it springs. The tone is occasionally savage but more often playful – a love-hate relationship with the everyday and the banal, whether the commercial folk imagery of popular culture or cliché images associated with high culture. At its best, this ironic sensibility takes the form of incisive wit, offering opportunities for reflection on the nature of mass culture and the visual language by means of which low or high art is disseminated. Roy Lichtenstein's prints epitomize this viewpoint: in a screenprint such as *This Must be the Place* (cat. no. 132) there is a witty play not only upon the Buck Rogers/Flash Gordon, pulp-magazine, science-fiction imagery but also upon the "futuristic" style of illustration and the printing methods used to convey such imagery to a mass audience. Lichtenstein chose as his print medium the "inartistic" commercial process of offset lithography and exaggerated the characteristic benday dots of the screen patterns of offset printing, producing vibrant and decorative optical effects.

Lichtenstein has a seemingly endless appetite for commenting upon and parodying established artistic styles, whether the '20s and '30s industrial design taste for Streamlined Modern (*Industry and Melody*, cat. no. 133; fittingly executed in crisp, flat screen printing on shiny aluminum foil) or the melancholy dissonances of early twentieth-century German Expressionist graphic art (*Reclining Nude* cat. no. 134; executed in the woodcut medium favored by the Expressionists).

Another artist obsessed by the dialogue of styles is the English painter and printmaker Richard Hamilton. *In Horne's House* (cat. no. 81) is a visual realization of a passage in James Joyce's novel *Ulysses*, which is written in a collage of various writing styles. In Hamilton's witty translation of the passage into visual terms the artistic styles of ancient Egypt, Easter Island, Rembrandt, and Picasso's Cubist period coexist amicably, just as they do in the encyclopedic art museums of our day.

A less rarefied and intellectual brand of wit and irony is seen in the sculptor Claes Oldenburg's proposal for a double Screwarch Bridge (see cat. nos. 166-167) for the city of Rotterdam. Oldenburg's designs for public structures customarily involve the enlargement of everyday objects to colossal proportions, the resulting monuments being amusingly grotesque and sometimes crudely erotic. As in *Screwarch Bridge*, the exquisitely detailed and straightfaced execution of these proposals for fantasy structures, this "paper architecture," is an essential part of the success of the joke.

The Serial Image

An obsession with printmaking's potential for producing variations on a single image or for documenting the evolution of an image – an emphasis on serial imagery or process – is one of the prominent characteristics of American printmaking from the 1960s to the present. It can, as we have seen with images such as Warhol's set of *Marilyns* (cat. no. 214), be a means of referring to the endlessly repeated images of the mass media, but it can also serve a more austerely conceptual goal in the hands of abstract artists. Josef Albers's work partakes of the Constructivist and Bauhaus traditions in which, having reduced the elements of art to the most basic geometric forms, the artist then proceeded to see how much visual richness he could wrest from such a primary vocabulary. In the series of screenprints *Grey Instrumentation* (cat. nos. 4-6), which parallels in format his extended series of paintings *Homage to the Square*, Albers restricted himself to an image of squares nested one within another and to flat tones of stenciled gray pigment, producing by means of shifting relationships of tone and value a whole spectrum of spatial relationships.

In a similar fashion, Brice Marden's etchings entitled *Ten Days* (cat. nos. 145-146) are limited to regular grids of etched lines filled with relatively dispassionate hatchings and crosshatchings, using the "non-colors" of black and white. Nevertheless, by means of various combinations of the plates, of reversals of values and overprintings, Marden managed to orchestrate a range of quietly sensuous variations on a single theme.

The Renewed Interest in Surface Texture

The print media favored by American painters and print publishers in the early 1960s were primarily lithography and silkscreen, print techniques characterized by smooth, relatively uninflected planar surfaces, as opposed to the more tactile relief and embossed textures of etching and woodcut. Jasper Johns, for example, had worked for several years almost exclusively in lithography until Universal Limited Art Editions added an etching studio in 1966 (see the *Ruler* etching of 1968; cat. no. 96).

A conspicuous contemporary example of the sensuous surface qualities of etching is seen in the deeply etched hearts on the frosted panes of Jim Dine's *Winter Windows on Chapel Street* (cat. no. 46). The sculptural qualities of the plate mark, as it impresses the paper during printing, are exploited in Ellsworth Kelly's austerely minimal *Wall* (cat. no. 115): the velvety rectangle of black aquatint seems to strain against the confines of the deeply embossed plate mark.

The renewal of interest in the woodcut medium on the part of American painters might very plausibly be pinpointed to 1973, the year in which Helen Frankenthaler began working so creatively with woodcut at Universal Limited Art Editions. In Frankenthaler's *Savage Breeze* of 1974 (cat. no. 56), the second woodcut she produced, the artist "drew" in the close-grained mahogany veneer blocks with a jigsaw, fitting the sawed pieces together for printing like a puzzle in a way that emulates Edvard Munch's approach to the woodblock. The delicate play of textures in *Savage Breeze* is the product not only of the fibrous translucent Japanese paper on which it is printed but also

of a subtle use of the dense wood grain. The pattern of the wood grain in the printed white underlayer runs perpendicular to the grain in the colors printed over it.

A sense of the wood block as an object with a sculptural dimension is nearly parodied in sculptor Donald Judd's untitled woodcuts (cat. nos. 100-101). The blocks began life as sculptural objects and were only later seen as potential matrices for printing. An edition was then printed with thick oil paint, probably in order to achieve the maximum tactility of surface.

A conceptual use of woodcut for its surface textures alone is seen in prints such as Jasper Johns's *Scent* of 1975-1976 (cat. no. 97) and Jennifer Bartlett's five-part *Graceland Mansions* (cat. no. 10). The three parts that compose Johns's abstract triptych of optically active red and green hatchings are printed in three different techniques: lithography, woodcut, and the woodcut-related relief technique of linoleum cut.

Because many of the painters who wish to work in woodcut often have little experience in (or interest in) carving the wood with the traditional knives and gouges, new means of working the blocks have emerged, in particular the power-driven tool. Power tools chew choppily but freely into the block, enabling the artist to achieve (as we see, for example, in the wriggling, worm-like lines of Louisa Chase's *Thicket* ; cat. no. 35) a new vocabulary of line and plane totally different from that of the German Expressionists. (The use of power-driven tools had already been exploited in contemporary engravings, as can be seen in the staccato "lines" that roughen the surface of the plate to create the smoky chiaroscuro of Michael Mazur's tabletop still life [cat. no. 147]).

Interest in the medium seems to have peaked now, in the early '80s, further stimulated by the recent importation of new German works in woodcut and linocut by artists such as Anselm Kiefer (cat. no. 116) and Georg Baselitz (cat. nos. 11 and 12). Many print workshops have added woodcut to their repertory of available techniques and new workshops specializing in woodcut, such as that of Chip Elwell in New York, have opened.

The Return to the Handmade and the Unique Variation

In the 1970s a reaction set in against the cool impersonal fabricated look and the impeccably consistent editions that had tended to characterize American printmaking by painters in the '60s. This reaction took many forms: hand coloring of editions, the use of collage, handmade or cast papers, as well as the choice of print media with more tactile surface qualities.

In the '60s hand coloring of prints was relatively rare and was generally viewed as a violation of the machined perfection of the printed edition. In the next decade, on the other hand, publishers such as Brooke Alexander actively encouraged artists to produce hand-colored editions. The color applied by hand is so dominant over the lithographic base in Aaron Fink's *Smoker with Fan Hand* (cat. no. 54) that it suggests a unique painting or colored drawing on paper, rather than a print. (Hand coloring of editions or of unique variants, was, of course, much favored by the German Expressionists in the earlier twentieth century, as we see in Emil Nolde's *Young Danish Woman* of 1913; cat. no. 165).

The new emphasis on the unique variation in the '70s and '80s has also encouraged a more positive attitude toward that stepchild medium the monotype. In making a monotype the artist paints with pigment on the smooth unworked printing surface, an image from which, as a rule, only one or two good impressions can be taken. In the sculptor Mags Harries's gestural monotype from her *Glove Series* (cat. no. 82) real gloves have left their impression in the ink.

During the 1960s Tanya Grosman of Universal Limited Art Editions had actively encouraged artists to print on fine handmade papers with distinctive colors and textures, occidental as well as oriental. Choice of an appropriate paper has thus become an increasingly critical factor in the conception of the final printed image. The tendency in contemporary painting to emphasize the individual properties of the artist's basic materials and to stress the identity of the whole picture as a created object (rather than as a pictorial illusion) is paralleled in printmaking by viewing the entire sheet of paper – not just the image printed on it – as the art object. Twenty-five years ago it would have been customary to overmat the margins of

a print rather than to "float" it in the mat opening; today we frequently revel in the object qualities of the whole sheet, whether the raveled edge of Japanese papers (see Frankenthaler's *Savage Breeze* ; cat. no. 56) or the deckled edge of Western handmade papers. In Robert Motherwell's spare but elegant aquatint *Red Open with White Line* (cat. no. 157) the placement of the image on the sheet is a critical factor. The margin of crisp white paper on the left forms an essential foil to the crimson field of aquatint that bleeds to the deckled edge on the other three sides.

There are a few exceptional contemporary prints in which paper takes on a more sculptural dimension or is penetrated by light and space. The thick sheets of Dorothea Rockburne's *Locus* series (cat. no. 192) were folded before being subjected to the pressure of printing and then unfolded to form a white-on-white relief sculpture when framed. Alan Shields's ethereal *Angel Scrim* (cat. no. 205) is an openwork grid printed on both sides and meant to be suspended so that light and space can penetrate it. Robert Rauschenberg's drawings and lithographs are usually characterized by a sense of layered transparency. In the *Hoarfrost* prints (cat. no. 191) these qualities become literal, the image consisting of freely suspended overlays of gauzy translucent fabric on which transfer images are imprinted or through which other elements of the composition are seen in misty soft focus.

The use of collage materials is yet another aspect of the recent emphasis on greater individual variations from print to print and on richer print surfaces. Steve Sorman (cat. no. 206) specializes in the collage approach; the use of contrasting exotic papers or of applied silver and gold foil frequently plays a central role in his printed images.

In the 1970s a wave of interest in the handmade paper object as a work of art in its own right swept the United States, encouraged by the activities of such craftsmen as Garner Tullis of the Studio for Experimental Printmaking. One of the artists who has worked most successfully in this medium is the abstract painter Kenneth Noland (cat. no. 161), who essentially paints with the dyed wet paper pulp, forming his image in the very fabric of the paper.

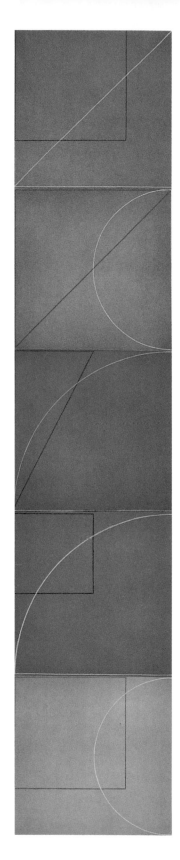

◁ **Robert Mangold.** Five aquatints (A-E), 1975.
(cat. nos. 138-142)

Helen Frankenthaler. *Savage Breeze*, 1984.
(cat. no. 56) ▷

Recent European Printmaking

The international triumph of contemporary American art in the 1960s led to a kind of embargo on contemporary European art on the part of American artists and critics. European art was labeled effete and repetitive; only what came from America was considered vital and alive. In the midst of the eclectic confusion in American art in the late '70s and early '80s, "new" European works, particularly by German and Italian artists, were imported and began to capture critical attention. Many of these artists had, in fact, been actively working since the '60s, and a number have proved to be gifted printmakers. It is not surprising, given the successes of earlier twentieth-century German artists with the woodcut medium, that many of the recent German artists have adopted the relief processes of woodcut and linocut as their favored media.

The German painter Anselm Kiefer frequently produces woodcuts but thus far no editions: all of his pieces are unique – the woodcuts being pasted onto canvas, collaged and overpainted or used to make pasted-up books of which only one copy exists. A collage woodcut with brush additions, the ironically titled *Tomb of the Unknown Painter* (cat. no. 116), has the scale of a painting and is supplied with its own "frame" printed from strongly grained boards collaged onto the central image. The image, a tomb or temple that might very well have been designed by the German neoclassical architect Schinkel, is apparently based on a project for a memorial to fallen soldiers designed by an architect of Hitler's Third Reich. Such ironic or romantic variations on themes from German political and cultural history are characteristic of Kiefer's art. The tomb of the anonymous fallen war hero becomes the tomb of the anonymous artist-hero fallen in the carnage of cultural wars. It is certainly no accident that the architecture of this tomb or temple corresponds rather closely in appearance to the ideal museum structure of the nineteenth or early twentieth century.

The German painter Georg Baselitz has worked in a variety of print media but it is the linoleum cut that he has particularly favored. In recent years he has chosen to invert his images, perhaps less with the intention of presenting a world-upside-down philosophical view of things than to stress more abstract formal qualities, particularly the nervous beauty and sensitivity of the negative lines scratched or gouged out of the dark field. This simple act of defiance of the laws of gravity is, nevertheless, infallibly disorienting to the average viewer, especially when life-size human figures are involved (cat. nos. 11 and 12). The monumental scale of many of these linoleum cuts is unprecedented, and the choice of oil paint for their printing gives them heightened tactility of surface.

Jörg Immendorff's frenzied allegory of contemporary political chaos, *Café Deutschland gut – New Majority* (cat. no. 90), which has the large scale of his paintings, is one of ten from a series of handcolored and color-printed variations on a single linoleum cut image. Immendorff picks up on the tradition established by Max Beckmann's harsh and biting symbolic scenes from contemporary life of the 1920s and '30s.

Many of the new German and Swiss artists are customarily discussed in terms of a revival of early twentieth-century German Expressionism, but, if this is so, it is an Expressionism thoroughly filtered through the international movement of painterly abstract painting of the postwar period known on this side of the Atlantic as Abstract Expressionism. The style is apparent in the work of two Swiss artists, Rolf Iseli and Martin Disler. In Iseli's print *Sous Roches* (*Under Rocks*; cat. no. 91) the abstract beauty of the bullet-like hail of ricocheting drypoint lines initially draws attention away from the landscape motif that is its base. Likewise, in Martin Disler's anarchically titled portfolio of aquatints (*Endless Modern Licking of Crashing Globe by Black Doggie – Time Bomb*; cat. nos. 47 and 48), etched images of human violence and voracity have a bold abstract gestural force that is closely akin to certain brands of Abstract Expressionism.

Private Mythologies

Much recent painting and printmaking is pervaded by figurative imagery that is irrational and dream-like in character – allegories of profoundly personal feeling. In Louisa Chase's enigmatic *Thicket* (cat. no. 35) a trunk suggesting a human torso seems to be threatened by hostile vegetation: branches like sharp forks and paired leaves like pruning shears. Susan Rothenberg's untitled aquatint (cat. no. 195) presents an equally personal and irrational mental landscape. Seen from above, a small boat sails on a profoundly dark sea, encircled by a ghostly ring of water that transforms itself into a sinister figure. A dream-like character – in the European surrealist tradition of Di Chirico – pervades Enzo Cucchi's *Obscure Image* (cat. no. 38), in which a minute figure encounters a colossal slumbering head in a dark and desolate landscape. Eric Fischl's troubling multipartite etching *The Year of the Drowned Dog* (cat. no. 55) is outwardly objective but – like many of his other recent paintings, drawings, and prints – suggests a recollected fragment of autobiography. The meaning of the incident is left hauntingly vague, subject to our own speculation and interpretation.

Today, in spite of chronic problems such as the uncertain economy and the resurgence of the facsimile approach to printmaking,[2] original prints are still a vital factor in the international contemporary art scene. Their continuing significance both artistically and economically is seen in the fact that now, as in the past, prints are often the first original works by new or emerging artists to cross state lines or international boundaries. To cite one recent example: in the last three or four years many Americans were initially exposed to work by new European artists in the form of the artists' prints rather than their paintings.

2. The facsimile phenomenon – so familiar in the '40s and '50s in the form of those splendidly crafted, handmade, artist-signed intaglio reproductions that flowed out of Parisian print ateliers – is with us again in the form of complex color woodcuts based on watercolors or gouaches provided by the artist or publisher and cut by highly skilled Japanese craftsmen trained in nineteenth-century Japanese woodcut traditions. Although their production is often supervised by the artist, these woodcuts essentially resemble the original watercolor rather than making an original statement in the print medium.

For Further Reading

Field, Richard S. "Contemporary Trends," Part III of *Prints, History of an Art*. Geneva and New York, 1981.

Castleman, Riva. *Prints of the Twentieth Century, a History*. New York and Toronto, 1976.

Castleman, Riva. *Printed Art* (exh. cat.). Museum of Modern Art, New York, 1980.

Plates

Authors of the Catalogue Entries

Williams College Museum of Art

Michael M. Floss	M.M.F.
Nancy Green	N.G.
Steven S. High	S.S.H.
Thomas Krens	T.K.
Deborah Menaker	D.M.
Nancy Spector	N.S.

Museum of Fine Arts, Boston

Clifford S. Ackley	C.S.A.
David P. Becker	D.P.B.
Sue W. Reed	S.W.R.
Eleanor A. Sayre	E.A.S.
Barbara Stern Shapiro	B.S.S.

The entries on the fifty prints from the Torf collection selected for discussion were read and revised for content by Clifford S. Ackley prior to submission to the editor. Mr. Ackley in a number of instances contributed new information or research to the entries.

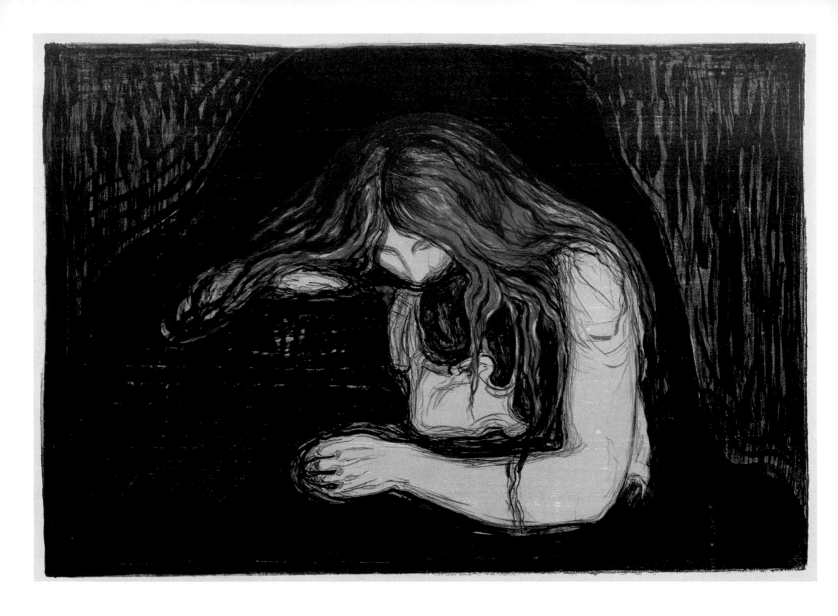

Plate I
Edvard Munch (Norwegian, 1863-1944)
Vampyr (Vampire), 1895
Lithograph from two stones and woodcut
Image: 15¼ x 21½ in. (38.7 x 54.6 cm.)
Sheet: 15⅜ x 22⅛ in. (39.0 x 56.1 cm.)
Signed: *E. Munch* in pencil l.r.
Printer: Lassally, Berlin
Reference: Schiefler 34, IIb (It is a first state, however, not a second state; Schiefler's I is from a different stone.)

Edvard Munch is one of a small number of artists whose prints have the power of conveying that what is said is of vital importance. We feel it instinctively, whether or not we are aware of the implications of his statements.

Here a man buries his head in the breast of a woman. She is naked, or perhaps half-dressed (impossible to tell); her mouth presses against the nape of her lover's neck while her long, unbound tresses partly cover his dark hair. It is disturbing that her red hair has such dominance and vigor – that the perspective from which we view her face dehumanizes it, and that Munch obscures her mouth so that we do not know whether she bestows a kiss or, as the title suggests, punctures her lover's neck with sharp teeth to suck his blood.

Munch often recast themes important to him. In tracing the history of this print, we encounter the composition first as a pastel that was exhibited in 1893, one of six paintings and pastels grouped together as *Study for a Series: Love*. He then gave the subject the title *Love and Pain*, one that was appropriate since, in the pastel, the relationship of the lovers is gentler and less disparate. Munch intended that the pastel should be preceded by *Dream of a Summer Night* and *Kiss* and followed by *The Face of a Madonna*, *Jealousy*, and finally *Despair*.

About the same time Munch began to conceive of exhibitions in which he would show his work under the title "Frieze of Life" – with two principal themes: love and death. All works were to be subjective, symbolic, and unflinchingly derived from personal experience. In 1894 the pastel was recast as a powerful painting to be hung in these "Frieze of Life" exhibitions. Its title, *Vampire*, was inspired by the Polish novelist Stanislaw Przybyszewski, and indeed the relationship of the lovers was shifted; the woman is now completely dominant while the man passively endures the pain of their relationship.

In 1895 Munch decided to translate his "Frieze" into etchings and lithographs, partly to make these images more readily available to the public and partly because he desperately needed money. *Vampire* was printed that year as a lithograph in black and white – but this subject needs color. Without the red of the woman's hair with its intimation of blood, the impact of Munch's concept is diminished and it is not surprising that he began to paint impressions with watercolor. One of these was shown in 1897 in an exhibition of paintings, prints, and drawings on the themes of the "Frieze of Life," but with a new title: "The Mirror" (used in its medieval sense – the mirror of the condition of man). A published portfolio of "Mirror" prints was also planned.

In 1902 Munch printed *Vampire* in color in a curious but extremely effective technique. The buff, blue, and green were printed from a single plank of wood that had been sawed into four pieces. In the print the pattern of the wood runs continuously across the image, very subtly strengthening the union of the interlocked figures. The red, however, is printed from a second lithographic stone, which more effectively emphasizes the sensuality of the woman's hair and sharpens Munch's statement about the painful complexity of sexual relationships.

E.A.S.

References

Schiefler, Gustav. *Verzeichnis des graphischen Werks Edvard Munchs bis1906*. Berlin, 1907.

Prelinger, Elizabeth. *Edvard Munch. Master Printmaker.* New York, 1983.

Epstein, Sarah G. *The Prints of Edvard Munch. Mirror of his Life* (exh. cat.). Allen Memorial Art Museum, Oberlin, 1983.

Rosenblum, Robert, et al. *Edvard Munch, Symbols and Images* (exh. cat.). National Gallery of Art, Washington, D.C., 1978.

Plate II
Erich Heckel (German, 1883-1970)
Weibliche Gesicht (Woman's Face), 1907
Woodcut
Image: 8 x 6 in. (19.9 x 15.2 cm.)
Signed: *Erich Heckel* in pencil l.r.
Reference: Dube 100

Abandoning a career as an architectual drafts-man, Erich Heckel joined Ernst Ludwig Kirch-ner, Karl Schmidt-Rottluff, and Fritz Bleyl in founding *Die Brücke* (The Bridge) artist's asso-ciation during the summer of 1905. Under the banner of the Nietzschean dictum of creation through destruction, the group rejected all artistic and social conventions in order to renew art and, through art, the world itself. Youthful passion and a love of exoticism transformed familiar landscapes, nudes, and portraits, imbuing them with a new expressive energy. In paintings, they employed the height-ened palette of the French Fauves; in the graphic arts, they drew inspiration from the evocative power of German medieval and Renaissance woodblock and folk prints. Tradi-tional standards of beauty and ugliness were eclipsed by a fascination with the immediacy of primitive art.

That the graphic arts were as important to *Die Brücke* as painting is evident from their exhibitions of 1906: the first show was of paintings, the second of prints. During that same year, the group issued the first of several print portfolios to be sold by subscription to sympathetic followers. The print, and the woodcut in particular, thus quickly became the means of disseminating their ideas to a wider audience, and of gaining some financial recompense.

Heckel, like Kirchner, was to produce over the years a prodigiously large body of graphic work. Scornful of most modern painting, espe-cially the works of Corinth and Slevogt, he turned for his sources to the Egyptian wood sculptures and South Seas carvings in the ethnological department of the Dresden Museum. This early print, the sculpturally forceful *Woman's Face* of 1907, evokes the over-articulated features and planar elements of primitive carvings; the texture of the wood itself (as in prints by Edvard Munch) functions as an expressive element of the composition. By setting the woman's face against this "unfinished" background, Heckel achieved a certain choppy, rough-hewn quality – a char-acteristic trait of early *Brücke* art. The bold contrast of broad areas of black and white shows the influence of the strongly patterned woodcuts from Félix Vallotton's Art Nouveau phase. In later woodcuts – when he had

developed his own graphic style – Heckel employed a more linear, incisive technique.

N.S.

References
Dube, Annemarie and Wolf-Dieter. *Erich Heckel, Das Graphische Werk*. New York, 1965.

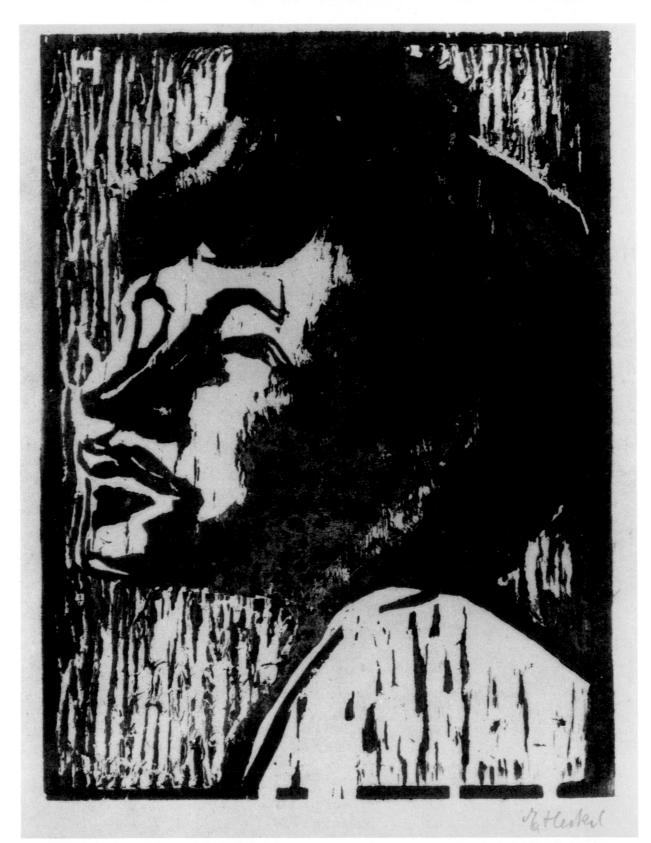

Plate III
Emil Nolde (German, 1869-1956)
Junge Dänin (Young Danish Woman), 1913
Lithograph from two stones (one of four examples
with hand coloring) on Japan paper
Image: 26¾ x 22¹⁄₁₆ in. (68.0 x 56.0 cm.)
Edition: 32
Signed: *Emil Nolde* in pencil l.r.
Titled: *Junge Dänin* in pencil l.c.
Inscribed: *Von 4 Dr. dieser Fassung/ No. 3.
(übermalt)* in pencil 1.1.
Reference: Schiefler, vol. 2, no. 58

Emil Nolde — like Munch, Kirchner, and other
Northern European painters of the late nine-
teenth and early twentieth centuries — made
extensive use of the graphic media. Between
1889 and 1937 he created over 200 etchings,
around 200 woodcuts, and more than 80
lithographs. Most of the lithographs came in
the years 1907, 1911, 1913, and 1926, the most
successful — both with regard to inventive
imagery and to the expressive use of color —
from the stones executed in Berlin in 1913.

Young Danish Woman is one of the 1913
group of large, painterly images executed by
Nolde in the difficult medium of brush and
tusche lithography. These prints were com-
posed of three to five stones that were printed
experimentally in different combinations of
color (Schiefler 49-60). The background of this
lithograph varies in color and tonality, whereas
the stone that carries the hair, eyes, and mouth
is printed in audacious alternative colors such
as deep red or acid green. The background of
the present impression, is printed in black and
the face in yellow, overlaid with hand-applied,
intensely hued watercolors: orange for the
hair, blue for the eyes, and red for the lips.

One might be tempted to associate this
particular impression, with its relatively nor-
mal coloration, with the features of Nolde's
Danish wife, Ada, whom he had portrayed in
two earlier prints (woodcut, Schiefler 17;
etching, Schiefler 165). However, many other
prints depict similar brows, noses, and chins,
and make a precise identification impossible.
Young Danish Woman appears to be a
generic, rather than a specific portrait, its
frontal image inspired by the primitive masks
that held such fascination for Nolde.

S.W.R.

References

Schiefler, Gustav. *Emil Nolde: Das Graphische Werk* (revised by
Christel Mosel) (2 vols.). Cologne, 1967.

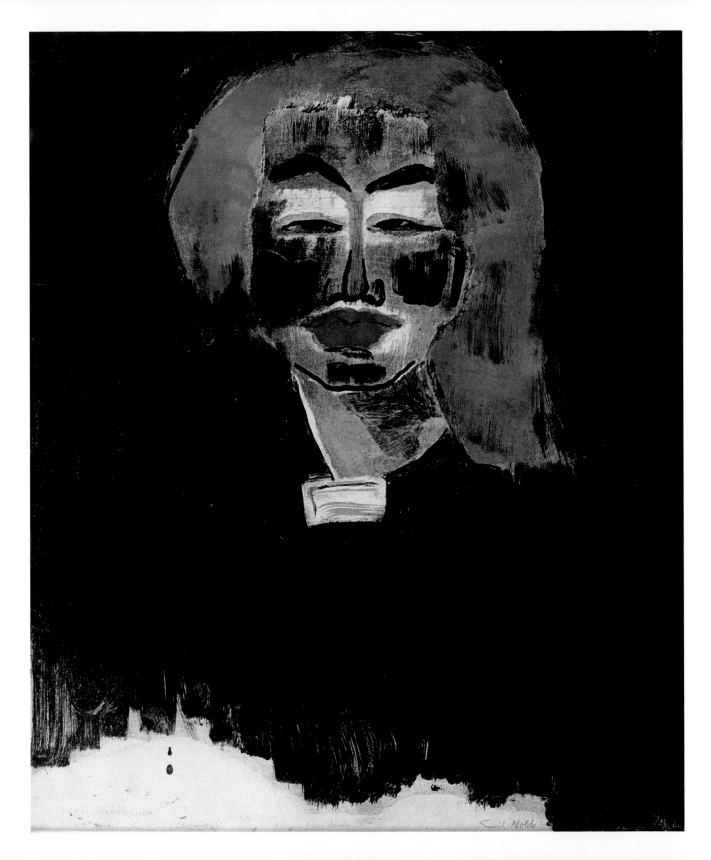

Plate IV
Ernst Ludwig Kirchner (German, 1880-1938)
Liebespaar am Morgen (Lovers in the Morning),
1915
Lithograph (crayon and tusche)
Sheet: 19⅝ x 23³⁄₁₆ in. (50.0 x 59.0 cm.)
Reference: Dube 276, II

German Expressionist artists such as Ernst Ludwig Kirchner were drawn to printmaking not only as a means of multiplying their imagery and making their art better known but also because of the potential for personal expression latent in the printmaking media. The result of their experimentation was a radical redefinition of how the various print media could be used and how they should look.

Mercurial in temperament, Kirchner appears never to have recovered from his military experience. The very year that *Lovers in the Morning* was executed, 1915, saw his discharge from the German army, suffering from a physical and nervous breakdown. Among his paintings from this time are portraits in which he betrayed his feelings of insignificance and self-abasement, one of the most striking being the *Self Portrait as a Soldier* (Allen Memorial Art Museum, Oberlin). It shows the emaciated Kirchner in military dress with a nude woman in the background, and – ultimate emblem of artistic impotence – his right hand symbolically severed.

Although he treated the theme of lovers in all media, it was in lithography that Kirchner made the most use of it. In 1911, he executed a series of six explicitly erotic lithographs of couples making love; in 1915 he created eight startlingly frank lithographs of prostitutes and their customers. *Lovers in the Morning* is, by comparison, exceptionally discreet, even tender in feeling

The male lover may be intended to represent Kirchner's friend Hugo Biallowons, who, with similar features, is seen reclining in military uniform in a lithograph of the same time (and probably executed on the same stone). When Biallowons was killed in action the next year Kirchner issued a woodcut portrait with the inscription: "Hugo Biallowons died for us."

The German Expressionists' exploitation of the expressive potentialities of the woodcut medium (stressing the "woodiness" of the wood, leaving clear traces of the attack of knife and gouge) is well known. Less discussed is their understanding of the unique properties of other print media, such as lithography. In *Lovers in the Morning* the design extends right to the edges of the lithographic stone, its irregular shape becoming an integral part of the image. An intentionally exaggerated

emphasis on the special qualities of both crayon and lithographic wash give new textural interest to the surface of the print. The granular crayon is applied broadly with rhythmically scribbled strokes and the puddled wash casts a dim gray veil over the lovers.

M.M.F.

References
Dube, Annemarie and Wolf-Dieter. *E. L. Kirchner: Das Graphische Werk* (2 vols.). Munich, 1967.

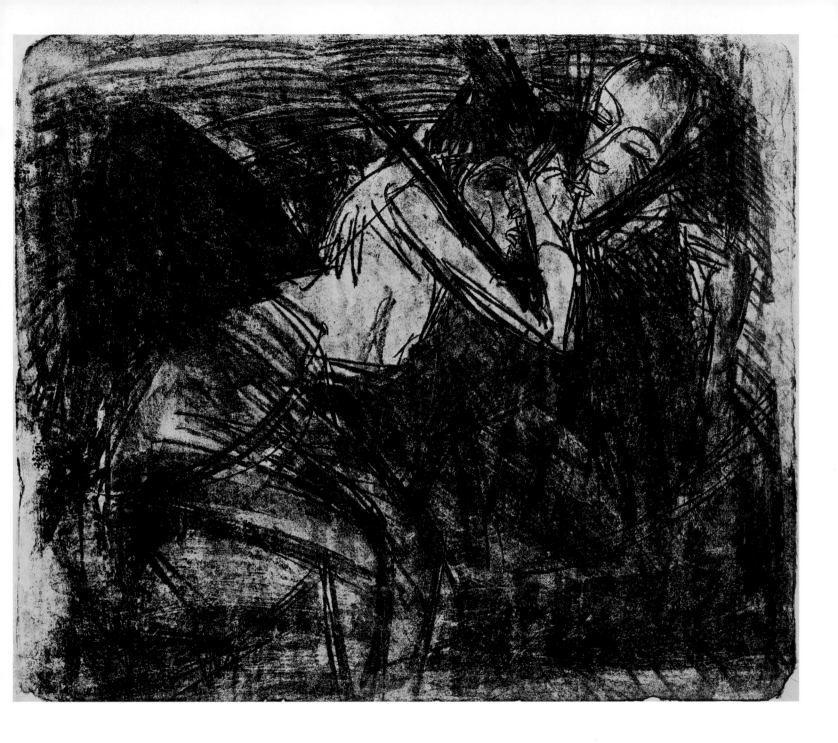

Plate V
Max Pechstein (German, 1881-1955)
Erlegung des Festbratens (Hunting of the Roast for the Feast), 1911
Woodcut with hand coloring
Image: 8¹⁵⁄₁₆ x 10¼ in. (22.7 x 26.0 cm.)
Sheet: 19⅝ x 12⅝ in. (50.0 x 32.5 cm.)
Edition: 100
Signed: *Pechstein 1911* in pencil l.r.
Inscribed: *9* in pencil l.l.; in type, lower margin,
MAX PECHSTEIN: Erlegung des Festbratens/Originalholzschnitt
Publisher: *Der Sturm*, Berlin
Reference: not in Fechter

When Max Pechstein created this woodcut, he was a member of the Expressionist artists' group *Die Brücke* (The Bridge). Having joined in 1906, he was expelled in 1912 for exhibiting with the more conservative Berlin Secession. Throughout his career, Pechstein pursued his artistic goals independently, sharing the Expressionists' rebellious attitudes but not their ideological camaraderie.

Hunting the Roast for the Feast partakes of the Expressionists' interest in primitivism, but the conception is nevertheless uniquely Pechstein's. In presenting an episode preparatory to an unspecified tribal feast, he simplified the human figure, omitting detail except for rudimentary facial features. The hunter's grip on his bow, in reality impossible, adds to the naive expressiveness of the image. Pechstein's technique, which exploits the texture of the woodblock, is characteristic of Expressionist printmaking, but he rarely shared the pessimistic viewpoint of his fellow artists. Instead of employing the dissonant angular forms used so effectively by Kirchner, for example, Pechstein created more decorative rhythms. This predilection for the decorative had several sources. First of all, in his youth, Pechstein was apprenticed to a house painter-decorator. Then, on his trip to Paris in 1907, he met the Fauve artists and was strongly affected by Henri Matisse's art. The bright colors of *Hunting the Roast for the Feast* may be inspired by the Fauve artists' color sense.

This print was published in the important German periodical *Der Sturm* (The Storm). Founded by Herwarth Walden in 1910, it provided the German Expressionists with a vehicle for publishing their graphic and literary productions. Walden, who was later to open a *Der Sturm* gallery, introduced a broader audience to advanced contemporary art, both German and foreign, through his publication and through the influential exhibitions he organized. Members of *Die Brücke* such as Kirchner and Nolde had been publishing woodcuts in the magazine since 1911, and Pechstein was, in his turn, to cut many blocks for publication there. It is clear that this image, the first of several cover illustrations he did, was one of the impressions originally intended for *Der Sturm*, since the magazine's typeset inscription (giving artist, title, and medium) is visible in the bottom margin. It was published in black and white; the festive colors were added later by hand and with the aid of stencils.

M.M.F.

References
Fechter, Paul. *Das Graphische Werk Max Pechsteins*. Berlin, 1921.

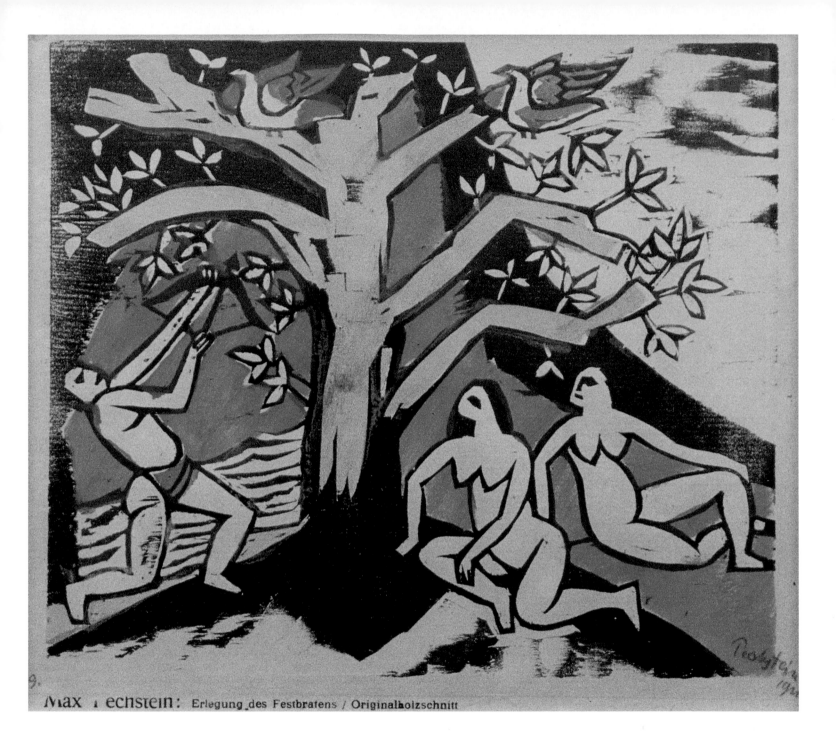

Max Bechstein: Erlegung des Festbratens / Originalholzschnitt

41

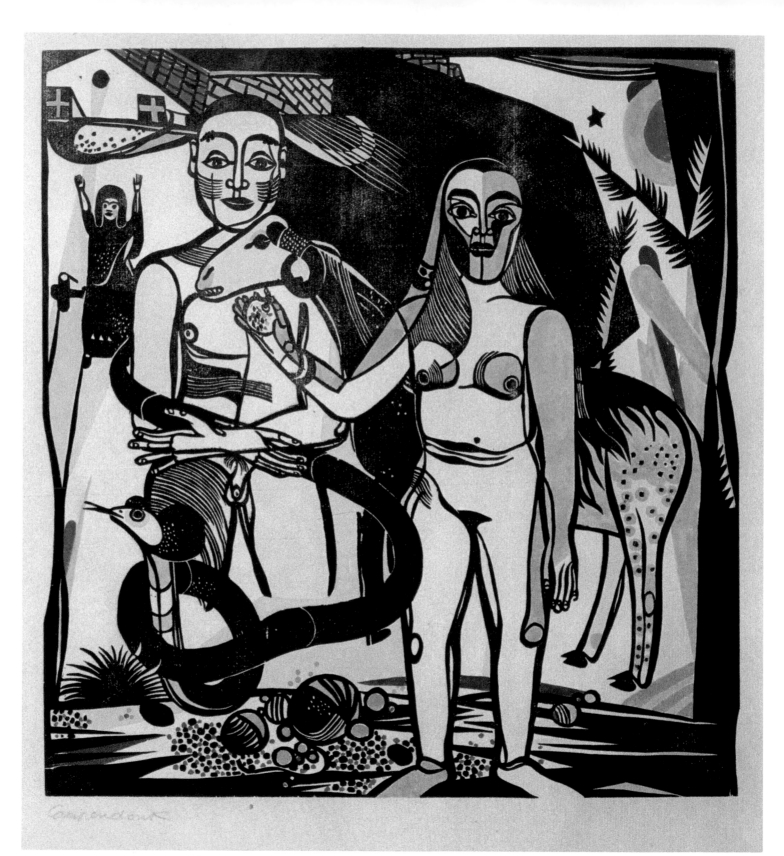

Plate VI
Heinrich Campendonk (German, 1889-1957)
Adam and Eve, ca. 1925
Hand-colored woodcut
Image: 12⅝ x 11¾ in. (32.0 x 29.8 cm.)
Signed: *Campendonk* in pencil l.l.
Reference: Engels 63

Heinrich Campendonk was working in solitude in Krefeld, the Rhenish town where he was born, when Franz Marc and Wassily Kandinsky stumbled upon his paintings. They soon invited him to participate in the activities of the Blue Rider group, for his work embodied a similar interest in the direct and simple clarity of folk art.

Campendonk must have been eager for the companionship of like-minded artists – he moved to the Bavarian village of Sindelsdorf, where Marc and August Macke lived, in October of 1911. Throughout the 'teens Campendonk's work was derivative of Marc's, and it was only after World War I that he broke free of outside influences and found his own voice as an artist.

Adam and Eve partakes of Campendonk's customary subject matter – peasants, nudes, farm animals, and rural huts. But, as Peter Selz writes: "He dismembers this ordinary world and reassembles it into a magic dreamlike place" (Selz 1957, p. 308). One's first impression of the print is that of a crude and simple depiction of Eve tempting Adam with the apple of knowledge, but closer examination reveals the scene to be more complicated: while Eve's feet are planted firmly on the ground, the hovering snake diverts us from noticing that Adam is bereft of limbs from his knees down. One may also ask where in the book of Genesis occur the ram, the shingled cottage, and the peasant woman who raises her arms in suprise. Perhaps Campendonk meant the viewer to witness a provincial woman's vision in the manner of Gauguin's painting *Jacob Wrestling with the Angel* (1888; National Gallery, Edinburgh), in which Breton churchgoers see the subject of the sermon materialize before their awestruck eyes – expressing a rural faith so fervent that biblical events appear as reality. The hand-coloring of the image – reminiscent of the folk prints the Blue Rider group collected – reinforces the mood of primitive piety.

Campendonk certainly knew Gauguin's work, which was frequently exhibited and published by the Blue Rider. Adam and Eve's masklike faces indicate as well the omnipresent influence of tribal carving – particularly in the symmetrical striations that score Adam's cheeks. The figures' stiff frontality and large staring eyes are a reminder that in 1920 Campendonk visited Ravenna, where he studied the mosaics of the Byzantine empire. In *Adam and Eve*, unlike his earlier work, these various sources are thoroughly digested and placed in the service of his personal vision.

D.M.

References
Engels, Mathias T. *Campendonk*. Stuttgart, 1959.
Selz, Peter. *German Expressionist Painting*. Berkeley, 1957.

Plate VII
Gabriele Münter (German, 1877-1962)
Herbstabend - Sèvres (Autumn Evening - Sèvres),
ca. 1907
Color linocut
Image: 4¹¹⁄₁₆ x 7 in. (11.9 x 17.8 cm.)
Sheet: 4⅞ x 7⅛ in. (12.4 x 18.1 cm.)
Edition: 9 (all with different color combinations)
Signed: *G. Münter* in pencil l.r.
Inscribed: *Handdruck* in pencil l.l.
Reference: Helms, no. 14

This print is one of those small miracles in which the artist's vision transforms the commonplace into poetry. The suburban vista of an unpopulated tree-lined street in Sèvres is the ostensible subject, but the print is really about the play of the latticed screen of trees against the muted pastels of the distant buildings. The dark silhouette of the intricate foliage against the rosy tints of dusk sparks instant recognition as a motif frequently encountered in nature. However, through the artistic choices she has made – generalizing, editing, adjusting patterns and tones – Münter distills what the eye sees to create something that clarifies perception.

Autumn Evening - Sèvres was created under the influence of Wassily Kandinsky, Münter's former teacher, with whom she had been traveling through Europe and Africa since 1904. The print bears an unmistakable resemblance to Kandinsky's hand-pulled woodcuts and colored linocuts from 1900 to 1907: the horizontal format with emphasis on parallel bands of road and sky, the strong contrast of dark contours against a light, diffuse background, the integration of the interior contours with the surrounding border, and even the incorporation of the monogram within the design are specific points of semblance (see Kandinsky's *Trumpet, Monk*, and *Organ Grinder*, all of 1907; Roethel, nos. 51-53.) Münter was, however, more attuned to the nuances of light and atmosphere and specific moods and cycles of nature than was her mentor. While Kandinsky depicted a fantasy world of fairy tales and folk legends, she drew inspiration from the world around her.

Münter and Kandinsky lived from June 1906 to June 1907 at no. 4 petite rue des Binelles in Sèvres, a suburb of Paris. The print communicates the tonic effect the quiet little town had upon the artist. (Soon after she returned to Germany, she chose to settle in the remote village of Murnau rather than in Munich, where Kandinsky was based.) Perhaps the seclusion she and Kandinsky enjoyed in Sèvres is unconsciously alluded to in the screen-and-wall motif of the print. The inviting areas of pale orange, yellow, pink, green, and lavender are removed from us by their atmospheric treatment, which makes them appear to recede into the distance.

Autumn Evening - Sèvres was exhibited in Münter's first solo exhibitions in Bonn and Cologne, as well as at the Salon d' Automne in Paris in 1908.

D.M.

References
Helms, Sabine. *Gabriele Münter: Das Druckgraphische Werk* (exh. cat.). Städtische Galerie, Munich, 1967.
Mochon, Anne. *Gabriele Münter: Between Munich and Murnau* (exh. cat.). Busch-Reisinger Museum, Harvard University, Cambridge, 1980.
Roethel, Hans Konrad. *Kandinsky: Das Graphische Werk*. Cologne, 1970.

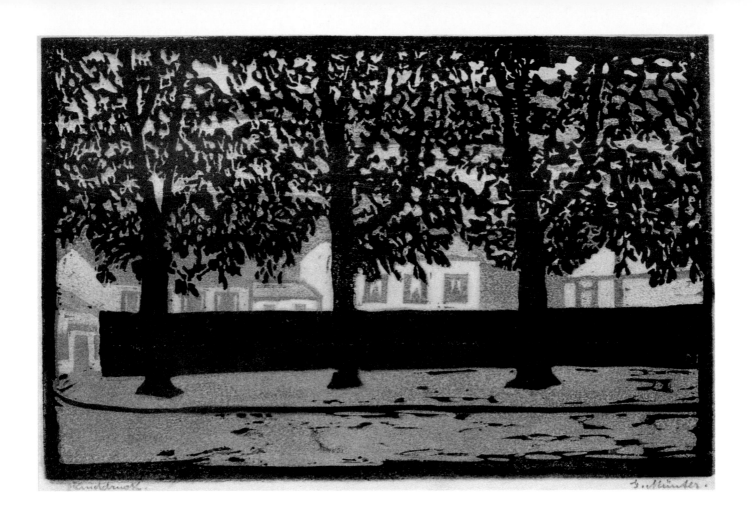

Handdruck. G. Münter.

Plate VIII
Erich Heckel (German, 1883-1970)
Parksee (Lake in a Park), 1914
Drypoint and engraving
Image: 9¾ x 8 in. (24.8 x 19.9 cm.)
Signed: *Erich Heckel 14* in pencil l.r.
Publisher: J. B. Neumann, Berlin
Reference: Dube 122

Portraits and other figural compositions prevail in Erich Heckel's choice of subjects until about 1911. In that year he made several horizontal landscape compositions that combine trees, water, and figures. The year 1911 also marked the *Brücke* group's collective move from Dresden to Berlin, where each member achieved greater individuality in style. Of the four original members of the group, Heckel had the greatest sensitivity to landscape. In 1913 he made his first prints in which the landscape dominated the figures that inhabit it.

Heckel depicted this lake in a park twice in 1914: once as a painting and once as a drypoint.[1] The composition is reversed in the drypoint, but the trees bend toward the middle in both; the foliage is generalized as angular clumps and the reflections of the trees in both painting and print appear more tropical than northern European. The lake may be located in a small town in the lower Rhine area called Dillborn, the site of Heckel's painting *Park in Dillborn* (1914),[2] or Osterholz, not far from Bremen, where he spent the summer of 1914.

In the painting the trees are disposed with a screen-like flatness across the surface of the canvas, and they focus our attention on a figure who stands on a raft in the center of the lake. The drypoint, on the other hand, has a more open, spacious quality that emphasizes the landscape. The foliage along the upper edge is thinner and the figure on the raft at center has disappeared; in its place, Heckel strengthened the reflection of two tree trunks.

The angular faceted forms Heckel often employed to render elements of landscape (ultimately derived from Cubism) did not always have the exaggerated expressionistic force of those used by some of his German contemporaries. In *Lake in a Park*, the serene crystalline forms of the leaning trees and their reflections suggest as much the quiet nave of a Gothic cathedral as they do psychological tensions or pictorial dissonances.

M.M.F.

1. Heckel learned the intaglio printmaking techniques of etching and drypoint from Emil Nolde, probably in 1906, when Nolde was a member of the *Brücke*.

2. Reproduced in Paul Vogt, *Erich Heckel*, Recklinghausen, 1965.

References
Dube, Annemarie and Wolf-Dieter. *Erich Heckel, Das Graphische Werk*. New York, 1965.

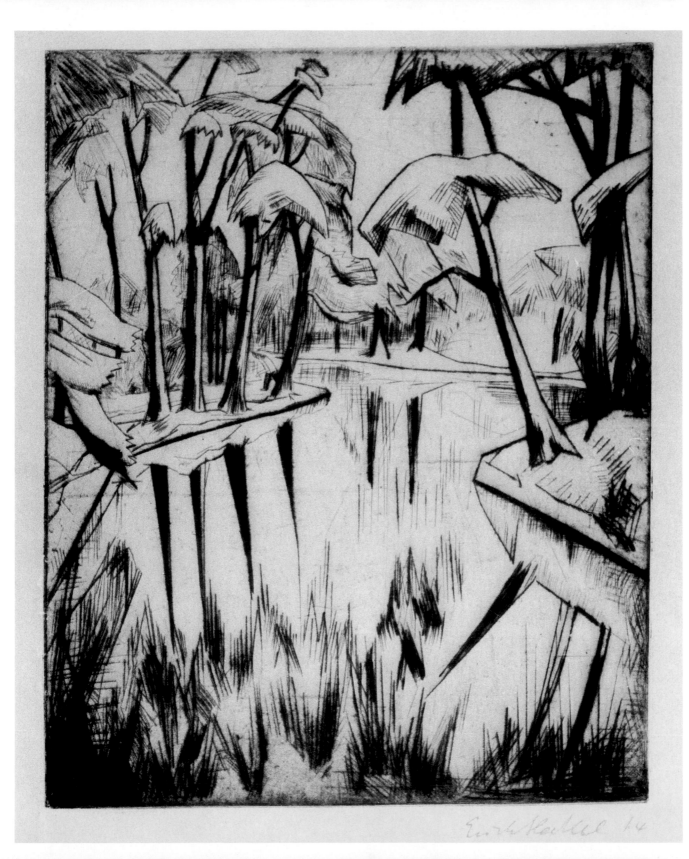

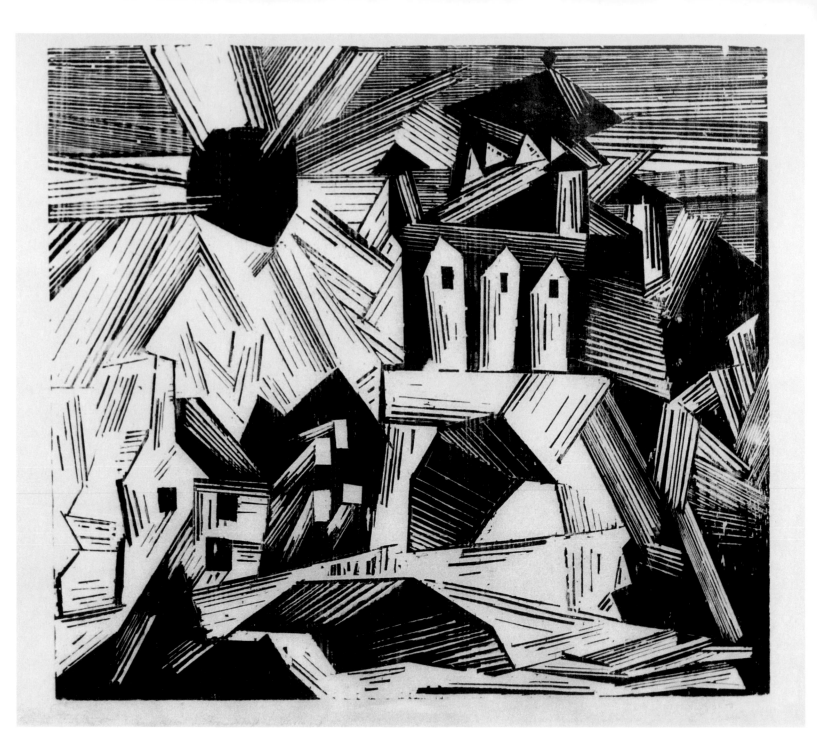

Plate IX
Lyonel Feininger (American, 1871-1956)
Das Tor (The Gate); also known as *Stadttor in der sonne*, 1920
Woodcut on Japanese laid paper
Image: 16⅛ x 17⅝ in. (40.8 x 45.1 cm.)
Edition: 5 proofs
Signed: *Lyonel Feininger* in pencil l.l.
Titled: *Das Tor* in pencil l.r.
Inscribed: *s.l. Galston in Freundschaft u. Verehrung* in pencil l.l.
Reference: Prasse 227, I

A student of the violin, Lyonel Feininger arrived in Hamburg, Germany, in 1887 to study music. Soon after his arrival, at the age of sixteen, he changed his career to art and entered the Kunstgewerbeschule (School of Applied Art) there. After further study at the Academy in Berlin, he became a caricaturist and illustrator for popular publications, continuing his painting in the evenings. In 1911, during a visit to Paris, he was in contact with the painter Robert Delaunay and the Cubist artists who were to have such an impact on his work. Two years later, Franz Marc was sufficiently impressed by Feininger's work to invite him to exhibit with the *Blaue Reiter* (Blue Rider) group in the First German Autumn Salon in Berlin.

His introduction to woodcut, and to printmaking in general, had begun in 1905 through Julia Berg, a friend and art student who later became his wife. In a letter of November 1 of that year he wrote to her: "In a short time you can learn many valuable things in regard to technique and methods, all of which you will share with me later, won't you? I have a great desire to make lithographs...to learn etching also...above all I want to do old towns..." (Prasse, p. 29). This desire reached fruition when, at the age of thirty-five, Feininger produced his first lithographs and drypoints. His *oeuvre* would, over the next fifty years, multiply to the impressive total of 320 woodcuts, 20 lithographs, and 65 etchings.

Das Tor was made during Feininger's tenure as head of the graphic workshop of the Bauhaus at Weimar (1919-1924). He had turned to the woodcut medium during the war, when painting materials were scarce in Germany and his copper etching plates had been confiscated. The new technique, one of the simplest and most direct of graphic media, suited his needs and temperament well. Feininger preferred to print all his proofs by hand, pressing with his palm the paper laid on the inked block and creating lightly printed, slightly transparent impressions. Most of the papers he chose were fine handmade types, particularly the soft, absorbent Japanese papers, which were unusually receptive to the ink.

First the subject of an etching with drypoint in 1912, *Das Tor* presents one of Feininger's favorite themes: an old town, here scintillating with sunlight. As dynamic rays of light, inspired by Futurism, give life to the inanimate scene, the rapid alternation of white surfaces and deep cast shadows produces an optical dazzle.

Growing up in New York City, Feininger was awed by the height of the buildings and their grand scale. It was an impression not forgotten: his cartoons and illustrations often reveal an exaggerated disproportion between the scale of figures and buildings. In *Das Tor* our perspective seems to be that of one standing below the scene, straining our necks to encompass the whole view. From this odd angle, what is above us seems to lose focus, splintered by the sunlight.

N. G.

References
Prasse, Leona E. *Feininger: A Definitive Catalogue of his Graphic Work* (exh. cat.). Cleveland Museum of Art, 1972.
Schardt, Alois J. *Feininger-Hartley* (exh. cat.). Museum of Modern Art, New York, 1944.
Lyonel Feininger (exh. cat.). Marlborough-Gerson Gallery, New York, 1969.
Hess, Hans. *Lyonel Feininger*. New York, 1959.

Plate X
Paul Klee (Swiss, 1879-1940)
Drei Köpfe (Three Heads), 1919
Lithograph on imitation Japan paper
Image: 4¾ x 5¾ in. (12.6 x 14.8 cm.)
Edition: 10
Signed: *Klee* in pencil l.r.
Dated: *1919* in pencil l.l.
Printer: Dr. C. Wolf & Son, Munich
Publisher: Georg Müller, Munich
Reference: Kornfeld 70, I/III

Born in Switzerland, Paul Klee spent most of his creative career in Germany. From 1906 to 1920 he lived in Munich, where, in 1920, he received a telegram from Walter Gropius asking him to join the Bauhaus design school. After ten years there and, subsequently, a position with the Prussian State Academy in Düsseldorf from 1931 to 1933, he returned to Switzerland, remaining until his death in 1940.

Three Heads, probably produced by transferring a finished drawing to the lithographic stone[1] was made at a pivotal point in Klee's career. It was created soon after his demobilization from the military (Klee lost several close friends in the conflicts of World War I, notably Franz Marc) and comes immediately prior to his shift in emphasis toward oil painting and his move to the Bauhaus. One of ten signed and numbered impressions, it is the ninth work produced by Klee in 1919, and is indicated by his work numbering system (see below the image immediately following the date). At least one example from this edition (that in the collection of the Musée National d'Art Moderne, Paris) was hand colored. A later edition of the print, without signature and numbering, was one of six Klee lithographs included in the publication *Munchner Blätter fur Dichtung und Graphik* (Munich Pages for Poetry and Graphic Art) of 1919.

With the publication of several other lithographs and important critical articles, Klee, after long years of struggle, was finally included within the small circle of leading German graphic artists. During this time he was becoming more absorbed in subjective works drawn from personal experience. His emphasis turned toward the human image in this work and in a related print of the same year: *Absorption - Self Portrait - Portrait of an Expressionist* (Kornfeld 73).

The central figure in *Three Heads* is probably not a self-portrait, but the closely knit figures do suggest a family group with the father figure outscaling wife and child. His face is dominated by enormous eyes with an anxious, searching expression.

The naive, childlike conception of the transparent figures and the spidery, tremulous strokes that delineate them are characteristic of Klee's art at this moment.

S.S.H.

1. Many of Klee's other lithographs from this time were transfer lithographs.

References
Kornfeld, Eberhard W. *Verzeichnis des graphischen Werkes von Paul Klee*. Bern, 1963.
Grohmann, Will. *Paul Klee*. New York, 1955.
Paul Klee Das Frühwerk 1883-1922 (exh. cat.). Städtische Galerie im Lenbachhaus, Munich, 1980.

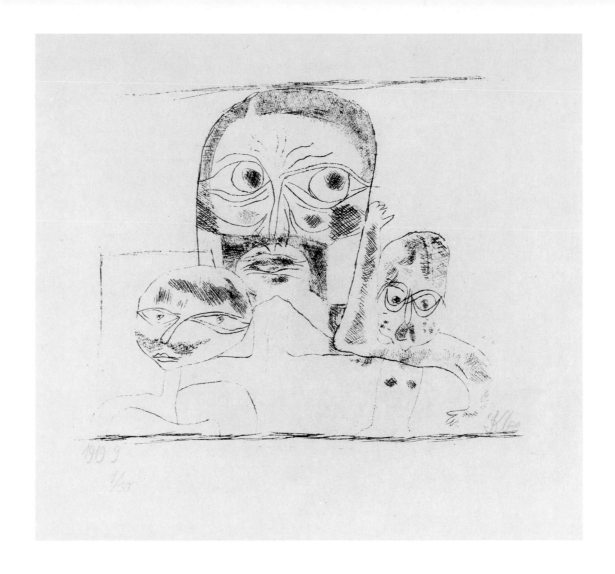

Plate XI
Wassily Kandinsky (Russian, 1866 - 1944)
Kleine Welten (Little Worlds), 1922
Six color lithographs (2 were originally published as woodcuts but are lithographs based in part on woodcut images), 2 woodcuts in black, and 4 drypoints
Sheet: 18½ x 14½ in. (47.0 x 37.0 cm.)
Edition: 230
Signed: *Kandinsky* in pencil l.r.
Printer: Bauhaus, Weimar (woodcuts, drypoints) and a Weimar printer (lithographs)
Publisher: Propyläen-Verlag, Berlin
Reference: Roethel 164-175

Wassily Kandinsky's contact with the graphic arts began in 1895, when he joined the Moscow printing firm of Kusverev as its art director. Though involved there in reproductions of works of art, Kandinsky quickly assimilated printmaking techniques into his own creative work. During his years in Munich he executed the lithographic poster for the first Phalanx exhibition, as well as numerous color woodcuts included in the almanac of the *Blaue Reiter* ("Blue Rider") and in his book of poems *Klänge* (Sounds).

Kandinsky employed the graphic media as a means of exploring and restating the complex issues raised in his writings and his paintings. He aspired to the *Gesamtkunstwerk* (or "total work of art"), which, by synthesizing many different media, would elicit response from several senses. Since the theater, with its blend of sight and sound, was the perfect arena for such works of art, Kandinsky experimented with the drama while in Munich. He was more intent, however, on translating his ideas into two-dimensional form, and the synthesis he sought came in 1922 with *Kleine Welten* (Little Worlds), a series of twelve original prints produced in the graphic workshops of the Bauhaus and at an independent firm in Weimar under the artist's supervision. Consisting of six lithographs, four etchings, and two woodcuts (two prints previously described as woodcuts are actually lithographs), the series is a miniature *Gesamtkunstwerk* in its plurality of techniques.

The *Kleine Welten* series signals a transitional phase in Kandinsky's stylistic development. While the forms that appear in the prints are less literal than the abstractions from nature of his Munich period, they are not yet as rigidly geometric as his later work. These nonobjective images, animated by energies that range from the serenely calm to the agitated, describe, according to the artist, four separate worlds. The floating shapes, swirling lines, and confetti-like markings perform a kind of "cosmic" ballet, their buoyant forms suggesting other realities.

N.S.

References
Roethel, Hans Konrad. *Kandinsky: Das Graphische Werk*. Cologne, 1970.

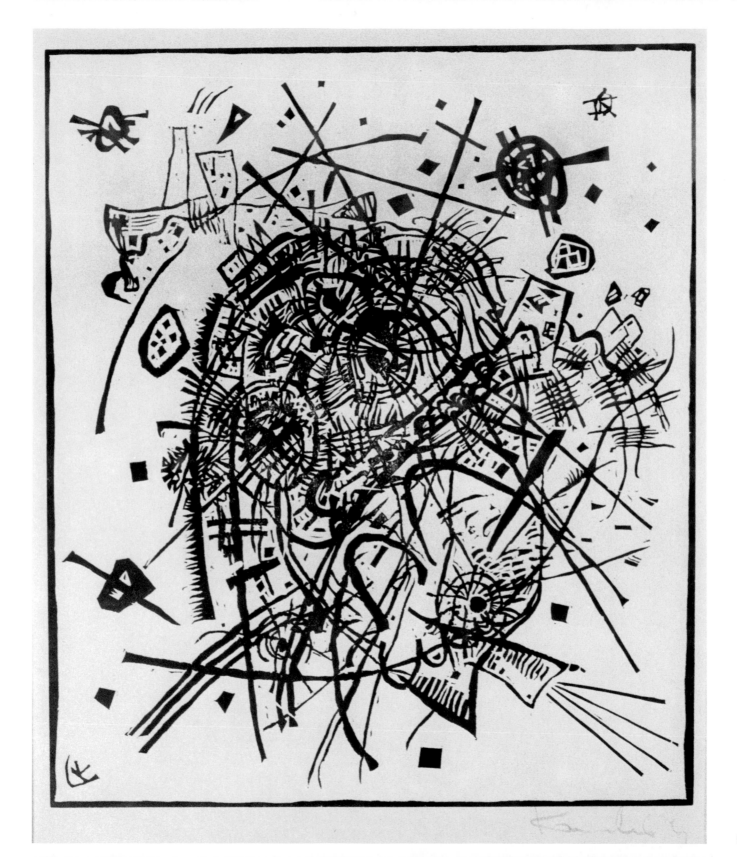

53

Plate XII
Max Beckmann (German, 1884-1950)
Zwei Frauen beim Ankleiden (Two Women Dressing); also known as *Bei der Toilette*, 1923
Woodcut
Image: 23⅝ x 17⅝ in. (60.0 x 45.0 cm.)
Sheet: 29¾ x 20¹⁵⁄₁₆ in. (73.0 x 53.2 cm.)
Edition: 55
Signed: *Beckmann* in pencil l.r.
Dated: *25* in pencil l.r.
Inscribed: *2. Frauen beim An Kleiden* in pencil l.l.
References: Glaser 232, Gallwitz 226

The majority of Max Beckmann's some 300 prints were made between 1911 and 1925. His first, an etching of 1901, is a self-portrait. Reminiscent of Edvard Munch's print *The Cry* of 1895, it shows the seventeen-year-old art student open-mouthed and screaming. Beckmann was to continue to be involved with his own image throughout his artistic career (see also the drypoint *Self-Portrait with Bowler* of 1921; cat. no. 13).

Max Beckmann, best known for his mastery of the difficult drypoint technique, made only about fifteen woodcuts, all relatively late, in the 1920s. His independent work is difficult to discuss in the same breath with the work of other German Expressionists – Kirchner, Heckel, Schmidt-Rottluff, and Nolde – who are so closely identified with the woodcut. Those of Beckmann share the boldness and force of other early twentieth-century German woodcuts, but the artist seems often to have been less involved than, for example, Kirchner or Nolde with the expressive uses to which the manner of execution – the actual cutting and gouging – or the texture of the wood plank itself could be put. As we see here, he sometimes did, like Kirchner, abandon the convention of the pictorial rectangle or borderline and let the image on the block define its own boundaries. (In a related manner, in Beckmann's lithographs of the time, elements of the composition often project over the drawn borderline.)

The ample figures of *Two Women* (who appear to be prostitutes)[1] are compressed into a rather shallow space with uptilted planes – a Cubist-inspired pictorial device that Beckmann employed in many of his compositions, creating a sense of unease or psychological tension. In addition, the fact that we view one woman from the front and the other from the back contributes to the image a feeling of naked exposure and voyeurism. As they joylessly enact their ritual of primping and getting dressed, a lute or mandolin that leans against the bed may convey a traditional allusion to music as symbolic of the fleeting nature of worldly pleasures.

M. M. F.

1. Prostitution was one of the most common and visible urban manifestations of Germany's economic problems at that time.

References
Glaser, Curt. *Max Beckmann.* Munich, 1924.
Gallwitz, Klaus. *Max Beckmann: Die Druckgraphik.* Karlsruhe, 1962.

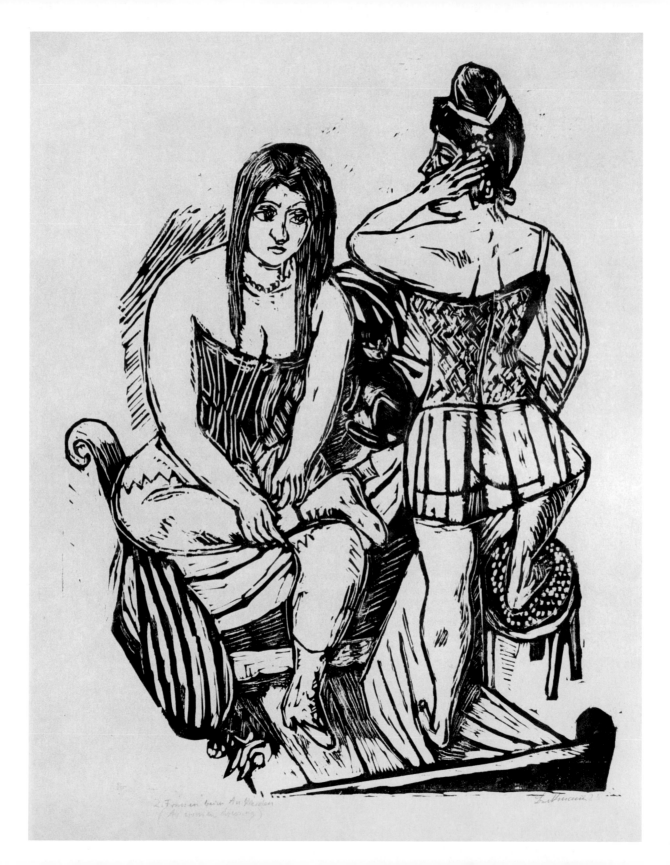

2 Frauen beim Ankleiden
(Women Dressing)

Plate XIII
André Derain (French, 1880-1954)
Tête de Femme (Head of a Woman), ca. 1910
Drypoint on Rives-Delâtre watermark paper
Image: 12⅜ x 8⅝ in. (31.5 x 21.8 cm.)
Signed: *Derain* in pencil l.r.
Reference: Adhémar 37

Born in Chatou, a small town outside of Paris, Derain knew very early in life that he wanted to study art; in his teens he could be found frequenting the Louvre to examine the early masters or "primitives." From 1898 to 1900 he studied with Matisse, whose influence continued to affect his art for years to come. He also met Vlaminck during this time and shared not only a studio but the common belief that the emotional and instinctual took precedence over imitation of the real.[1] As a result of his exposure to African Negro art around 1904, heads and figures in his work began to reveal primitive characteristics: the etching *Tête de Femme* suggests the clearly defined separate planes of an African mask.

For his selective accentuation of forms in order to stress their plastic, sculptural qualities, Cézanne was a particularly important influence on Derain; likewise, the works of Gauguin, with their sinuous rhythms and flat tones, were significant in the evolution of his style. Around 1907 Picasso's early Cubist explorations directed Derain toward more geometric forms. But ironically, as the fully developed Cubist style shook European art to its foundations, Derain withdrew and returned to the reexamination of reality, rejecting abstraction. He argued that the slavish imitation that normally accompanied the depiction of reality could be avoided if it were viewed through one's individual temperament. Few of Derain's avant-garde contemporaries agreed with this stance, however, and he was left to pursue his own individual style for the next forty years.

Dérain's etching of a woman's head from his Cubist phase oscillates between the purely linear and fuller sculptural modeling. The hand, indicated only by a few sketchy lines, reads as flat form, while the rhythmically curving planes of head and hair – with their curiously warped torsion – have the three-dimensionality of high relief sculpture. The velvety, softly graded accents of drypoint burr enhance the modeling.

N. G.

1. Artists such as Vlaminck, Derain, and Matisse were dubbed the "Fauves" (Wild Beasts) at the Salon d'Automne of 1905, particularly because of their arbitrary use of color for expressive purposes.

References
Adhémar, Jean. *Derain. Peintre-Graveur* (exh. cat.). Bibliothèque Nationale, Paris, 1955.

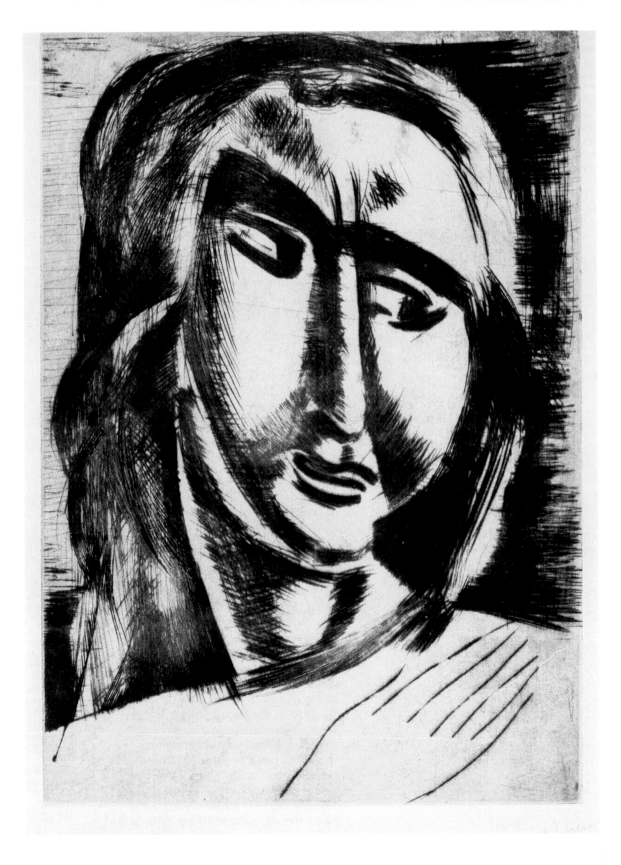

Plate XV
Jacques Villon (French, 1875-1963)
Portrait de Jeune Fille (Portrait of a Young Woman),
1913
Drypoint
Image: 21⅝ x 16⅜ in. (55.0 x 41.5 cm.)
Edition: 30
Signed: *Villon* in pencil l.r.
Reference: Auberty and Perussaux 193, Ginestet
and Pouillon E 282

Jacques Villon (born Gaston Duchamp),
already an established illustrator and etcher
working in color aquatint, developed his skill in
handling the drypoint medium in 1904 and
1905, when he made fashionable portraits in
the manner of Paul Helleu's drypoints. A more
personal style evolved in such works as the
Renée series of drypoints (1911), in which he
depicted the adolescent sitter with balloon-
like voluminousness. In that same year Villon
came into contact with a group of Cubist
artists that included Gleizes and Metzinger
and began to paint in a new style – essentially
realistic, but with the images broken into
faceted planes. It is in this modified Cubist
style that he made a series of oil studies of his
younger sister, Yvonne Duchamp, seated in an
armchair with a book resting on her lap.
Concurrently, the artist depicted Yvonne in
several prints, among them this large drypoint.

Portrait of a Young Woman is based quite
closely, even in its size, on the 1912 oil sketch
Study for Young Woman (Fogg cat. 35; Cincin-
nati private collection). In each medium Villon
portrayed in a recognizable fashion the sitter's
head and her pose, leaning forward with right
hand resting on her left forearm. The print,
however, goes beyond a reproduction of the
painting, pursuing the Cubist aesthetic in a
satisfyingly graphic manner.

In keeping with the precepts of Cubism,
Villon concentrated on the central part of the
image, suggesting the three-dimensionality of
the head and the essential outline of the back.
The remainder of the figure and its setting
become more diffuse and flatten out toward
the edges, relating more closely to the two-
dimensional picture surface.

The image is built up of many angular,
shifting planes or facets, much like a relief
map of a mountain range or a mass of irregular
pyramids. The direction of the hatching defines
the orientation of the planes. Each facet is
composed of parallel lines incised with a
drypoint tool manipulated so as to achieve a
range of values from light to dark, depending
on the depth of the line and the distance
between lines. Villon was a master at handling
the point so as to raise burr in greater or lesser
degrees; the lines with the most burr retain
large amounts of ink along the burr and the
surrounding surface of the plate.

In his use of drypoint Villon is far more
vigorous than either Picasso or Braque in their
Cubist prints of 1910-1911. The hatched lines
in *Portrait of a Young Woman* evoke broad
brushstrokes, while the various tonalities sug-
gest color. Whether seen from afar as the
lively play of light over faceted forms or close
at hand so that each spiky line can be read
alone or as part of its grouping, Villon's print is
an outstanding example of his printmaking
skills and a herald of his mature graphic style.

S.W.R.

References
Auberty, Jacqueline, and Perussaux, Charles. *Jacques Villon,
Catalogue de son oeuvre gravé.* Paris, 1950.

de Ginestet, Colette, and Pouillon, Catherine. *Jacques Villon, Les
Estampes et les illustrations.* Paris, 1979.

Robbins, Daniel, ed. *Jacques Villon* (exh. cat.). Fogg Art Museum,
Cambridge, 1976.

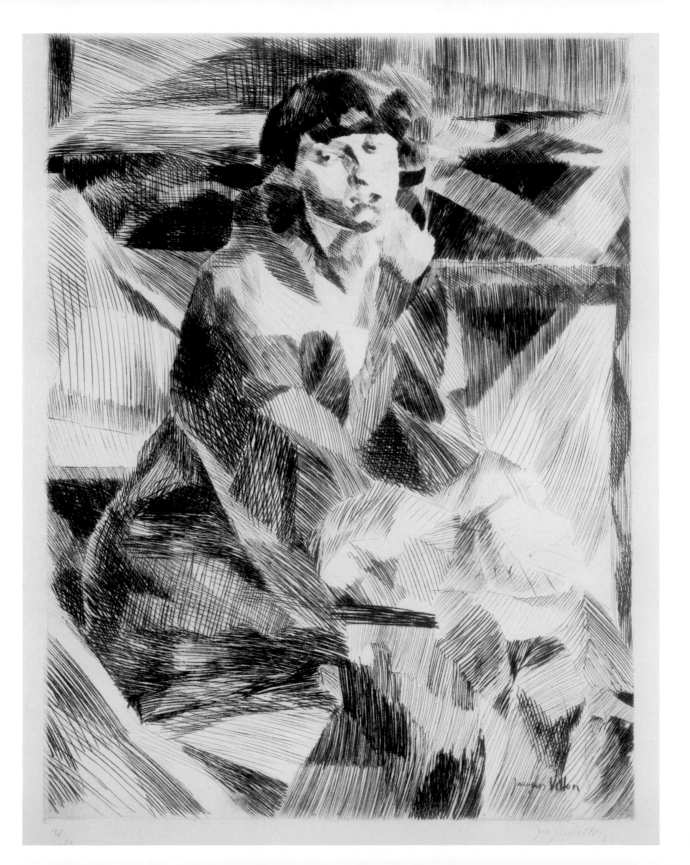

Plate XVI
Robert Delaunay (French, 1855-1941)
La Fenêtre sur la ville (Window on the City), 1925
Transfer lithograph
Image: 21¼ x 16¼ in. (54.0 x 41.8 cm.)
Edition: 60 (This is a separate proof.)
Signed: à *Roches aimablement R. Delaunay* in pencil l.r.
Reference: Loyer and Perussaux 4

The Window on the City is one of a number of Robert Delaunay's lithographic restatements of themes from earlier paintings. The print, with its view of the Eiffel Tower framed by window curtains, relates to three canvases of 1911 entitled *La Ville* (The City). These are the first of Delaunay's Paris-through-a-window paintings and a prelude to the radical semi-abstract *Fenêtre* (Window) oils of 1912. All of the window paintings wittily redefine the traditional conception of the picture as a window opening into a pictorial illusion.

In both the 1911 paintings and the 1925 lithograph – based on a photograph taken from the southwest corner of the top of the Arc de Triomphe – [1] near and far are confounded. The paintings' panorama is fragmented not only by subtle shifts in viewpoint but by passages of checkerboard strokes that suggest the dazzle of light and atmosphere. Similarly, the lithograph emphasizes descending diagonal beams of light that fragment city and tower. Its draped curtains meld with and become inseparable from the cloud forms they echo.

The lithograph is the most conservative of all of the window views, and presented Delaunay, whose art from 1912 on is usually associated with rainbow-like planes of transparent color, with the challenge of translating these painterly values into black and white. The lithograph looks back beyond Cubism to the formal language of Cézanne, Cubism's progenitor. The manner in which the vignetted image bleeds off into the blank paper at the edges recalls not only Cézanne's watercolors but Cubist paintings by Braque and Picasso of 1910-1912, in which the painting is heavily built up at the center and tapers off to raw canvas around the edges.

The Eiffel Tower, a dramatic demonstration of the possibilities offered by the new technologies of steel, was erected for an exposition in 1889. This soaring structure, which many found vulgar in its naked functionalism, was regarded by Delaunay as a symbol of the dynamism of the modern age and is the focal point of many of his works. The fact that it is a transparent openwork structure penetrated by light and air accords well with his interest in transparency of forms.

N. G.

References
Rudenstine, Angelica Zander. *The Guggenheim Museum Collection: Paintings 1880-1945*, vol. 1. New York, 1976.
Loyer, J. and Perussaux, Charles. "Robert Delaunay: Catalogue de son oeuvre lithographique," in *Nouvelles de l'estampe*, no. 15, 1974.

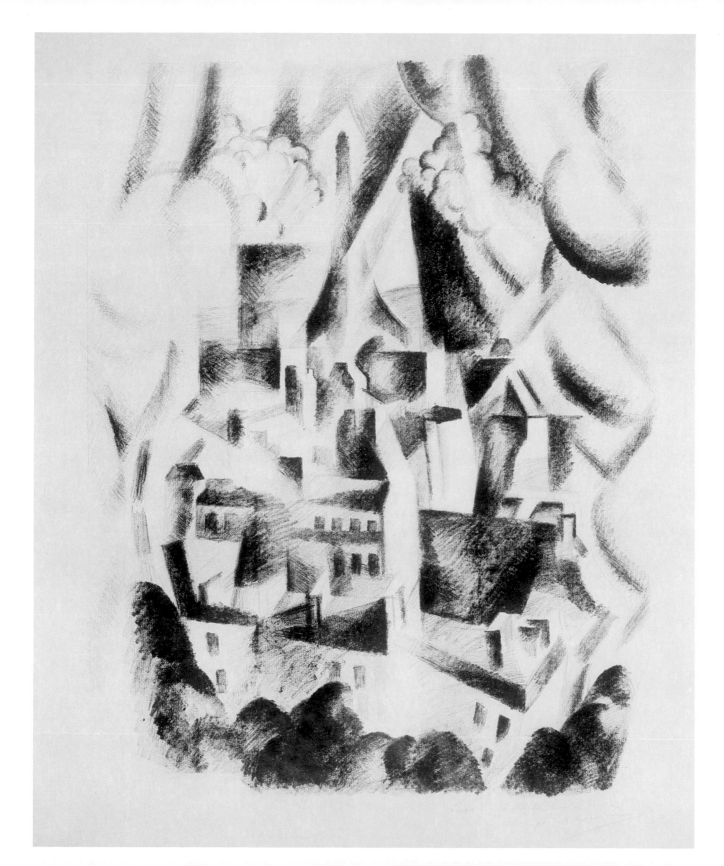

Plate XVII
Pablo Picasso (Spanish [active in France], 1881-1973)
Visage, 1928
Lithograph on cream imitation Japan paper
Image: 8 x 5⅝ in. (20.5 x 14.2 cm.)
Edition: 75 (various editions totaling 220)
Signed: *Picasso* in pencil l.r.
Reference: Geiser 243, Bloch 95

Throughout the 1920s Picasso had depicted monumental figures inspired by his vision of classical antiquity. It was not surprising, therefore, that in January of 1927, when he spied a seventeen-year-old girl with even features emerging from the Métro, he accosted her as if she were a lost possession rather than a total stranger. In effect, he recognized her the moment he saw her, for he had created the image of Marie-Thérèse Walter in his art long before he encountered her in the flesh (see, for example, *La Source* of 1921; cat. no. 176).

In *Visage*, made in the summer of 1927 and published a year later, we see Picasso at the apex of his infatuation with Marie-Thérèse. His ideal of classical perfection looms larger than life, barely contained within the dimensions of the stone. Light seems to emanate from her lunar double aspect, the simultaneous three-quarter and profile views enhancing her mysterious presence. As she gazes past and through the viewer in all-knowing serenity, a slight smile crosses her lips. The beauty of this face stems not only from its classical features but from the state of supreme consciousness it conveys.

Because the affair that ensued between Marie-Thérèse and Picasso was clandestine (Picasso was married to Olga Koklova at the time), Marie-Thérèse does not appear in recognizable form in any work, with the exception of *Visage*, until 1931. The singular qualities Picasso presents were, however, the result of wishful projection and a lover's idealization rather than a faithful record of his sitter's true persona. As was often the case with Picasso, his ardor cooled and Marie-Thérèse was progressively demoted from goddess to sexual convenience. Over a period of eight years, the artist was increasingly unable to sustain his invented myth and had to come to terms with the reality of an ingenuous, vulnerable, and nonintellectual mistress more than thirty years his junior.

Other prints in the Torf collection document Marie-Thérèse's metamorphoses. She is the victim of near-drowning in the *Rescue* of 1932 (cat. no. 179). The etching *Head* of 1933 (cat. no. 180) parallels Picasso's sculptural investigations of her features: by degrees he transformed his model's classical profile into a conglomeration of exaggerated phallic and vaginal shapes. A year later she appears as the little girl leading Picasso's bestial alter-ego, the blind Minotaur, through the night (cat. no. 184). She also makes frequent appearances, in the sculptor's studio of the Suite Vollard, as the neglected model who is unable to compete in her lover's affections with the art she inspires (cat. nos. 181-185).

When other media failed him, as many critics feel oil and canvas did in his old age, Picasso's graphic mastery remained intact. Throughout his life he confided his most personal thoughts, emotions, and fears to the lithographer's stone and the etcher's plate.

D.M.

References
Bloch, Georges. *Pablo Picasso, Catalogue de l'oeuvre gravé et lithographié 1904-1967*. Berne, 1968.
Gedo, Mary Mathews. *Picasso, Art as Autobiography*. Chicago, 1980.

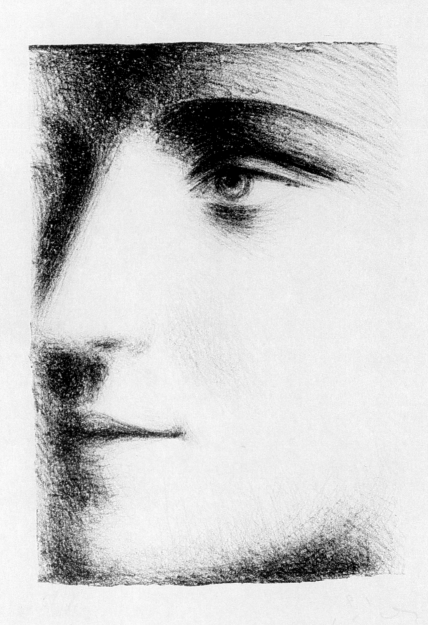

Plate XVIII
Salvador Dali (Spanish [active in France], born 1904)
Mobilier Fantastique (Fantastic Furniture), 1934
Etching on Arches paper
Image: 9½ x 11¾ in. (23.9 x 29.9 cm.)
Sheet: 16¹⁵⁄₁₆ x 18¹⁵⁄₁₆ in. (43.3 x 48.3 cm.)
Edition: about 20-30
Signed and dated: *Salvador Dali 1934* in pencil l.l.

As a child, Dali suffered from fits of hysteria that often led to uncontrolled acts of rage. He searched for an identity through his art, associating himself with a variety of artistic movements in succession, including Cubism, the Italian Metaphysical School, Art Nouveau, and the work of the Catalonian architect Antonio Gaudi. When, around 1930, his work began to incline toward the irrational worlds of the Dada and Surrealist artists (Duchamp, Picabia, and Max Ernst), it was apparent that he still retained much from his earlier interest in Giorgio de Chirico. Both employed sharply receding perspective and unnatural disposition of light and shadow, but De Chirico seemed to Dali to overidealize his dream world, whereas Dali wanted to make the unreal more vividly real. He loathed the modern industrialism and scientific rationalism idolized by many of his contemporaries, affirming that "the animate and the inanimate are interdependent in significance and function, with the inanimate taking its vitality from its relation to the living or from a strong capacity to come alive."[1]

Mobilier Fantastique reveals Dali's preoccupation with malleability and the fascination with bones and bone distortion typical of his works of the early '30s. An artist who designed for his own use a sofa resembling Mae West's lips, as well as a telephone in the shape of a lobster, he also spawned most unusual furniture in this print: the bentwood rocker is remolded to suggest bonelike forms, trees sprout from chairs, hands reach out of trees, and a faucet protrudes from a chair. The grotesque invention of this biomorphic fantasy is ironically juxtaposed with mundane household objects: an iron, a cup and spoon, and laundry on a clothesline.

N.G.

1. Quoted in Soby, p. 22.

References

Soby, James Thrall. *Salvador Dali* (exh. cat.). Museum of Modern Art, New York, 1941.

Passeron, René. *Salvador Dali*. New York, 1981.

Salvador Dali retrospective 1920-1980 (exh. cat.). Centre Georges Pompidou, Musée National d'Art Moderne, Paris, 1979.

Longstreet, Stephen. *The Drawings of Salvador Dali*. Los Angeles, 1964.

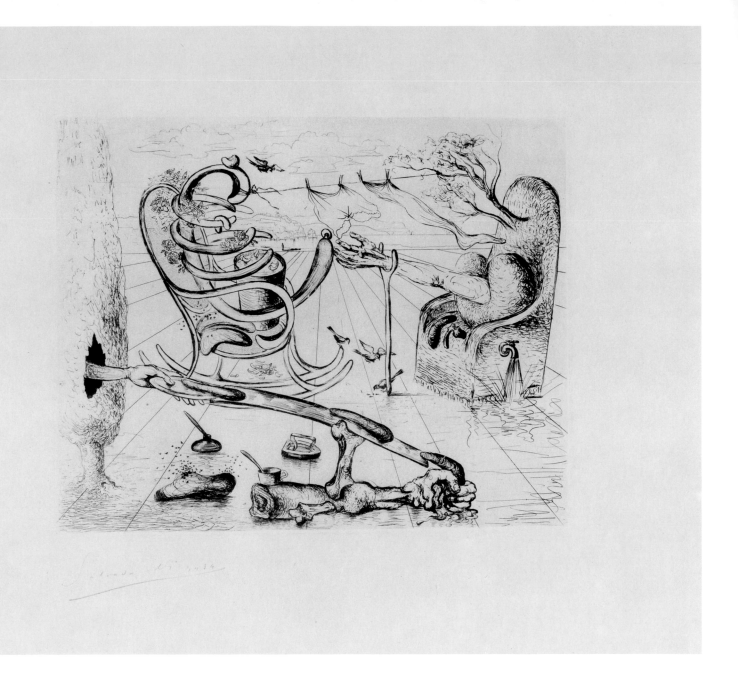

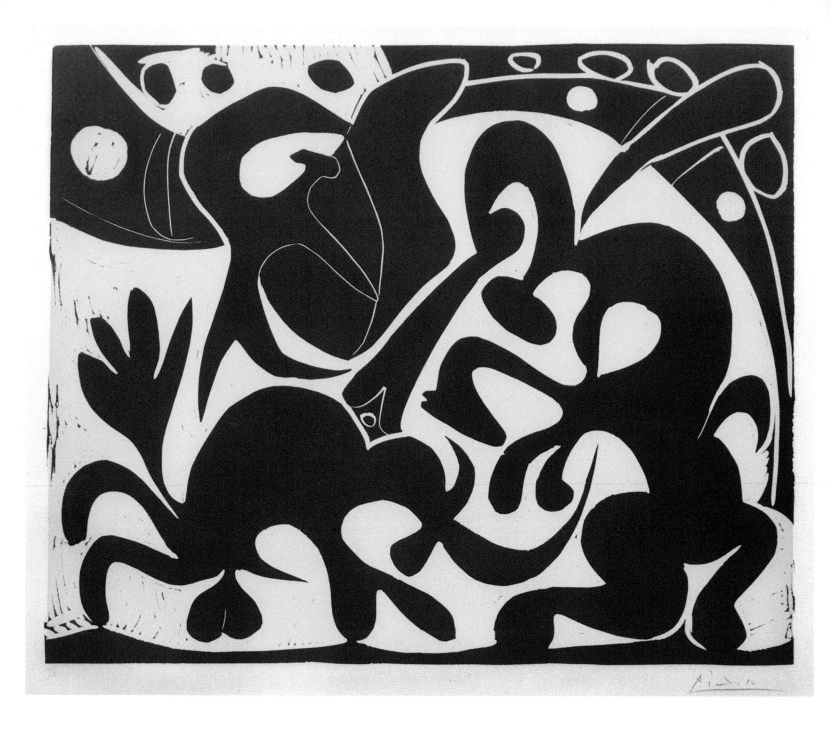

Plate XIX
Pablo Picasso (Spanish [active in France], 1881-1973)
Pique (Rouge et Jaune) (The *Pic*, Red and Yellow), 1959
Linocut
Image: 20⅞ x 25⅛ in. (53.0 x 63.7 cm.)
Edition: 50
Signed: *Picasso* in pencil l.r.
Inscribed: *44/50* in pencil l.l.
Reference: Bloch 908

When Picasso was in his seventies, he began experimenting with a print medium new to him: linoleum cuts. He was to push this medium beyond its known boundaries so that it would express more cogently what he wished it to say.

He used linoleum as early as 1952 for annual posters for the town of Vallauris, which had made him an honorary citizen two years earlier, and for the *corridas* held there once the government permitted bulls to be fought in France. But it was not until 1959 that Picasso seriously explored the medium, producing that year forty-five linoleum cuts.

The ease with which linoleum can be cut (it is often used to introduce primary school children to the art of making prints) as well as its availability and low price were all factors that intrigued Picasso. However, there was nothing naive or childish in his use of the material. He scratched images into it as though it were a plank of wood, or engraved it lightly to give an effect similar to his simplified linear etchings on copper plates. He perceived too, as we see here, how the potential of linoleum to print with broad, flat tones of color could be exploited.

Fully a third of Picasso's 1959 linoleum prints are concerned with bullfighting. It has been suggested that he was influenced in this choice of subject by his then mistress, Jacqueline Roque, who also loved *corridas*. But a more likely reason is that Picasso began that year to make wash drawings and aquatints for a commission he had received two years earlier. He had been asked to illustrate a new edition of a book first printed in 1796, *Tauromaquia* (Art of Bullfighting), ascribed to the great matador Josef Delgado, who fought as "Pepe Hillo." Two of Picasso's illustrations for the new edition of this book show picadors at work.

In the present print a mounted picador (right) has pushed the sharp tip of his long *pic* into the huge neck muscle of the bull (left). The animal strains to overturn horse and rider as a second fighter (upper left) stands ready with his cape to lure the bull away should it succeed in doing so. The clash of strong red and strong yellow colors plays a vital part in suggesting the impact of the encounter.

E.A.S.

References
Zervos, Christian. *Pablo Picasso*, vol. 17. Paris, 1932.
Bloch, Georges. *Pablo Picasso. Catalogue de l'oeuvre gravé et lithographié, 1904-1967*. Berne, 1968.
Boeck, Wilhelm. *Pablo Picasso. Grabados al Linoleo* (Maria Lopez Sert, transl.). Barcelona, 1962.

Plate XX
Max Ernst (French, 1891-1976)
Number 4 from the album *Fiat modes, pereat ars*,
1919
Lithograph on yellowish machine-made paper
Image: 15½ x 10⅝ in. (39.5 x 27.0 cm.)
Sheet: 17⅞ x 13 in. (45.5 x 33.0 cm.)
Edition: unknown (edition of 60 originally planned)
Printer: the artist
Publisher: Verlag Arbeitsgemeinschaft Bildender
Künstler, Cologne;
schlömilch-verlag, Cologne
Reference: Leppien 7

In 1919 Max Ernst traveled to Munich to meet with Paul Klee. While visiting the Goltz book-store there, he chanced upon an issue of *Valori Plastici* (Plastic Values), in which works by Giorgio de Chirico were reproduced. On returning to Cologne, the impressions he had received resulted in Ernst's first and most important assimilation of the Italian *Pittura metafisica* (metaphysical painting). The work – eight lithographs, of which the fourth is included here – was entitled *Fiat modes, pereat ars* (Long live fashion, down with art).

The influence of De Chirico turned Ernst away from the Dadaist style he had been exploring[1] and toward a form of fantastic realism. In these lithographs of 1919 and in an oil of the same year, *Aquis Submersis*, he employed the distorted perspective, manne-quins, and haunted empty spaces of De Chi-rico, demonstrating that he had discovered and analyzed De Chirico's work long before the latter artist became the paradigm for the Surrealists.[2] In the present example, the upended and confused perspective gives an illogical orientation to the geometric forms; shadows fall where there should be no shade and rise where there are no obstacles. The three mannequins stand isolated, self-absorbed, only the middle figure actively studying the towering wall before him. The dress mannequins and tailor's dummies that appear in the prints of the portfolio play upon the "fashion" of the title, with overtones of both conventional bourgeois taste and the modish in art.

The eight lithographs are a relatively rare example of Ernst's use of direct drawing in lithography. He was not to turn to lithography again until 1939, and when he then used the medium, it was often to be with an intermedi-ary step, such as transferred rubbings or photolithography.

The edition size of the portfolio is not known. In an advertisement by Kairos-Verlag of Cologne in the publication *Der Strom*, the portfolio was announced as a series of eight watercolored lithographs in an edition of 60. The original plan to color the lithographs with watercolor was discarded: Ernst destroyed the majority of the edition and only one known watercolored example survives. Owing to the difficulty he encountered in working with the

Verlag A.B.K. of the city government, Ernst took over the publication with his fictive *schlömilch-verlag*.

S.S.H.

1. Just after the end of the war in 1918, Ernst had become actively involved with the Dada movement, initiating the Cologne offensive of the group with Johannes Theodor Baargeld. The works of this period were political as well as abstract: "our enthusiasm encompassed total revolution."
2. Ernst himself referred to this portfolio in writing as an homage to De Chirico.

References
Leppien, Helmut R. *Max Ernst: Das Graphische Werk*, vol. in *Max Ernst, oeuvre-katalog* (Werner Spies, ed.). Houston, 1975.
Russell, John. *Max Ernst, Life and Work*. London, 1967.
Waldman, Diane. *Max Ernst – A Retrospective* (exh. cat.). Solo-mon R. Guggenheim Museum, New York, 1975.

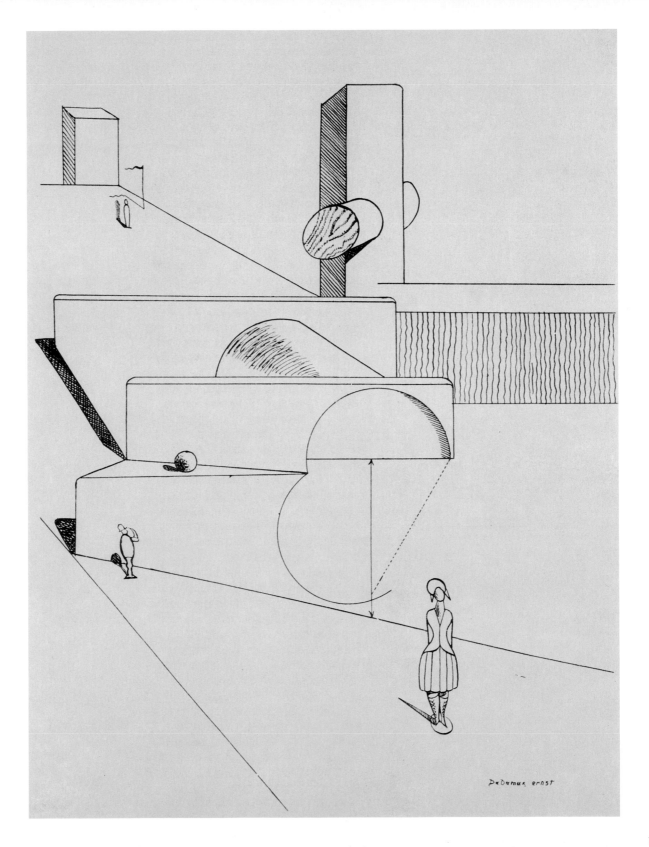

Plate XXI
El Lissitzky (Russian, 1890-1941)
Totengräber (Gravedigger) from the portfolio *Die Plastischen Gestaltung der Elektro-Mechanischen Schau Sieg über die Sonne* (The Plastic Form of the Electro-Mechanical show "Victory over the Sun"), 1923
Color lithograph
Image: 14⅝ x 10⅝ in (37.2 x 26.8 cm.)
Sheet: 17⅝ x 12½ in. (44.6 x 31.8 cm.)
Edition: 75
Signed: *El Lissitzky* in pencil l.l.
Printer: Robert Leunis and Chapmann G.M.B.H., Hanover
Publisher: the artist
Reference: Lissitzky-Küppers pl. 61, Gmurzynska pl. 63.

El Lissitzky was born in Vitebsk, Russia, and trained as an architect at the Technische Hochschule in Darmstadt, Germany. Forced to leave Germany quickly at the onset of World War I, he returned to Moscow and became involved with the Revolutionary Committee for Art. It was through this committee that he designed the first flag of the Central Committee of the Soviet Communist Party.

In 1919 Marc Chagall invited Lissitzky back to Vitebsk to teach architecture and the applied arts. While there he was influenced by the artistic theories of the Suprematist painter Kasimir Malevich and by his use of pure geometric shapes instead of natural forms. It was at this time that Lissitzky developed his concept of the "Proun" (see cat. no. 135) – in his own phrase: "the interchange station between painting and architecture." (The *Proun* incorporates his acceptance of the use of nonobjective imagery but moves beyond Suprematist flatness into three dimensions.) Lissitzky returned briefly to Moscow, forming a Constructivist group with Rodchenko, Naum Gabo, and others; in 1921, he was sent to Germany, where he remained for three and a half years, during which time the series including *Totengräber* (Gravedigger) was published. Settled again in Moscow in 1925, Lissitzky began to move away from his earlier abstract imagery, accepting the dictates of Soviet Socialist Realism into his work. As Stalinist views on art restricted creative expression, his work lost momentum. The later paintings and prints have little of the energy and visual originality apparent in those of the early '20s.

Gravedigger, a product of Lissitzky's peak creative period, is one of ten lithographs from the *Figurinenmappe* (figurine or puppet portfolio), which presents his plans of 1920-1921 for a restaging of A. Kruchenykh's Futurist opera "Victory over the Sun" as an electromechanical marionette show. The opera was performed originally in St. Petersburg in 1913 with costumes, lighting, and decor by Kasimir Malevich. "Victory over the Sun" celebrated man's technological supremacy over natural forces. This radical operatic work involved the use of atonal music and an alogical text based on a "transrational language."

Lissitzky's portfolio, the second of two published in 1923 under the auspices of the Kestner Gesellschaft, Hanover's influential avant-garde art association, included ten lithographs plus cover and title page. The series begins with a design for stage equipment, to be put in movement by "electro-mechanical forces and devices," followed by nine sheets of characters from the opera. The present work is plate 9, the eighth of the nine figures.

Gravedigger represents the outmoded conceptions that must be buried in order that society may advance toward the ideal: the new man. The repetition of cruciform motifs reinforces the theme of the moribund and *Neuer* (New One), the last print in the portfolio, embodies the new ideal. Contrasting sharply with the contained coffin-like forms of *Gravedigger*, the figure energetically radiates outward, its head crowned by the Soviet Star and the core of its body a red square (the latter a pivotal image in Malevich's Suprematist works).

S.S.H.

References
Lissitzky-Küppers, Sophie. *El Lissitzky*, *Life-Letters-Text*. London, 1968.
El Lissitzky (exh. cat.). Galerie Gmurzynska, Cologne, 1976.
Birnholz, Alan Curtis. "El Lissitzky" (Ph.D. dissertation, Yale University, 1973).

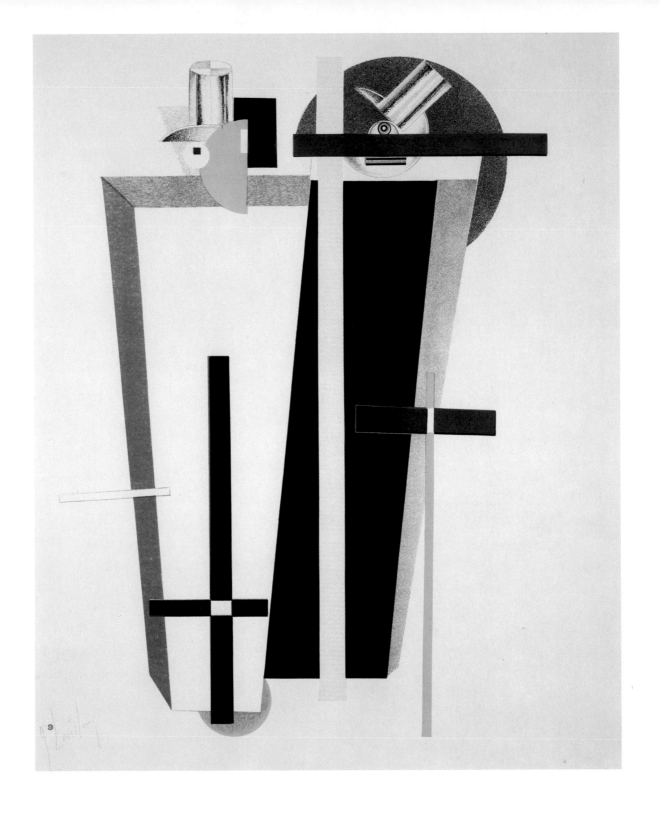

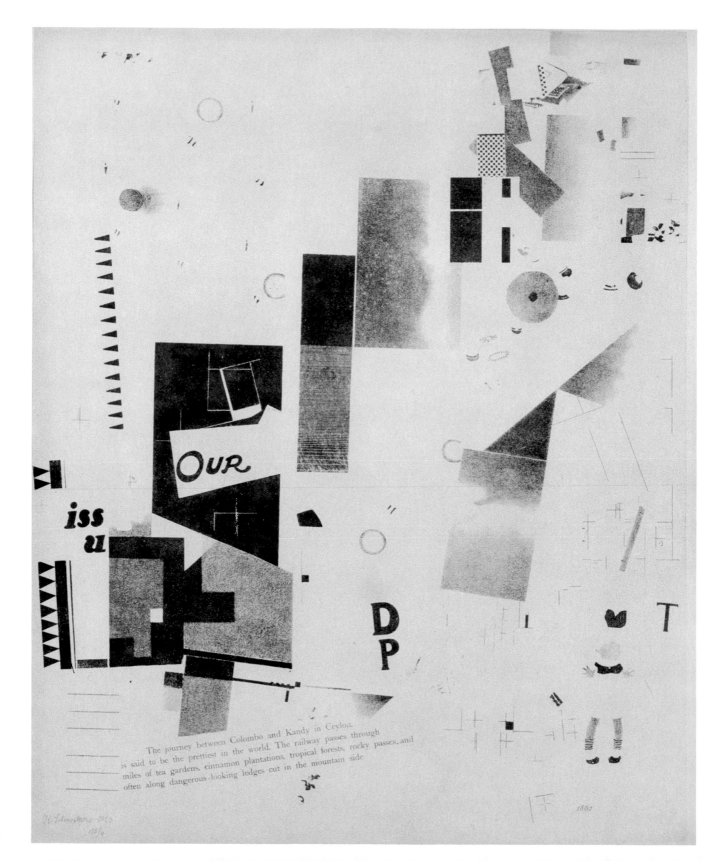

The journey between Colombo and Kandy in Ceylon
is said to be the prettiest in the world. The railway passes through
miles of tea gardens, cinnamon plantations, tropical forests, rocky passes, and
often along dangerous-looking ledges cut in the mountain side

Plate XXII
Kurt Schwitters (German, 1887-1948)
Untitled, Number 2 from *Merz 3 : Merzmappe: 6 lithos*, 1923
Lithograph
Image and sheet: 21⅞ x 17¾ in. (55.5 x 45.0 cm.)
Edition: 50 (?)
Signed: *K. Schwitters 1923* in pencil l.l.
Inscribed: *15/4* in pencil l.l.
Publisher: Merz Verlag (the artist)
Reference: Schmalenbach 88, no.2

Kurt Schwitters is best known as the inventor of "Merz" art, the collective title for his own personal variation on the Dada movement. The name, part of the German word *Kommerz* (commerce), is a nonsense term that originated in 1919, when Schwitters created several collages containing fragments of words and phrases, one including "merz." Delighted with this chance word mutation, he chose "Merz" as the generic name for his collages and for all his artistic activity.

This untitled lithograph is one of six from a portfolio that constituted the third issue of Schwitters's magazine *Merz*, which began publication in 1923.[1] The "6 Lithos auf den Stein gemerzt" (6 lithos "merzed" on stone) are an extension of his collage working method.[2] In this instance Schwitters collected rejected printer's proofs from a commercial printing establishment and transferred them to the stone – apparently while the ink of the freshly printed proofs was still wet – making his final image out of numerous components.[3] Printer's devices such as registration marks acquire in his inventive hands the formal interest of a Mondrian plus-and-minus painting. The teasing, witty use of the printed word in a visual composition – ultimately derived from Cubism – is seen here in the tantalizingly enigmatic fragment from a romantic account of travel in Ceylon and the inclusion (at the lower right) of the anachronistic date "1862."

While Schwitters's Merz art grew out of German Dada, it is fundamentally different in its emphasis on formal design; pure Dadaists abhorred such establishmentarian values. For all the anti-art sentiments that are implied by the source of the Merz fragments – commercial labels, newsprint, scraps of metal and cloth – Schwitters always surmounted the sense of randomness by the formal control he imposed on the "inartistic" materials through textural contrasts, repeated patterns, and geometric structures.

The Merz lithographs anticipate, in their qualities of formal design, the Constructivist direction that Schwitters's art would take, encouraged by contact with friends such as the Russian Constructivist El Lissitzky and the Dutch *De Stijl* artist Theo van Doesburg. Even more significantly, however, their collaging of photomechanical materials from commercial sources anticipate prints by Rauschenberg and

Twombly (cat. nos. 189-191 and 208-211) from our own time.

M.M.F.

1. The six lithographs in the portfolio are printed in a single color. Here it is a reticent gray, but in other instances it is a strong blue or red. On some examples (not in this instance) Schwitters added by hand actual collage: rectangles of cream paper pasted over the printed image.

2. These were not Schwitters's first lithographs. In 1919 he contributed a lithograph with a head in profile to the third *Bauhaus Portfolio* (which also included Campendonk and Marc; see cat. nos. 33 and 143). The following year he issued a small booklet with eight lithographs entitled *Die Kathedrale* (The Cathedral). The latter involved collage plates and images that combined words and abstract geometric forms.

3. Many of these retrieved proofs were incomplete images that represented a stage or element in the printing of the final image (see, for example, the mysterious little girl at the lower right).

References
Schmalenbach, Werner. *Kurt Schwitters*. Cologne, 1967.

Plate XXIII
Alexander Rodchenko (Russian, 1891-1956)
Composition, 1919
Linocut on wove paper
Image: 6¼ x 4¼ in. (15.9 x 10.8 cm.)
Sheet: 6½ x 4½ in. (16.5 x 11.4 cm.)

Alexander Rodchenko's series of linocuts of nonobjective, geometric designs signal his shift from the metaphysical implications of Suprematism to the more purely structural concerns of Constructivism. In 1918 he began to experiment with using line as the sole basis for his art. Eliminating what he described as the "last strongholds of painting" – color, tone, and surface texture – he proceeded to explore the pictorial possibilities of composing with line alone. This led quite naturally to the three-dimensional architectural constructions of the same year. The graphic arts proved equally attractive to him by providing yet another sympathetic medium for his reductivist endeavors.

Composition of 1919 reflects Rodchenko's desire to create an art devoid of personal style – an art with universal vocabulary that would be immediately comprehensible. The search for a fundamental, anti-elitist art form symbolizing scientific progress was grounded in the utopian vision of post-revolutionary Russia. This white-on-black design, elegant in its simplicity, may have been made with the assistance of ruler and compass, as were many of his earlier works. The artist had not, however, purged his image of all elements of "style." The fractured, overlapping planes owe much to French Cubism, while the crisscrossing or radiating dynamic lines are partly indebted to Italian Futurism. While clearly linear in conception, the linocut is not devoid of tonal and textural variety. Shading lines around the circle's perimeter suggest that it is spherical, rather than two-dimensional. Despite Rodchenko's claim to nonobjectivity, forms and space may suggest to the viewer a landscape with horizon line and blazing sun. By 1920, he had rejected such "useless" representation in favor of a "Productivist" art that would serve the needs of the worker: designs for clothing, factories, and homes.

N.S.

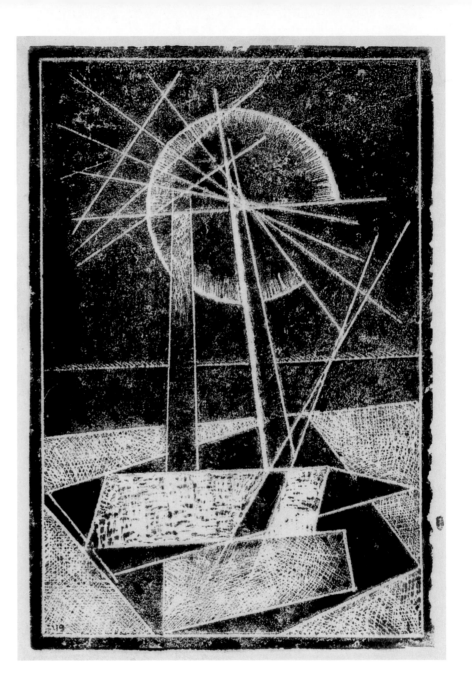

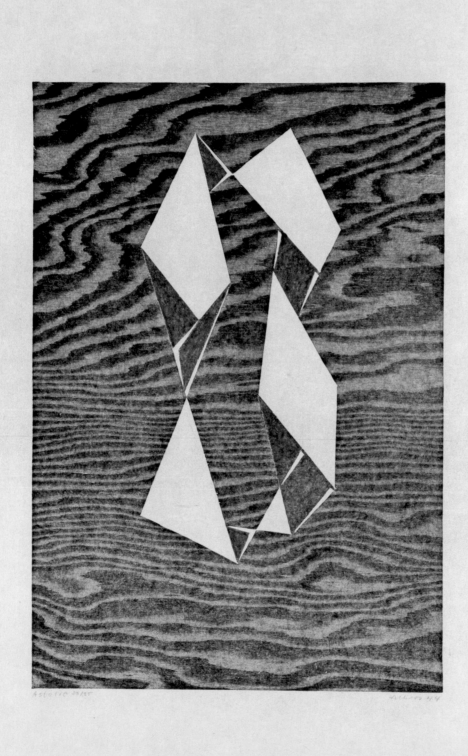

Plate XXIV
Josef Albers (American [born in Germany], 1888-1976)
Astatic, 1944
Woodcut on Japan nacré paper
Image: 13¼ x 9 in. (33.6 x 22.5 cm.)
Edition: 35
Signed and dated: *Albers 44* in pencil l.r.
Titled: *Astatic* in pencil 1.1.
Publisher: Biltmore Press, Asheville, N.C.
Reference: Miller 67

Josef Albers, a member of the Bauhaus design school in Weimar, Germany, is best known for his paintings that explore the relativity of color. Of great interest, also, are the series of prints he made throughout his lifetime, executed in a variety of innovative techniques.

Albers designed his first print in 1915 and continued to produce woodcuts and lithographs while he attended and later taught in an art school in Essen. His first movement toward abstract, nonobjective design appears in the early 1920s, when he transferred his well-known variations on the rectangle and the square to stained-glass windows. When the Bauhaus was forced to move to Berlin in 1932 Albers returned to making prints, including small editions of relief prints with abstract images. Under pressure to leave Germany in 1933, Albers accepted an invitation to teach in the United States; he remained there permanently and, during the war years, produced many of his major printed works.

For decades Albers believed that prints generated by mechanical means under the artist's supervision could be aesthetically successful; despite this conviction, he executed by hand a series of woodcuts, cork reliefs, and linoleum prints. The woodcut *Astatic* was printed from a sheet of strongly grained veneer that created an undulating backdrop in gradations of gray and black. Within this matrix Albers carved out irregular geometric hollows in which he laid precisely cut triangular and trapezoidal segments of wood.

As the title *Astatic* suggests, there is no steady or fixed position; the kite-like construction projecting from the wavy field appears to hover in space, and the combination of geometric elements and rhythmic lines gives the illusion of vibrant movement. Furthermore, Albers invented an ambiguous space in which the simple forms and the woodgrain constantly shift their roles as figure and ground.

B.S.S.

References
Miller, Jo. *Josef Albers: Prints 1915-1976* (exh. cat.). Brooklyn Museum, New York, 1973.
Gomringer, Eugen. *Josef Albers*, New York, 1968.

Plate XXV
Naum Gabo (Russian [active in United States], 1890-1977)

Opus 1 from *A Portfolio of Twelve Monoprinted Wood Engravings*, 1950
Wood engraving in brown (monoprint) on Japan paper
Image: 2¾ in. diameter (7.0 cm. diameter)
Sheet: 10⅞ x 8⅛ in. (27.8 x 20.7 cm.)
Edition: over 60
Signed: *Gabo* in pencil l.r.
Titled: *Opus 1* in pencil l.l.

Opus 2, 1950
Wood engraving in brown (monoprint) on Japan paper
Image: 8 x 6¼ in. (20.4 x 15.8 cm.)
Sheet: 11⅛ x 8 in. (28.2 x 20.4 cm.)
Edition: 31; 5 artist's proofs, 1 other
Signed: *Gabo* in pencil l.r.
Titled: *op. 2* in pencil l.l.
Marked: Gabo's red monogram u.l.

Opus 3, 1950
Wood engraving, with sanding disks, stipple marks, and scratching (monoprint) on Japan paper
Image: 6 x 8⅛ in. (15.3 x 21.0 cm.)
Sheet: 11 x 8 in. (28.0 x 20.4 cm.)
Edition: 15; 6 artist's proofs, 10 others
Signed: *Gabo* in pencil l.r.
Titled: *op. 3* in pencil l.l.
Marked: Gabo's red monogram l.r.

Opus 4, 1950
Wood engraving in brown and black on Japan paper
Image: 6¼ x 9½ in. (15.9 x 24.2 cm.)
Sheet (assembled as 2 sheets, superimposed):
 a) 11 x 8 in. (28.0 x 20.4 cm.)
 b) 9½ x 6½ in. (24.2 x 16.5 cm.)
Edition: 23; 6 artist's proofs, 6 others
Signed: *Gabo* in pencil on both l.r.
Titled: *N4* in pencil l.l.

Opus 5, 1950
Wood engraving in brown (monoprint) on Japan paper
Image: 9⅝ x 8⅛ in. (24.2 x 20.7 cm.)
Sheet: 12 x 9⅛ in. (30.5 x 23.2 cm.)
Edition: 26; 11 artist's proofs, 5 others
Signed: *Gabo* in pencil l.r.
Titled: *op.5* in pencil l.l.

Opus 6, 1954-1956
Wood engraving in brown (monoprint) on Japan paper
Image: 15 x 13 in. (38.1 x 33.0 cm.)
Sheet: 19⅞ x 15¾ in. (50.5 x 40.0 cm.)
Edition: 34
Signed: *Gabo* in pencil l.r.
Titled: *op. 6* in pencil l.l.

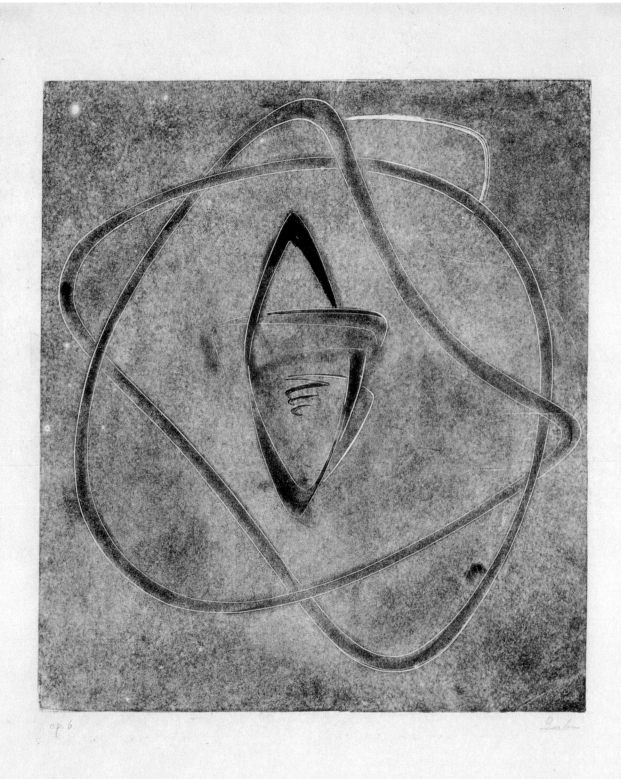

Opus 6 (cat. no. 62)

Plate XXV
Naum Gabo (Russian [active in United States], 1890-1977)
Opus 7, 1956-1973
Wood engraving in blue (monoprint) on Japan paper
Image: 8 x 10 in. (20.4 x 25.4 cm.)
Sheet: 11 x 15⅛ in. (28.0 x 38.3 cm.)
Edition: about 50
Signed: *N. Gabo* in pencil l.r.

Opus 8, 1956-1970
Wood engraving in green (monoprint) on Japan paper
Image: 12 x 9¼ in. (30.5 x 23.5 cm.)
Sheet: 19⅞ x 15⅞ in. (50.5 x 40.4 cm.)
Edition: 41
Signed: *N. Gabo* in pencil l.r.

Opus 9, 1973
Wood engraving in blue (monoprint) on Japan paper
Image: 7¾ x 9¾ in. (19.7 x 24.8 cm.)
Sheet: 15⅛ x 20⅜ in. (38.3 x 51.7 cm.)
Edition: 51; 1 artist's proof
Signed: *N. Gabo* in pencil l.r.

Opus 10, ca. 1970
Wood engraving in green (monoprint) on Japan paper
Image: 12 x 14 in. (30.5 x 35.5 cm.)
Sheet: 16⅛ x 19¼ in. (41.0 x 48.9 cm.)
Edition: 31
Signed: *N. Gabo* in pencil l.r.

Opus 11, ca. 1955
Woodcut in siena and umber (monoprint) on Japan paper
Image: 7½ in. diameter (19.2 cm. diameter)
Sheet: 9 x 12⅛ in. (22.8 x 30.7 cm.)
Edition: 32; 4 artist's proofs, 2 others
Signed: *Gabo* in pencil l.r.

Opus 12, ca. 1955
Wood engraving in blue (monoprint) on Japan paper watermarked "A la Main"
Image: 6 in. diameter (15.3 cm. diameter)
Sheet: 10⅞ x 8½ in. (27.7 x 21.6 cm.)
Edition: 25; about 7 artist's proofs
Signed: *N. Gabo* in pencil l.r.

Naum Gabo's twelve wood engravings form an integral part of his artistic production, most relating closely to his sculptures. These are characterized by a clean technological look and were often constructed from man-made materials such as transparent plastic, shaped and arranged as interpenetrating planes. The curving, tubular forms of *Opus 6* correspond closely to those of a large wall relief executed for the U. S. Rubber Company at Radio City, New York. *Opus 3* – in which the intersecting planar forms are textured by scratching, hatching, and stippling – suggests the incised surfaces of the small transparent plastic sculptures Gabo made from the 1930s onward. One of this visionary artist's primary aims was to incorporate into his work in any medium the fourth dimension of time, as expressed through rhythm and movement. The wood engraving *Opus 5* (1950) with its rotating, fin-winged forms suggests mysterious, celestial movement.

Gabo took up printmaking relatively late in his career. A Connecticut neighbor, William Ivins, the brilliant former curator of prints at the Metropolitan Museum, introduced burin and block as a diversion for the ailing artist in the winter of 1950. It is not surprising that the wood engraving medium appealed to him, for the block offers a smooth, resistant surface that the burin can incise only when guided by the controlled hand of a purposeful mind. Gabo elected to engrave images that, like his sculptures, stem from the scientifically plotted arcs and curves of an engineer or mathematician. Between 1950 and 1973 he engraved twelve blocks, which he printed at different times with many expressive variations, including color of ink. By varying the pressure as he hand-rubbed the sheet laid down on the inked blocks, Gabo picked up different densities of ink, usually on thin, receptive Japanese papers. Forms recede or advance, rotate on one or another axis, become opaque or transparent. Just as the sculptures change as one's viewpoint moves, so do the prints take on altered appearance as one shape or area is emphasized in the printing.

Although it was the artist's intention to make sets of these prints, the selection and mode of presentation was not resolved until after his death in 1977, when his widow, Miriam, and the artist Michael Mazur assembled the portfolios. Because of the many variations in printing, no uniform edition exists. This portfolio was the first to be sold and, in addition to the twelve prints, *Opus 1-12* includes nine variant proofs from six blocks, all individually selected by the Torfs.

S.W.R.

References
Naum Gabo: A Portfolio of Twelve Monoprinted Wood Engravings, introduction by Michael Mazur.
Mazur, Michael. "The Monoprints of Naum Gabo," in *Print Collector's Newsletter* 9, no. 5 (Nov.-Dec. 1978), pp. 148-151.
Read, Herbert, and Martin, Leslie. *Gabo: Constructions, Sculpture, Paintings, Drawings, Engravings.* Cambridge (Mass.) and London, 1957.

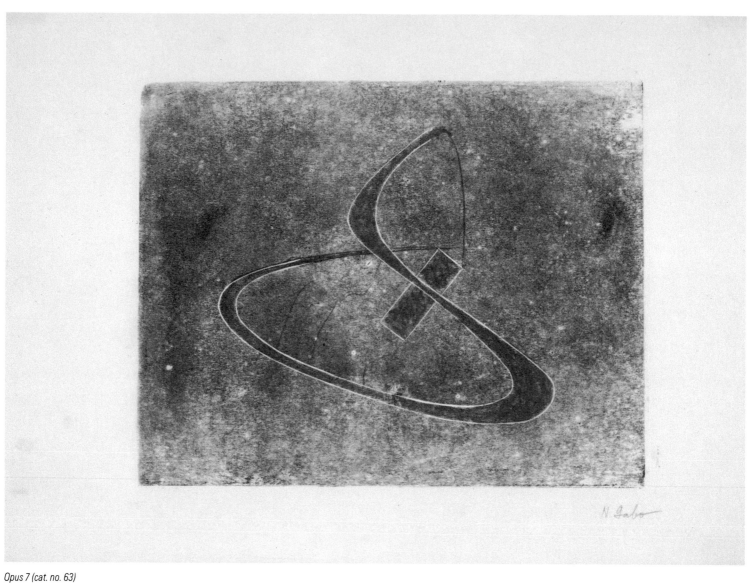

Opus 7 (cat. no. 63)

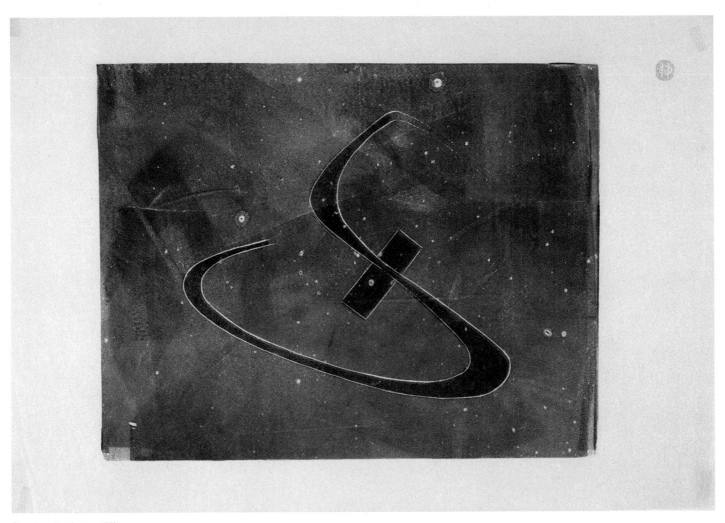

Opus 7, variant (cat. no. 76)

Plate XXVI
Dorothea Rockburne (Canadian [active in United States])
Locus Series #4, 1972-1975
Etching and aquatint (from a portfolio of 6) on Strathmore folded paper (Rag Bristol)
Image and sheet: 40 x 30 in. (102.5 x 77.2 cm.)
Edition: 42; 15 artist's proofs
Signed and dated: *Rockburne 72 32/42* in pencil
Titled: *Locus Series #4* in pencil
Printer: Jeryl Parker at Crown Point Press, Oakland
Publisher: Parasol Press, N.Y.

The Locus series contains six prints, executed from 1972 to 1975. Each sheet was first printed flat with etched lines in light gray ink, which served to determine the folding of the sheet prior to the final printing in white ink. As the sheet was then printed in white ink while folded, the actual printed surface occurs on both the "front" and "back" of the flat sheet. After printing, the sheets were then unfolded for viewing. The paper is very heavy and smooth, and the prints retain a multifaceted range of lines, angles, and impressions of varying strength obtained from the plate and previous folds, in addition to the deep texture of the ink obtained from the printing surface.

Rockburne's characteristic art of lines, folds, color, and textures involves a complex personal process of conception and execution, a process that the artist has elucidated in written statements. The following indicates her concern with measurement within the paper rectangle and the multiple interactions involved in the actual printing process:

I always do work front to back, back to front in all of my work. I am concerned with continuous surfaces...The last year of work was spent coordinating the ink, lines, and folds, so that no part has more pronouncement than the other...It's called the *Locus* series because the generating point is in the center and the spines move around that center.[1]

D.P.B.

1. The artist's statements were made on the occasion of the exhibition of the *Locus* prints at the Museum of Modern Art in 1981.

References
Olson, Robert. "An Interview with Dorothea Rockburne," in *Art in America* 66, no. 6 (Nov.-Dec. 1978), pp. 141-145.
Perrone, Jeff. "Working Through, Fold by Fold," in *Artforum* 17 (January 1979), pp. 44-50.

Plate XXVII
Sol Lewitt (American, born 1928)
Squares with a Different Line Direction in Each Half Square, 1971
Set of ten etchings on BFK Rives paper
Image: 7⅜ x 7⅜ in. (18.7 x 18.7 cm.)
Sheet: 14½ x 14½ in. (36.8 x 36.8 cm.)
Edition: 25; 7 artist's proofs
Signed: *Lewitt* in pencil l.r.
Printer: Kathan Brown at Crown Point Press, Oakland
Publisher: Parasol Press, N. Y., and Wadsworth Atheneum, Hartford

Lewitt's elementary vocabulary of forms is based on the straight line, the square, and the grid. He has given etching a new imagery – one that proclaims the purity and beauty of linear geometry – and he pursues it with a commitment reminiscent of the earlier European Constructivists and Dutch De Stijl artists.

These prints aspire to an emotional coolness and detachment that appeals primarily to the intellect. As in all Lewitts – whether sculpture, wall drawing, or print – the idea is the most essential element. The concept is usually fully formed prior to beginning the work rather than evolving during the process of execution.

Squares with a Different Line Direction in Each Half Square is one of the early serial sequences in which Lewitt shares with us all the steps in the working out of a preconceived idea or program. He establishes at the beginning a governing set of rules that ultimately determines how many combinations of the basic elements can be generated in a particular series, in this case eighteen. Nine of the images are single squares, while the tenth print is a grid composed of nine smaller squares – the nine other possible combinations. Lines may, of course, be broken or curved as well as straight, as they are here. By staying within a limited vocabulary, Lewitt challenges himself to produce a visually interesting situation with seemingly unpromising materials. Each image is precisely etched, clearly revealing the layered buildup of lines within the square.

N. G.

References

Legg, Alicia (ed.). *Sol Lewitt* (exh. cat.). Museum of Modern Art, New York, 1978.
Sol Lewitt Graphik 1970-75 (exh. cat.). Kunsthalle, Basel, 1975.

Plate XXVIII
Jasper Johns (American, born 1930)
False Start II, 1962
Lithograph from II stones on paper with watermark
"A. Millborn and Co. - British handmade"
Image: 17⅝ x 13¾ in. (44.8 x 34.9 cm.)
Sheet: 31 x 22½ in. (77.5 x 57.2 cm.)
Edition: 30; undetermined number of proofs
Signed and dated: *J. Johns '62* in blue crayon l.r., *II* in l.l.
Printer: Robert Blackburn
Publisher: Universal Limited Art Editions, West Islip, N.Y.
Reference: Field 11

In 1960, Tatyana Grosman of Universal Limited Art Editions left a lithographic stone with the painter Jasper Johns, hoping to persuade him to try his hand at printmaking. The result of this gamble has been, over the last two decades, a succession of lithographs, etchings, and silk-screens that are creative variations on Johns's paintings.

The canvas from which *False Start I* and *II* [1] derive is aggressively executed with strokes of strong color vigorously brushed onto the ground. Stenciled names of colors are intentionally mismatched: for example, "WHITE" is stenciled in red on a yellow ground. It is a visually active intellectual puzzle that teases us with its bewildering confrontation between symbol and visual reality. Concerned with the relationship between knowing and seeing, the composition is as much about the naming of colors as about the visual sensation of them.

Johns achieves a similar visual and intellectual complexity in the lithograph, matching the painterly density of the work on canvas by using eleven stones — an unusually large number. The lithograph *False Start I* was printed in bright colors; *False Start II*, from the same set of stones, was printed in a scale of grays. (It thus bears the same relationship to *False Start I* as the 1959 painting *Jubilee* [2] bears to the *False Start* painting: *Jubilee* is a gray version of the colorful *False Start*.)

Both the *False Start* paintings and prints inject a new sense of abstractness into Johns's work when compared with his more literal "representational" variations on such conventional signs and symbols as flags, targets, maps, and numbers. This loose web of strokes looks forward to the regularized mosaics of parallel hatchings in later prints such as *Scent* (cat. no. 97) or the *Usuyuki* variations (cat. nos. 98 and 99).

N.G.

1. Reproduced in Michael Crichton, *Jasper Johns* (exh. cat.), Whitney Museum of American Art, New York, 1977, pl. 51. The teasing title *False Start* derives from a racing print Johns saw in the Cedar Bar in New York and exemplifies Johns's sense of paradox.
2. Ibid., pl. 52.

References
Field, Richard S. *Jasper Johns: Prints 1960-1970* (exh. cat.). Philadephia Museum of Art, 1970.

7/30 II

89

Plate XXIX
Jasper Johns (American, born 1930)
Scent, 1975-1976
Offset lithograph, linocut, and woodcut in four
colors on Twinrocker handmade paper watermarked
"scent"
Image: 25 x 42¾ in. (63.5 x 108.6 cm.)
Sheet: 31¾ x 46¾ in. (80.7 x 118.8 cm.)
Edition: 42; 7 artist's proofs
Signed and dated: *J. Johns '75-76* in pencil l.r.
Printer: Bill Goldston and James V. Smith (offset);
Juda Rosenberg (letterpress)
Publisher: Universal Limited Art Editions, West
Islip, N.Y.
Reference: Field 208

Though it would appear to be very different
from Jasper Johns's early series of flags,
targets, and numbers, *Scent*'s bundles of
parallel markings have the same Duchampian
implications of perceptual paradox: with its
strong patterning and optically active color
contrasts, the all-over design does not lie flat
but evokes a shallow, oscillating space. First
articulated in Johns's works in the left-hand
panel of a four-panel painting of 1972 and the
lithographs known as *Four Panels from Untitled* of the same year, the hatching motif has
subsequently appeared in several paintings
and prints.

As an amplification of ideas set forth in the
1973 painting of the same name, *Scent*
presents a seemingly random mosaic of markings that is actually an intricate pattern of
visual repeats based upon a predetermined
plan. With intimations of detective stories and
hidden clues, the title of the print invites the
viewer to decipher Johns's compositional
strategy of repetitions and inversions. The
optical activity of patterns and colors function
like camouflage imposed to make the act of
deciphering more difficult. As always with
Johns, the issue here is one of problems of
perception, of the relationship of eye and
intellect.

Although it is by no means obvious at first
glance, the print consists of three vertical
panels created by means of three contrasting
graphic techniques. Upon closer scrutiny, the
viewer discovers the subtle nuances of surface
that distinguish the lithographic, linocut, and
woodcut panels separated by discreet vertical
seams. The lithographic wash has a fluid
quality that contrasts with the somewhat
harsher, flatter, and more vivid hues of the
linocut. In the third panel the fine-grained
texture of the wood veneer adds depth and
substance to the colors. Such almost subliminal variations in technique draw our attention
to the sensuous surface qualities of *Scent* and
add to the complexity of deciphering it.

N.S.

References
Field, Richard S. *Jasper Johns: Prints 1970-1977* (exh. cat.).
Wesleyan University, Middletown, Conn., 1978
Geelhaar, Christian. *Jasper Johns Working Proofs*, New York,
1980.

Plate XXX
Jennifer Bartlett (American, born 1941)
Graceland Mansions, 1978-1979
One drypoint, one aquatint, one screenprint, one
woodcut, one lithograph on J. Green paper and on
BFK Rives paper (lithograph)
Image (each): 24 x 24 in. (61.0 x 61.0 cm.)
Edition: 40; 16 proofs
Signed: *J. Bartlett* in pencil l.r.
Printer: Prawat Laucharoen (drypoint and aquatint),
Hiroshi at Simca Print Artists (screenprint), Chip
Elwell (woodcut), and Maurice Sanchez (lithograph)
Publisher: Brooke Alexander and Paula Cooper
Gallery, N.Y.

Graceland Mansions is a continuous sequence
of five separate abutted sheets in five different
print media: drypoint, aquatint, screenprint,
woodcut, and lithograph (from left to right). In
each section the same simplified cube-like
house – a primal image of a house like that in a
Monopoly game – is seen from varying angles
of vision. Nevertheless, there is a certain
symmetry in the conception: we see the
central house at eye level, its jutting corner
bisecting the whole composition and the
shadow suggesting that the sun is directly
overhead. By contrast, in the two prints at
either end, we look down at the house from
above and the shadows are cast inward
toward the center of the composition. As the
eye moves left or right over the five panels, it
seems that we move around the house, or the
house revolves. The shifting shadows in the
sequence of panels may be read as alluding to
the different times of day. (A serial Bartlett
print of 1978 involving the image of a house is
entitled *Day and Night*.)

The colors employed are consistent from
sheet to sheet but the choice of medium and
the patterns of its application vary, each of the
five sections having its own distinctive surface
texture and reflecting the light in its own way.
The drypoint lines are tightly wound into little
spirals that form dots somewhat like the dot-
like strokes in a *pointillist* painting. The
silkscreen marks are stenciled on in neat
patches resembling the composition of cork or

a terrazzo floor. The woodcut panel is an
optically active openwork grid that suggests
transparency and depth.

This ambitious print evolved out of an
eighty-part serial painting of the same title on
square enameled steel plates. It is one of a
number of Bartlett's serial paintings whose
theme is the primitive image of a house and
whose title is an address with fond associa-
tions for the artist; Graceland Mansion was
the home of singer Elvis Presley.

Jennifer Bartlett's work is, in part, a
response to the austerities of "minimal" and
conceptual art (see Sol Lewitt's series; cat.
nos. 122-131). Her use of different media
within one work is related in idea to Jasper
Johns's earlier print *Scent* (cat. no. 97), but the
way she contrasts them is not as understated.
The repertory of styles – an idea Bartlett has
developed further in recent work – reminds
one of Picasso's eclecticism in his later years
and of the restless progress many twentieth-
century artists have made through a succes-
sion of artistic styles in one lifetime.

C.S.A.

References
Jennifer Bartlett (exh. cat.). Albright-Knox Art Gallery and
Hallwalls, Buffalo.
Extensions (exh. cat.). Contemporary Arts Museum, Houston.

At Home's Louse R Hum Hoz ⁸⁴/₁₂₀

94

Plate XXXI
Richard Hamilton (British, born 1922)
In Horne's House, 1982
Etching and lift-ground aquatint
Image: 21 x 17 in. (53.3 x 43.2 cm.)
Sheet: 29⅜ x 22¼ in. (74.5 x 56.5 cm.)
Edition: 120
Signed: *R. Hamilton 36/120* in pencil l.r.
Titled: *In Horne's house* in pencil l.l.
Printer: Aldo Crommelynck
Publisher: Waddington Graphics, London

Richard Hamilton's homage to James Joyce is a valentine of thirty years gestation. In 1947, while fulfilling military service, the artist immersed himself in reading and re-reading Joyce's novel *Ulysses.* The mastery in weaving together disparate literary styles struck a responsive chord, and Hamilton set out to illustrate the masterpiece. Initially he intended to produce one etching in a different style for each chapter, but the project was never realized.

Of all the episodes in *Ulysses* "Oxen in the Sun" demonstrates most vividly the "conjunction of disparate styles" that Hamilton so admired. Thus, in 1980, when, on the eve of Joyce's centenary, Hamilton began to think again about illustrating Leopold Bloom's eighteen-hour odyssey through Dublin, the segment of that chapter recounting the drunken carousal in Arthur Horne's maternity hospital came naturally to mind.

In the course of relating the pedestrian events whereby Bloom checks on the accouchement of a Mrs. Mina Purefoy, is waylaid by a medical student, and coaxed into joining a rowdy drinking party, Joyce analogizes the birth of a child to the birth of language. Beginning with confused babytalk, the author parodies the evolution of the English language, from Anglo-Saxon through Shakespeare up to Dickens, and concludes with current slang. The episode ends in disordered chatter – a pointed comment on "the collapse of the old patterns of culture and the decay of literature begun in the nineteenth century and accelerated in the twentieth" (Blamires, *The Bloomsday Book*, p. 162).

The original 1949 study for *In Horne's House* was a paraphrase of Cubism, which Hamilton called in retrospect "an unworthy

solution" as compared with the dauntless ambition of Joyce's pyrotechnics. "A pastiche of different historic styles of art is clearly more appropriate for the birth episode" (Hamilton, *Collected Words*, p. 109.) No doubt, Joyce would have been pleased with Hamilton's solution, combining as it does straightforward allusions to past art with multilevel correspondences. Hamilton situates the viewer in a room in the lying-in hospital, where the medical students, Stephen Dedalus, and Leopold Bloom have gathered to drink and make lewd banter. The chief action focuses on Punch Costello, one of the young doctors, who pounds his fist on the table while striking up a bawdy song. The noise summons nurse Quigley, who angrily demands quiet (Joyce, *Ulysses*, p. 392). The nun seems to stand also for Sister Callan, another nurse who appeared in the doorway earlier and also begged for restraint from the roisterers. Certainly the younger and sweeter Sister Callan is more like Hamilton's source – Giovanni Bellini's *Madonna and Child* in Bergamo from 1460-1464 – than the "ancient" Quigley.

The figure of Punch Costello, like that of Nurse Quigley/Callan, also accommodates another identity. It seems to stand for Stephen Dedalus delivering his blasphemous diatribe a few paragraphs further on (*Ulysses*, p. 394). Costello is described as "ugly and misshapen," while Dedalus is a heroic figure – admittedly a flawed one – more in keeping with Hamilton's artistic source: the fist-pounder is lifted from Baron Gros's *Napoleon at Arcole* (1801 Salon, Musée du Louvre), not from Jacques-Louis David, as Hamilton states (*Collected Words,* p. 109). On the opposite side of the table sits the Cézannesque Leopold Bloom. He pours a beer, referring to the passage later on in the text in which he helps the medical student Lenehan to a bottle of Bass. This moment in the narrative is one of increasing diffusion, a perfect place for Hamilton to introduce the Cubist-style still life on the table. Its inclusion is even wittier since Braque's Cubist still life *Bass* of 1911 (see cat. no. 28) refers to precisely the same brand of ale: "…number one Bass bottled by Messrs. Bass and Co. at Burton on Trent" (*Ulysses*, p. 417).

Hamilton, known for his scrupulousness as a printmaker, comments: "…a *tour de force* of

lift-ground etching, the composition was elaborated with carefully timed acid bites applied to the plate by brush and swab rather than by immersion in a bath. There is some stipple and line etching and a little tidying up with a burin" (*Collected Words*, p. 109).

<div align="right">D.M.</div>

References
Blamires, Harry. *The Bloomsday Book: A Guide through Joyce's Ulysses.* Methuen, London, and New York, 1966.
Hamilton, Richard. *Collected Words, 1953-1982.* London, 1982.
Joyce, James. *Ulysses.* New York, 1914.

Plate XXXII
Robert Rauschenberg (American, born 1925)
Scrape, from *Hoarfrost Editions*, 1974
Transfers from offset lithographs, silkscreened images and newspaper images, and collage of paper bag and fabric on China silk and silk chiffon
Image: 75⅝ x 35½ in. (192.0 x 90.2 cm.)
Edition: 32
Signed and dated: *R. Rauschenberg 22/32 '74* in pencil l.r.
Printer: Gemini G.E.L., Los Angeles
Publisher: Gemini G.E.L., Los Angeles

Scrape is printed not on paper but on cloth. It is not intended to hang flat, for it has machine-stitched holes at the top so that it can billow like a curtain. What is perceived as the surface of the print consists, in fact, of three lengths of different fabrics (two of them translucent), to which Rauschenberg has transferred directly offset lithographs, silkscreened images, or newspaper and magazine images that he found rather than invented.

In these respects, *Scrape* violates the traditional canons of printmaking as decisively as the composer John Cage, a close friend of Rauschenberg, breaks with traditional music – using, for example, a piano prepared in advance to produce a new vocabulary of percussive sound. However, whereas Cage limited himself to only two of the components of music – the duration of sounds and silences between them – Rauschenberg, in contrast, used various components of printmaking – color, imagery, and surface – and, in this instance, added another element: the third dimension.

Each length of cloth has its own basic color and its own images, some of which are made ambiguous by being printed backwards, upside-down, or both, or through being partly obscured by the transparent fabric over them. Rauschenberg once defended the diversity of unrelated objects found in his "combine-paintings" by the assertion that they gave his canvases a reality equivalent to life. As in his "combine-paintings," the choice of images cannot be logically justified. Reading from the top to bottom, there are paper bags from which spill pink scallop shells; comic strips (*Blondie, Beetle Bailey*, and *In the Days of King Arthur*); a small plane printed in blue and greens; blue gulls; what seems to be an altar frieze printed upside-down in yellow-gray and green; a red, white, and green fried egg; and finally images of gulls, of beach grass, and of fishing.

Rauschenberg has defended the diversity of unrelated objects found in his "combine-paintings" by the assertion that he integrates the random objects of living into his canvases in order to give them a reality equivalent to life.

E.A.S.

References
Tomkins, Calvin. *Off the Wall: Robert Rauschenberg and the Art World of Our Time*. New York, 1980.
Rauschenberg Exhibitions. Galerie Ileana Sonnabend (exh. cat.). Paris, February, 1963.

Plate XXXIII
Cy Twombly (American, born 1929)
Plates VI, VII, VIII, and X from *Natural History Part I: Mushrooms*, 1974
Color lithographs hand-printed with additional grano lithography, collotype, and photochrome; elements hand-collaged and elements drawn with painting chalk and crayon (from a portfolio of 10) on Rives Couronne paper
Image and sheet: 30 x 22 in. (76.0 x 55.9 cm.)
Edition: 98; 17 artist's proofs, 1 other
Signed: *C.T.* in pencil l.r.
Printer: Mathieu Litho, Zurich
Publisher: Propyläen Verlag, Berlin

The suite of lithographs from which these images derive is unusual in Cy Twombly's *oeuvre* for several reasons: in the first place, the collaged and representational imagery is a counterpoint to his calligraphic abstraction; second, the technological *tour de force* that the prints represent is unlike the spontaneous directness manifest in his paintings and prints both before and after the *Natural History* series was produced. Perhaps the most plausible explanation of these contradictions is to be found quite simply in Twombly's association with Robert Rauschenberg. Twombly had made prints in Rauschenberg's studio on Captiva Island in Florida, and Rauschenberg, as the American master of lithography and graphic invention, is likely to have interested Twombly in its subtleties and in the potential of collage and pictorial juxtaposition.

At first glance, it is difficult to determine whether the photographic images that grace the surface of the sheet are collaged or printed. The *trompe l'oeil* effect becomes a major feature of the work, as the dynamic between the printed and hand-drawn images is played over and over: scotch tape that is printed and real tape that is collaged; photographs that are printed and photographs that are pasted or taped to the surface; the characteristic nervous energy of marks that are drawn directly with chalk on paper and those that are printed from stone.

As always with Twombly's work, the intriguing questions of symbolic content, the mechanics of writing, and the process of making are disingenuously posed. His choice of mushrooms as a subject, for example, is both self-referential (it reflects a personal fancy) and a historical footnote: it seems that mushrooms, thanks to John Cage, have become the passion fruit of the post Abstract Expressionists. But most important, Twombly delights in playing at the edge of extreme sophistication by indulging a propensity for exaggerated childlike scribblings that have the character of being tightly controlled despite their lyrical vitality. These prints can be seen, then, as both a paradigm and a parody of his work as an artist. On the one hand, they display the essential structural characteristics of his drawings and paintings; on the other hand, the very fact of their almost impossible technical

virtuosity caricatures the style of making that Twombly has adopted as his own – a style that challenges style by posing as its opposite.

T.K.

Plate XXXIV
James Rosenquist (American, born 1933)
Chambers, 1980
Color lithograph on Twinrocker paper with watermark: artist's signature and "ULAE"
Image: 24 x 40 in. (61.0 x 101.7 cm.)
Sheet: 30 x 56 in. (76.2 x 142.3 cm.)
Edition: 45
Signed and dated: *James Rosenquist 1980* in pencil l.r.
Titled: *Chambers* in pencil l.l.
Printer: Keith Brintzenhofe, Thomas Cox, Bill Goldston, and James Smith
Publisher: Universal Limited Art Editions, West Islip, N.Y.

Many of James Rosenquist's ideas for canvases were stimulated by his early experiences as a billboard painter, working up close on enormous advertising images executed in a slick commercial illustration style. Like the sign painter who can see only one section, one enormous detail at a time, Rosenquist juxtaposes intuitively selected fragments of reality in startling new relationships. These magnified details of images from consumer culture, usually executed in a personal paraphrase of the styles of commercial advertising illustration, are often magnified to the point that they are not immediately recognizable in their new context.

Rosenquist's prints are often creative variations on his paintings or details from them. The recent lithograph *Chambers* (like the painting of the same title) refers to his move to a new studio on Chambers Street in New York. The print's private metaphors appear to revolve around a sense of new beginnings, of doors opening. In the upper left corner, an asbestos-gloved hand holds a panel with a soot painting in progress – a pearly image made with acetylene torch or candle flame. To the right of center is an outsize razor blade; the act of shaving is the beginning of the artist' day. The partially transparent blade – non-threateningly frontal rather than edge to – has a gleaming doorknob that invites us to open it and see what lies beyond. Its shape is echoed by another rectangle suggesting a falling door panel seen in perspective.

The classical columns at the center suggest the architecture of the courthouse on Chambers Street. Knowledge of the artist's private associations with the imagery should not, however, limit the viewer's imagination; an air of mystery or enigma, of a poetic image half-grasped, is an important aspect of the lithograph's mood.

Chambers was printed at ULAE, where Rosenquist first began working in lithography in 1964 and 1965. Like many of his color lithographs, it is executed, in part, with the spatter technique employed by the painters and poster artists Jules Chéret and Toulouse-Lautrec in their lithographs from the late nineteenth century. Rosenquist used not only the traditional spatter technique with a stiff-bristled brush but the compressed air spray of

the modern airbrush. Both methods transfer the lithographic wash to the surface of stones or plates in open clouds of atom-like flecks of pigment. The sleek continuous gradations of tone thus produced evoke the continuous tones of photography or of advertising art made with an airbrush.

N.G.

References
Tucker, Marcia. *James Rosenquist* (exh. cat.). Whitney Museum of American Art, New York, 1972.
James Rosenquist (exh. cat.). Kunsthalle, Cologne, 1972.
James Rosenquist (exh. cat.). National Gallery of Canada, Ottawa, 1968.

Plate XXXV
Vito Acconci (American, born 1940)
Three Flags for One Space and Six Regions, 1979-1981
Color photoetching with aquatint on BFK Rives paper
Image 23½ x 30⅞ in. (59.7 x 78.4 cm.)
Sheet: 70½ x 61¾ in. (179.1 x 156.8 cm.)
Edition: 25; 10 artist's proofs
Signed and dated: *Vito Acconci 1981* in pencil l.r.
Printer: Nancy Anello
Publisher: Crown Point Press, Oakland

Born in Brooklyn and raised in Catholic schools, Acconci attended Holy Cross in Worcester and received his master's degree from the Writers' Workshop at the University of Iowa. His career as a poet came to be overshadowed by his need for a more explicit form of communication. In the early performance pieces of the 1960s, he literally incorporated himself into the work, whether by biting his own flesh or burning his chest hairs or leaping off a chair. The audience's reaction was here an essential element of the performance. For later works such as the *Project for Pier 17* (1971), he stayed at the end of the deserted Pier 17 warehouse every night for a month. People were encouraged to go there between 1 and 2 a.m. to listen to him tell a secret, giving them something "on" him and bringing them directly into his space.

From this point on, Acconci he developed more technically advanced works that employed tapes of his voice and often video film. He thus removed himself from the viewer's space while retaining clear control, allowing the viewer to react without inhibitions. In such situations we are one step removed from an actual confrontation, although as viewers we are still an essential part of the work.

In the late '70s Acconci's style underwent another change. His pieces from this time were very sophisticated, finished sculptural installations for which, again, audience participation was crucial. One such work is *Instant House* (1978), consisting of four interior house walls – on which the image of the American flag is painted – lying flat on the floor. At the center hangs a child's swing, which, when sat upon, raises the four walls to enclose the swing and to expose the exterior wall, on which the Soviet flag is painted.

The foregoing piece is related in imagery to the photoetching *Three Flags for One Space and Six Regions*. It consists of three overlapping flags printed on six sheets; at the lowest layer is the Russian standard with only the hammer and sickle barely perceptible through the overlappings of the Chinese and the American. The translucent mesh of the rippled fabric gives a literal presence to the actual-size, photoetched flags printed from flag-shaped plates. The only barrier Acconci erects here between spectator and illusion is his division of the image into six separately framed pieces of equal size that fit together to form the whole, creating a gridlike effect.

N.G.

References
Diacono, Mario. *Vito Acconci*, New York, 1975.
Vito Acconci: A Retrospective (exh. cat.). Chicago Museum of Contemporary Art, 1980.

Plate XXXVI
Claes Oldenburg (American, born [in Sweden]1929)
Double Screwarch Bridge, States II and III, 1980-1981
Etching and aquatint from five plates (state III with monotype additions)
Image (each): 23½ x 50⅝ in. (59.7 x 128.6 cm.)
Sheet (each): 31½ x 58 in. (80.0 x 147.4 cm.)
Edition: State II, 35; state III, 25
Signed and dated: *Oldenburg 81* in pencil l.r. (state III)
Printer: Patricia Branstead at Aeropress
Publisher: Multiples/Goodman, N. Y.

Oldenburg has kept daily "notebooks" of sketches and ideas since his childhood, and in recent years has explored extensively the mutability and monumentality of everyday objects. "Soft" sculpture ranks as one of his most important visual innovations, and he has advanced numerous proposals for colossal public monuments and constructions formulated from such commonplace objects as a baseball bat, a lipstick tube, a three-way electrical plug, an umbrella, and a screw.

The first version of a colossal screw proposal was a moving sculpture that would constantly be raised and lowered in the ground. In 1975, a soft screw sculpture was cast in urethane, and the idea of an arched screw of monumental size was explored in sketches and a lithograph (*Arch in the Form of a Screw for Times Square, New York City*).

In connection with plans for a new bridge over the New Maas river in Rotterdam, Oldenburg was commissioned in 1978 by the Museum Boymans-van Beuningen to develop his own alternative ideas for a bridge. Joining two bent screws together, he arrived at a double suspension bridge, as depicted in a bronze model and in this print. Three states of the *Double Screwarch* print were published during 1980-1981, the first being a pure line etching of the bridge without landscape setting.

The two later states of the print are mature examples of Oldenburg's draftsmanship and his increased involvement with the printmaking process, which probably resulted from his study of old master prints, expecially those of Rembrandt and Hercules Segers. Each impression was made from five copper plates worked in the processes of spitbite, aquatint, hardground etching, and sanding; the plates were hand-wiped before printing. State II is printed solely in black; state III is printed in colors and, in addition, the artist monotype-inked the plate before printing each impression, adding sitespecific details such as cars and boats in the bustling harbor. In a few proofs outside the edition, Oldenburg experimented with different settings, ranging from a desert to the American Great Lakes. Despite the challenge to serious expectations presented by a bridge

formed from a soft screw, the wit and monumentality of these proposals are undeniable.

D.P.B.

References
Goldman, Judith. *American Prints: Process & Proofs* (exh. cat.). Whitney Museum of American Art, New York, 1981, pp. 124-129 (repr.).
van Bruggen, Coosje; Oldenburg, Claes; and Fuchs, R. H. *Oldenburg: Large-Scale Projects, 1977-1980.* New York, 1980, pp. 44-49 (state I repr. p. 48).

Plate XXXVII
Andy Warhol (American, born 1928)
Marilyn (from a set of ten), 1967
Screenprint in black, silver, and gray on wove paper
Image and sheet: 36 x 36⅛ in. (91.4 x 91.7 cm.)
Edition: 200; 26 artist's proofs
Signed: *Andy Warhol* in pencil on verso
Printer: Aetna Silkscreen Products Inc./Du-Art
Displays
Publisher: Factory Additions, N.Y.
Reference: Wünsche 7

As a successful commercial artist during the 1950s and early '60s – designing advertisements for Tiffany's and Bergdorf Goodman – Andy Warhol was unusually aware of the consumer-oriented values of our culture. In an era of processed food, prepackaged goods, and mass-media "hype," he found the imagery of his art on supermarket shelves and in newspaper headlines. Using objects from daily life such as the Campbell's soup can, the Coca-Cola bottle, and the dollar bill, Warhol picked up where Marcel Duchamp (with iconoclastic found sculptures and "readymades") had left off. Rather than questioning the validity of art through real objects as Duchamp did, Warhol satirized public taste in his translations of images into paintings and silkscreen prints. Holding up a mirror to consumer society, he created a new iconography for our age.

In addition to depicting objects that now – twenty years later – have become emblems of "Pop" culture, Warhol reproduced disasters from the front pages of the *Daily News* and made portraits of celebrities. True to our mass-media age, he used photographic images and transformed them by the garish colors of his day-glo palette and by off-register or intentionally careless printing.

The chill of Warhol's vision is most evident in his portraits of Marilyn Monroe – an image he treated several times after the star's death in 1962. Her legendary smile is repeated in silkscreen on canvas in multiples of two, six, and ten; her face is floated on a gold ground like a Byzantine icon; and more radically, her lips are screened 168 times on 49 square feet of canvas.

Marilyn is seen here in a black, gray, and silver version from a set of ten silkscreen print variations. These repeated images call attention to the proliferation of mass-produced goods in our society and to the tragic fact that people have also become commodities. Photography and processed photomechanical images from the popular press and the commercial advertising medium of silkscreen are the perfect techniques for Warhol's unsettling message.

N.S.

References
Wünsche, Hermann. *Andy Warhol, Das Graphische Werk, 1962-1980.* Bonn, 1981.
Gablik, Suzi. "Andy Warhol," in *Andy Warhol: Portrait Screenprints, 1965-1980.* Arts Council of Great Britain, 1981.
Rosenblum, Robert. "Andy Warhol: Court Painter to the 70s," *Andy Warhol: Portraits of the 70's* (exh. cat.). Whitney Museum of American Art, New York, 1980.

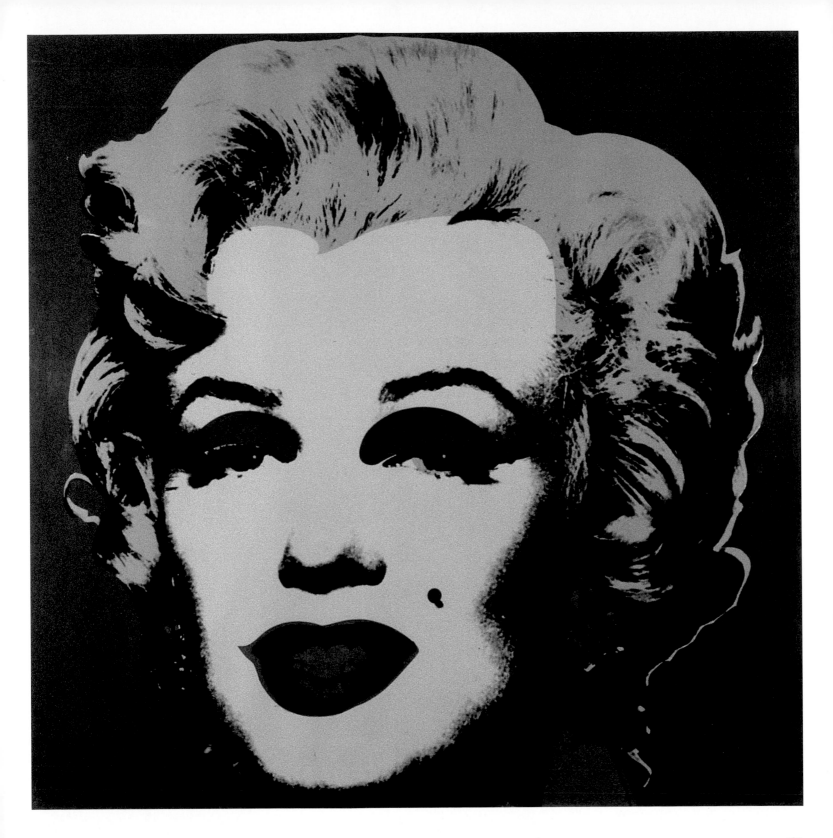

Plate XXXVIII
Roy Lichtenstein (American, born 1923)
Reclining Nude, 1980
Four-color woodcut with embossing on Arches
cover paper
Image: 28½ x 33⅝ in. (71.7 x 85.2 cm.)
Sheet: 35⅛ x 40⅜ in. (89.2 x 102.5 cm.)
Edition: 50; 13 artist's proofs, 12 others
Signed and dated: *rf Lichtenstein '80* in pencil l.r.
Printer: Anthony Zepeda, James Reid, Martin Klein,
Richard Garst, and Larry Krueger (Gemini G.E.L.), Los
Angeles
Publisher: Gemini G.E.L., Los Angeles

During the 1960s, when Abstract Expression-ism had achieved wide public acceptance in America, Roy Lichtenstein elected to challenge the existing movement. By depicting trivial subject matter derived from the commercial media without a trace of painterly brushwork, Lichtenstein negated the aesthetic theories of the preceding generation and declared his artistic independence. His early attachment to the comic strip frame – composed of simplified lines, form, and color – was perfectly suited to these new investigations. The enlargement of details within bold outlines, a dramatic crop-ping of images, a limited range of color, and especially the distinctive use of benday dots (the screen pattern used in commercial repro-duction) – all became trademarks of Lichten-stein's idiosyncratic style. This transformation of a popular American idiom into fine art helped to define a new stylistic classification called Pop Art.

In his early work as a printmaker, Lichten-stein had used woodcut, etching, and lithogra-phy in a traditional manner. When he intro-duced commercial graphic effects into his paintings, he temporarily stopped making prints. Confronted with the problem of how to combine a new-found "graphic" style with conventional printmaking techniques without becoming merely a comic strip illustrator, Lichtenstein settled eventually upon offset lithography and silkscreen as appropriate tech-niques: both could achieve the hard mechani-cal surfaces, the clean outlines, and intense hues that he found aesthetically pleasing. In addition, both media involved collaboration with professional printers, who could neatly execute a print under his direction but with the notable absence of the artist's "hand."

Lichtenstein's interest in Expressionist sub-ject matter first appeared in his 1950s pre-Pop American Indian woodcuts, a theme he read-dressed during 1979 and 1980. Ultimately, however, it is the paintings and woodcuts of the German Expressionist artists who worked between 1906 and 1920 that served as the source for his explorations.

Reclining Nude is one of a group of seven "German Expressionist" woodcuts printed and published by the Gemini workshop. As a group, the images reflect subjects common to German Expressionism – portrait heads and nudes – although Lichtenstein conveys the emotional content in a contemporary manner, giving it a sleek, impersonal character. The exaggerat-edly sharp angles, jagged fragments, and overdramatized gestures and expresssions add an ironic twist to the splintered images of earlier German examples. Only an occasional glimpse of the close-grained surface with its embossed patches suggests the medium that is the oldest printmaking technique.

In these woodcuts Lichtenstein did not employ the customary benday dots, but used irregular contour lines and parallel stripes that define block-like unworked areas. The colors in *Reclining Nude* – beige, cadmium yellow, blue, and black, with the key block in blue - represent a new palette, and the optical mixture suggests a further range of olive greens and purples.

B.S.S.

References
Cowart, Jack. *Roy Lichtenstein 1970-1980*. New York, 1981.
The Graphic Art of Roy Lichtenstein (exh. cat.). Fogg Art Museum, Cambridge, 1975.
Waldman, Diane. *Roy Lichtenstein*. Solomon R. Guggenheim Museum, New York, 1970.

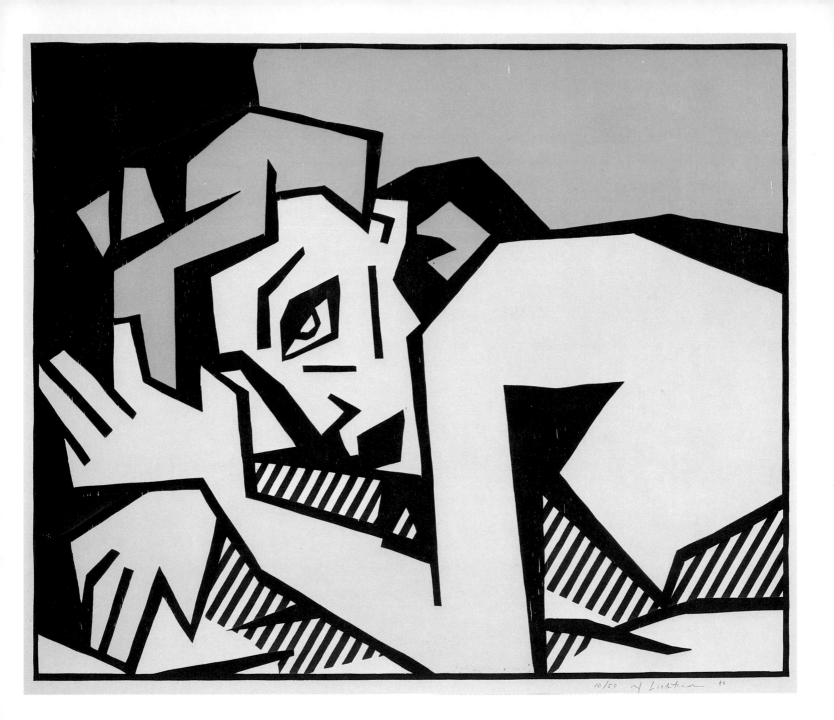

10/50 rf Lichtenstein 80

Plate XXXIX
David Hockney (British, born 1937)
Celia, 1972-1973
Lithograph (crayon and tusche) from one stone on
Angoumois buff handmade paper
Image: 22⅛ x 15¹⁄₁₆ in. (56.2 x 38.2 cm.)
Sheet: 42 x 28 in. (108.0 x 71.0 cm.)
Edition: 52; 6 artist's proofs, 8 others
Signed: *David Hockney 72* in green crayon l.r.
Titled: *Celia* in green crayon l.r.
Printer: Serge Lozingot
Publisher: Gemini G.E.L., Los Angeles
Reference: Scottish Arts Council 148

David Hockney grew up in the working-class city of Bradford in the north of England, where he struggled to create for himself an environment conducive to art. He attended the local grammar school and then, at sixteen, entered the Bradford School of Art. In 1954, he made his first recorded print – a self-portrait lithograph. Two years after graduation in 1957, Hockney enrolled at the Royal College of Art in London and started etching because, in his words, "I'd run out of money and I couldn't buy any paint, and in the graphic department they gave you the material free."

At the RCA Hockney soon became friends with the American painter R.B. Kitaj, who encouraged him to use his own interests as the subject matter of his art; thus, he began to depict the people, places, and objects that appealed to him, often incorporating literary references into his paintings. All of his portraits, with the exception of one commissioned painting, are close friends or family members with whom he enjoys a loving relationship.

In January of 1973, Hockney made one of his many trips to California and worked at the Gemini studio on a group of lithographs. *Celia* is a portrait of Hockney's good friend Celia Birtwell, a textile designer and wife of another familiar sitter, Ossie Clark. This is one of three "Celias" executed by Hockney and proofed by the master printer Ken Tyler, who worked with the artist on many of his lithographs. Celia is seated in a classically modern chair by Marcel Breuer, a favorite Hockney prop. Despite the soft repeated contour lines, she appears as a detached "cutout" applied to the buff sheet. Crayon – used both with great precision and with calligraphic freedom – is combined with a thin wash of lithographic tusche that weightlessly describes her simple dress. In this print, Hockney has looked back toward the nineteenth century not only in his use of traditional techniques but also in his desire to capture with elegance and sensitivity the personality of one of his favorite sitters.

B.S.S.

References
Stangos, Nikos, ed. *David Hockney by David Hockney*. New York, 1977.
David Hockney Prints 1954-77, Midland Group with the Scottish Arts Council and Petersburg Press, 1979.
David Hockney: Prints and Drawings. Introduction by Gene Baro, Washington, D.C., 1978-1980.

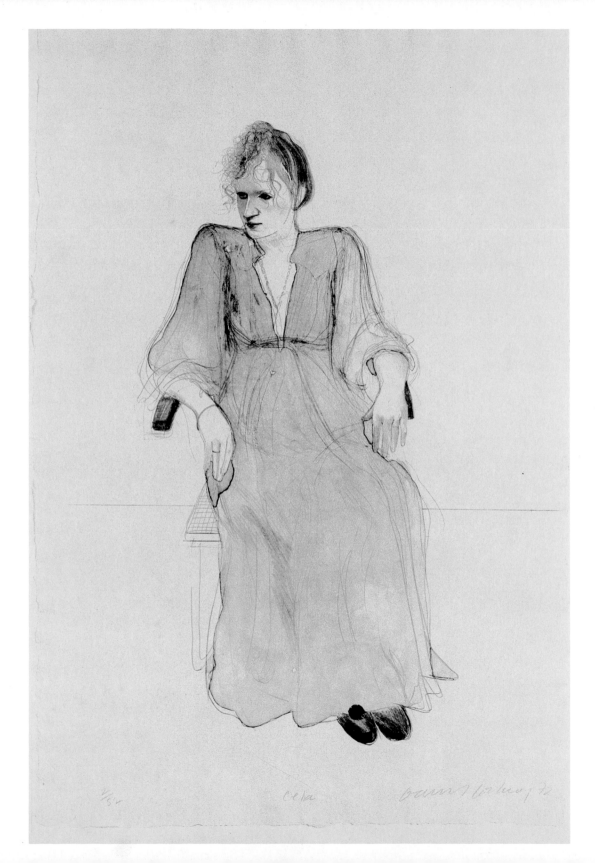

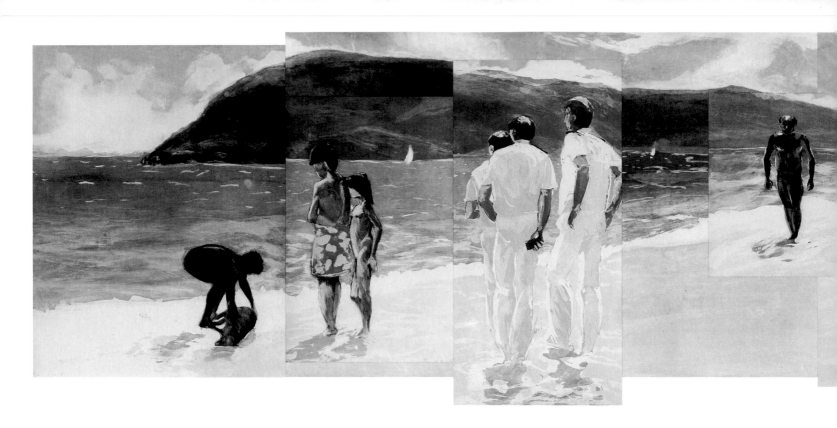

Plate XL
Eric Fischl (American, born 1948)
Year of the Drowned Dog, 1983
Aquatint, softground, drypoint, and scraping from a
portfolio of 6 on Zerkall paper
Image: a) 22½ x 34¾ in. (56.3 x 86.9 cm.)
 b) 22 x 16¾ in. (55 x 41.9 cm.)
 c) 17½ x 11¼ in. (43.8 x 28.1 cm.)
 d) 22¾ x 11¼ in. (56.9 x 28.1 cm.)
 e) 12½ x 9¾ in. (31.3 x 24.4 cm.)
 f) 23 x 19¼ in. (57.5 x 48.1 cm.)
Edition: 35; 10 artist's proofs
Printer: Peter Kneubühler, Zurich
Publisher: Peter Blum Edition, N.Y.

Eric Fischl invests his suburban narratives with a sense of menacing psychological urgency that dramatizes the disparity between the idealized media image and the reality. Using motifs that he has either experienced or taken from the mass media, he describes the disintegration of confidence in a lifestyle predicated on order and comfort. Behind the "happy housewife," the "girl-next-door," and the "young executive" is a lonely woman, an awkward teenager, and an insecure man.

Fischl imbues the visual clichés of our advertising culture — beach resorts, baseball games, clothing stores — with an aura of disquiet. His scenes are fragments wrenched from a larger narrative whole and thereby provoke the viewer to complete the story. Because so many of the situations depicted are uncomfortably private, we feel that we are intruders: for example, in the painting *Bad Boy* of 1981 (private collection), a teenaged boy reaches stealthily into a purse while in front of him, on the bed, lies a nude woman (possibly his mother) unaware of his presence.[1] In another work, *Inside Out* (collection of Elaine and Werner Dannheisser, N.Y.) we see a couple making love in front of a home-video camera; the man is preoccupied with his own Beta-Maxed image.

It is not only the content of these scenes that conveys a disturbing impression. Through minor shifts in scale, unusual perspectives, and compressed spaces, Fischl upsets the equilibrium of standard realist depictions. In *Year of the Drowned Dog*, a composite work consisting of six colored etchings, he stresses the physical as well as psychological distance between people gathered on a public beach.

The separate panels — each containing a landscape segment or figural anecdote — may, if the owner chooses, be fitted together to form one continuous overlapping image. The juxtaposition of figures and landscape and the time of day are, however, not perfectly synchronized, implying that something is amiss. Though more reticent than previous work, this radiant, sundrenched coastal view with its rather acid *National Geographic* colors has at its heart a grim subject. A drowned dog is observed by three small figures for whom this is a tragic event. One of them crouches over the dead animal and touches it. Their dark skins, their tropical or "primitive" clothing, and their concern for the dead animal suggest that they are natural inhabitants of this tropical paradise. In contrast, the bathers at the right and the naval personnel in their white clothing — all apparently detached observers or indifferent to the death of the dog — seem to be outsiders. As the artist has said: "Dreadful things often occur in beautiful light, which makes the event more intolerable."

N.S.

1. Reproduced in *Arts*, September 1981, pp. 88-91.

References
Tatransky, V. "Fischl, Lawson, Robinson, and Zwack: They Make Pictures," in *Arts* 55, no. 10 (June 1981), pp. 147-149.
Yau, John. "How We Live: The Paintings of Robert Birmelin, Eric Fischl, and Ed Paschke," in *Artforum* 21, no. 8 (April 1983).

Plate XLI
Jim Dine (American, born 1935)
Winter Windows on Chapel Street, 1982
Four etchings on heavy wove Arches paper
Image: 22 x 19 in. (55.9 x 48.3 cm.)
Sheet: 50 x 43 in. (127.0 x 109.2 cm.)
Edition: 40; 10 artist's proofs
Signed and dated: *Jim Dine 1982* in pencil l.r.
Printer: Nigel Oxley at Kelpra Studio, London
Publisher: Pace Editions, N. Y., and Waddington
Graphics, London

In *Winter Windows on Chapel Street* Jim Dine returns once more to the heart motif, an image that, since the early 1960s, he has painted, sculpted, drawn, lithographed, etched, and silkscreened. The stylized sign that stands for the human heart provides him simultaneously with an opportunity to explore abstract form and with an instant symbol of romantic sentiment. The heart refers broadly to human feelings and, more specifically, to his wife, Nancy.

During the past twenty years Dine's graphic work – an area of artistic activity in which he particularly excels – has been extensive and varied. Often combining a variety of techniques, he creates from a simple motif a complex and texturally rich image. Many of the prints depict almost banal objects, but – unlike the cool, ironic detachment of most Pop Art – they are usually presented in a highly personal, expressive manner: neckties, bathrobes, palettes, tools, and paintbrushes stand in for the artist's own image. Dine reveals his romantic tendencies by charging such simple motifs with symbolic or literary content, many of his works paying homage to writers such as Wilde, Flaubert, and Rimbaud. An artistic debt to Picabia is evident not only in the lithographic series bearing the Dadaist's name, but in all of Dine's works that incongruously juxtapose word and image.

In the recent prints *Winter Windows on Chapel Street*, *A Heart on Rue de Grenelle*, and *The Heart Called Paris Spring* Dine's hearts each evoke different moods, places, or seasons. The four individual sheets that compose *Winter Windows* – each containing one large white heart on a black field – suggest the separate panes of a window. The puddled fluid forms of the hearts resemble a coating of winter frost through which the night sky is visible.

N.S.

References
Castleman, Riva. "Jim Dine's Prints," in *Jim Dine Prints 1970-1977* (exh. cat.). Williams College Museum of Art, 1977.
Shapiro, David. *Jim Dine: Painting What One Is*. New York, 1981.

Plate XLII
Kenneth Noland (American, born 1924)
Handmade Paper: Horizontal Stripes Series III, 1978
Cast paper pulp, dyes, bits of fabric
Sheet: 49⅝ x 33 in. (126.0 x 83.8 cm.)
Edition: unique
Signed and dated: *Noland '78* in pencil l.r.
Printer: Kenneth Tyler and Lindsay Green with the artist
Publisher: Tyler Graphics, Bedford Village, N.Y.

Kenneth Noland's paintings are usually in a precise, geometric format with color that is optically active, constantly shifting its spatial position in the eyes of the viewer. His feeling for composition in color is, in part, an outgrowth of his time spent at Black Mountain College in North Carolina, between 1946 and 1948. There he studied with Josef Albers, who taught Bauhaus color theory, concentrating on the optical interaction of colors. He also had classes with Ilya Bolotowsky, a follower of Mondrian.

During the next decade Noland began to use acrylic-based paint to stain color into the very fabric of the raw canvas. (This method, like the handmade paper pieces of the 1970s, did not allow for reworking.) In the late 1960s came the first horizontal stripe paintings in which color was more than ever the essential element of the piece. The cast paper pulp *Horizontal Stripe* series of 1978, derived in format from the acrylics, is composed of unique color variants combining a variety of ways of working with the raw material. Besides using pulp that had been pre-dyed to his specifications, Noland painted with liquid dyes, staining the still-wet pulp, and dropped confetti-like bits of found colored fabric into the mixture as it set. These horizontal fields of color – mostly earth tones – are layers that have fused together, resulting in a thickly textured sheet. The new process offers the opportunity to experiment with new color and textural relationships and a looser, more painterly manner of execution than is the case in Noland's precise, carefully planned canvases.

N.G.

References
Moffett, Kenworth. *Kenneth Noland*. New York, 1977.

Plate XLIII
Robert Motherwell (American, born 1915)
Red Open with White Line, 1979
Aquatint in red from one copperplate and etching in black from one copperplate on Hawthorne of Larroque handmade paper, watermarked with the artist's initials.
Image: 19 x 36 in. (48.7 x 91.4 cm.)
Sheet: 18 x 36 in. (45.7 x 91.4 cm.)
Edition: 56; 10 artist's proofs, 7 others
Signed: *R.M.* in ink
Printer: Catherine Mousley
Publisher: distributed by Brooke Alexander, N.Y.
Reference: Belknap 207

Robert Motherwell's earliest experiments in the graphic arts reflect an abiding interest in the expressive potential of black and white. His involvement with printmaking began in 1943 at Stanley William Hayter's Atelier 17, but it continued only sporadically until 1965, when he worked in collaboration with the printer Irwin Hollander. *Automatism A* (cat. no. 156) from this productive period exploits the fluid properties of lithographic wash. Forceful brushstrokes and gestural splashes evoke the same sense of spontaneity and chance occurrence so crucial to many of his Abstract Expressionist canvases.

In marked contrast to these aggressively gestural works, *Red Open with White Line* is a luminous field of color interrupted only by the subtle etched rectangle that hangs trapeze-like from the print's upper edge. Deeply bitten aquatint printed on the rough-textured surface of handmade paper results in intense saturation of hue and a richly modulated field of color. The minimalist restraint and classical serenity of the image derive from Motherwell's "Open" series of paintings begun in 1967. The print *Red Open with White Line* grew more specifically out of his aquatint illustrations to the Spanish poet Rafael Alberti's poem about painting *A la Pintura*, published in 1972.

The rectangle within a rectangle, the recurrent theme of the "Opens," suggests a window in a wall. There is an expansive quality to the field of red color, which bleeds to the edge in three directions, arrested only by the white margin of paper at the left (the "white line" of the title).

N.S.

References

Terenzio, Stephanie. *The Painter and the Printer, Robert Motherell's Graphics 1943-80* (catalogue raisonné by Dorothy C. Belknap). American Federation of Arts, New York, 1980.

Arnason, H. H. *Robert Motherwell*. New York, 1977.

Kelder, Diane; McKendry, John J.; and Motherwell, Robert. *Robert Motherwell's A La Pintura: The Genesis of a Book* (exh. cat.). Metropolitan Museum of Art, New York, 1972.

Plate XLIV
Frank Stella (American, born 1936)
Talledega Three I from *Circuits*, 1981-1982
Etching and foul bite (magnesium plate) on hand-made rag paper fabricated at Tyler Graphics
Image and sheet: 66 x 51⅜ in. (167.8 x 130.5 cm.)
Edition: 30; 10 artist's proofs, 4 others
Signed and dated: *F. Stella '82* in pencil l.r.
Reference: Axsom 135

Every so often, an artist develops a working relationship with printmaking that operates strictly within the conventional parameters of the medium, but with an intuitive understanding of the nature of the idiom that is so thorough, precise, and provocative that the marriage between image and technique elevates the state of the art to new plateaus. Rauschenberg and Johns made such a contribution to the state of lithography in the 1960s; Picasso and now Frank Stella have done as much for etching.

Stella has been making prints for more than fifteen years. But while his printed works announce a craftsmanlike competence, they are so thoroughly obligated to his painterly images that they are virtually small reproductions of the larger two-dimensional work, probably because he viewed printmaking as a subordinate medium. Beginning with his *Exotic Bird Series* in 1976, however, Stella's restraint with respect to etching (perhaps the least likely printmaking medium to refer to his painterly work) was abandoned to a growing fascination with the literal fact of the plate itself; an intensive experimentation with etching techniques over the next few years reached full creative flower with the *Circuits* series in 1982.

It appears that Stella was motivated to this involvement by his experience of working directly with sheet metal, which is, of course, the material of etching and engraving. In 1976, like Lichtenstein and Rauschenberg before him, Stella traveled to India at the invitation of the Sarabhai family to consider working on a project using local materials. In the marketplace of the city of Ahmedabad he discovered flat sheets of aluminum upon which the labels for American soft-drink brands had been misprinted before the sheets were to be formed and welded into cans. Apparently, it is more profitable for the misprinted sheets to be sold to Indian craftsmen, who use them to make storage boxes for spices and other culinary products, than it is to have them melted down and recycled. In any event, the sheets were readily available in India, and the red Coca Cola and green Seven-Up labels provided a ready-made surface decoration that Stella and the local artisans both found attractive. Working with the sheets, Stella sliced out his familiar protractor and french-curve shapes to manufacture three-dimensional maquettes that were the forerunners to his large-scale metal cutout and painted constructions of recent years.

It was the cutout shapes from the large metal works that directly inspired the *Circuits* prints. Many of the shapes for the metal constructions were cut with a laser beam that burned through the successive metal sheets onto the tabletops upon which they rested. This nest of interactive lines "etched" into the tabletop was the inspirational matrix for the image of *Talledega Three I*. Stella's particular genius was to recognize that the scale and physicality of his cutout metal shapes could be translated into prints. But more important, he had become confident enough of his own powers as a printmaker, and skilled enough in understanding the potential dynamics of etching, that he understood how his ideas could be implemented and thus was able to give free rein to them; he could imagine an image-technique combination that was as powerful an expression of his particular range of interests as it was an unparalleled technical synthesis. For the fact remains that *Talledega Three I* is a superbly inventive etching that reflects a masterful command of printmaking language.

T. K.

References
Axsom, Richard H. *The Prints of Frank Stella: A Catalogue Raisonné.* New York and Ann Arbor, 1983.

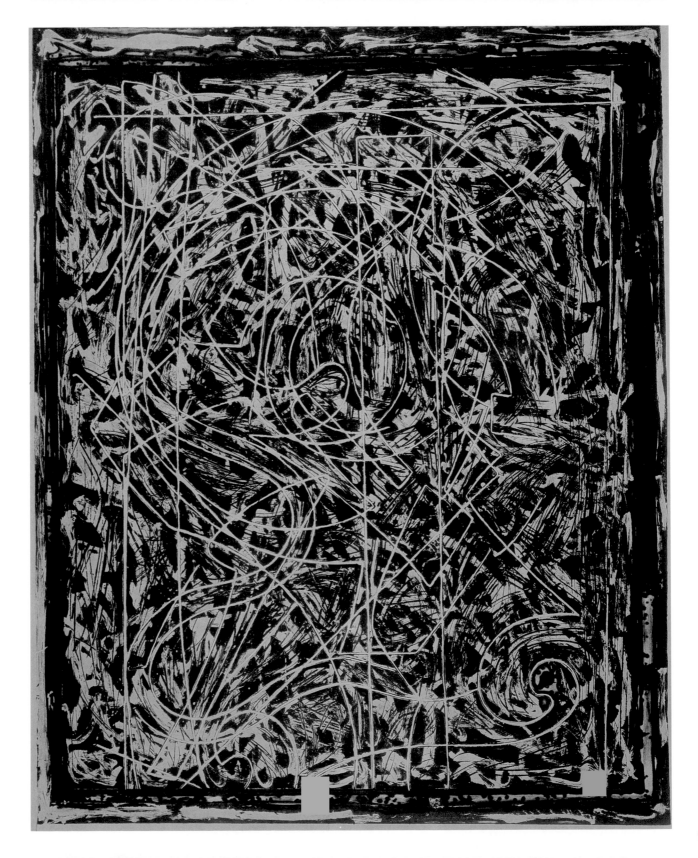

Plate XLVI
Susan Rothenberg (American, born 1945)
Untitled, 1983
Drypoint, aquatint, burnishing, and etching on Somerset Satin paper
Image: 25⅝ x 21¾ in. (65.1 x 55.3 cm.)
Sheet: 34 x 30¼ in. (86.4 x 76.9 cm.)
Edition: 35; 5 artist's proofs, 1 printer's proof, 1 *bon à tirer* and 2 Mountain Shadow Studio impressions
Signed and dated: *S. Rothenberg 83* in pencil l.r.
Printer: Charlie Levine at Mountain Shadow Studio
Publisher: Mountain Shadow Studio, Highland, N.Y.
Reference: Friedman 12

Beginning with her "horse" and "bone" paintings of the 1970s, Susan Rothenberg has been developing an imagery that makes reference to the real but appears to have more to do with metaphor and dream. Ambiguity is rife: a form once identified is likely to suggest another form or identity.

Accompanying the evolution of Rothenberg's imagery has been a dialogue concerning the nature of the pictorial space of her roughly brushed canvases. Are the figures embedded in the surface or do they project from it? Is the space flat, shallow, or suggestive of depth and atmosphere? In some of her recent works, all of the above possibilities appear simultaneously viable for figures and spaces. Relationships are shifting and ambivalent.

In the untitled aquatint the almond-shaped sailboat seen from above and its double or reflection may not immediately suggest to every viewer's eye the curving hull of a boat: they may also be read as vaginal forms. The "water" is a profoundly dark void conjured up by the velvety grained aquatint surface. It is worth noting that in the execution of the print most of the forms have been defined both by negative white shapes scraped out of the dark aquatint field and by positive etched and drypoint lines, encouraging a double reading of all the forms.

The "boat" is ringed about by a ghostly circle that becomes at the top a skull-like head and a rigid arm that appears to bar the way.[1] The spectral circle is itself ambivalent: does it lie on the surface like the reflection of the moon's circle or is it the rim of a deep whirlpool that threatens to engulf the boat?

C.S.A.

1. The print relates to a group of sailboat and water paintings of 1981-1982 that Rothenberg made during a period of residence on Long Island. She associated the graceful light boats propelled by the wind with growth and journeying, with freedom. (From "Expressionism Today: An Artist's Symposium," in *Art in America*, December 1982, pp. 65 and 139.)

References
Friedman, Ceil. *Susan Rothenberg Prints, 1977-1984*, (exh. cat.). Barbara Krakow Gallery, Boston, 1984, no. 12.
Nilson, Lisbet. "Susan Rothenberg, 'Every Brushstroke is a Surprise,' " in *Artnews*, February 1984, pp. 47-54.

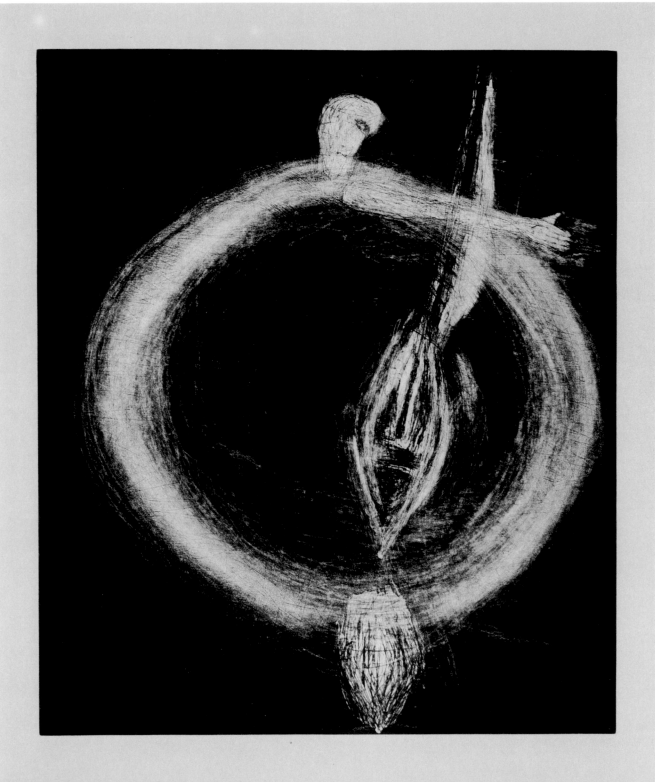

Plate XLVII
Anton Heyboer (Dutch, born [in Indonesia], 1924)
Red Afghan Kazak, 1982
Four etchings printed from 4 separate plates on 4
sheets with hand-applied colors
Image: 39⅛ x 20⅞ in. (99.4 x 53.0 cm.)
 39¼ x 21⅛ in. (99.7 x 53.6 cm.)
 39⅛ x 25 in. (99.4 x 63.5 cm.)
 39¼ x 21¼ in. (99.7 x 54.0 cm.)
Signed and dated: *Anton Heyboer 1982* in pencil l.l.
Inscribed (on verso, left edge): *Rode Afgaan Kazak
Anton Heyboer 1982* in pencil

A nomadic, abused childhood and time spent
in a concentration camp during 1943 both
contributed to Heyboer's rejection of conven-
tional values and lifestyle. Currently choosing
to live isolated from society in a dimly lit farm
building near Amsterdam, he has evolved a
highly personal symbolism. His bold, crudely
drawn prints serve as a continuous chronicle of
his existence, surrounded by female compan-
ions, a few animals, and a miscellaneous
accumulation of car wrecks, stones, fossils,
and driftwood.

Heyboer has been a prolific etcher since the
early 1950s. His printmaking techniques are
brutally simple: lines deeply gouged or etched
into zinc plates, to which is then applied by
hand a brown ink composed of automobile tar.
The raw colors – brown, red, orange, blue, and
green – often obtained directly from the earth,
are either brushed on in monotype fashion
before printing or added later. The deceptively
spare graphic language of the prints is
enriched by the rough application of ink and
color.

This recent print does not involve Heyboer's
customary numbered geometric diagram that
charts his emotional state; indeed, it seems
unusually representational. Two female
figures sit on either side of an octagonal
oriental rug; like all of his figures they are two-
dimensional, their linear contours resembling
those of tribal carvings. The rug adds a
mandala-like decorative element at the very
center of the image. With a deep feeling for
the immediacy of each of his prints, Heyboer
frequently goes back and "corrects" the
plates, so that rarely does a standard edition
result.

D.P.B.

References
Farber, J.B. "Perpetual Twilight," in *Artnews* 78 (February 1979),
pp. 152-155.
Locher, J.L. *Anton Heyboer*. Amsterdam, 1976.
Sizoo, Hans. "Expressionist Philosopher and Philosopher among
Expressionists," *Dutch Art and Architecture Today*, December
1982, pp. 8-13.

Plate XLVIII
Georg Baselitz (German, born 1938)
Dreibeiniger Akt (Three-Legged Nude), 1977
Linocut printed with oil paint
Image: 79½ x 59½ in. (202.0 x 151.2 cm.)
Sheet: 86⅝ x 62¼ in. (220.0 x 158.0 cm.)
Edition: 8 (all unique impressions, of which this is number 5)
Signed and dated: *nr. 2/3 Mars 1977 G. Baselitz* in pencil l.r.
Publisher: the artist

Georg Baselitz has done for the linocut what must have seemed impossible less than a decade ago: he has revitalized the simplest and most primitive of printmaking techniques and reinvested it with an extraordinarily expressive power that was last demonstrated by Picasso in the early 1960s. The process by which this transformation has taken place is remarkably similar to the manner in which artists like Johns, Rauschenberg, and Stella came to exercise a masterful control over the techniques of lithography and etchings. Baselitz had been a painter-printmaker in the early part of his career and, more often than not, was prone to use etching as a direct extension of his work in drawing and painting. But an awareness of the power of the medium gradually developed from a number of sources, not least important the German tradition of graphic excellence. As his own increasing experience began to produce valuable insights, he began to view printmaking as a fully viable mode of expression in and of itself, and not in terms of how it related to his other work.

Breakthroughs began to occur for Baselitz in the early 1970s. He had cut something of an independent figure in Germany in the previous decade with a style of work that he referred to as *Stil Malerei* ("style-painting"),[1] whose figurative and expressive elements were totally opposed to the current conceptual climate. Despite the huge success that the various European expressionist modes have enjoyed in recent years, however, Baselitz remains something of an enigma as a result of his tactic of literally inverting the subject matter in his work.

Baselitz's most sophisticated linocuts began to surface in 1975 and 1976, when the expanded scale of his work pushed him to the frontier of the medium. To cut linoleum of such size requires bold and decisive strokes that lend an atmosphere of energy and power to the prints. The sheer practical problems posed by inking and printing linoleum sheets as large as two meters have been turned into assets on several fronts. His manner of inking such large surfaces – rolling the linoleum with heavy oil-based paint and moving the ink around with his hands and fingers – have made the linocuts as grand in conception as the most dignified painting, for the ink of the printed image has a three-dimensional quality that adds to its dramatic tension.

Used in concert with the enigmatic attitude of the upside-down figure, these working methods tap the sources of German expressionism and mysticism. The power of the imagery is a result of an intimate and intuitive sense of the medium that is a requirement of all great printmakers; that Baselitz has achieved such insight with a printmaking technique that was hardly legitimate in the eyes of most artists and writers only a few years ago serves to underscore the importance of his achievement.

T. K.

1. Dorothea Dietrich-Doorsch, "The Prints of George Baselitz," in *Print Collector's Newsletter* 12, no. 6 (Jan.-Feb. 1982), p. 165.

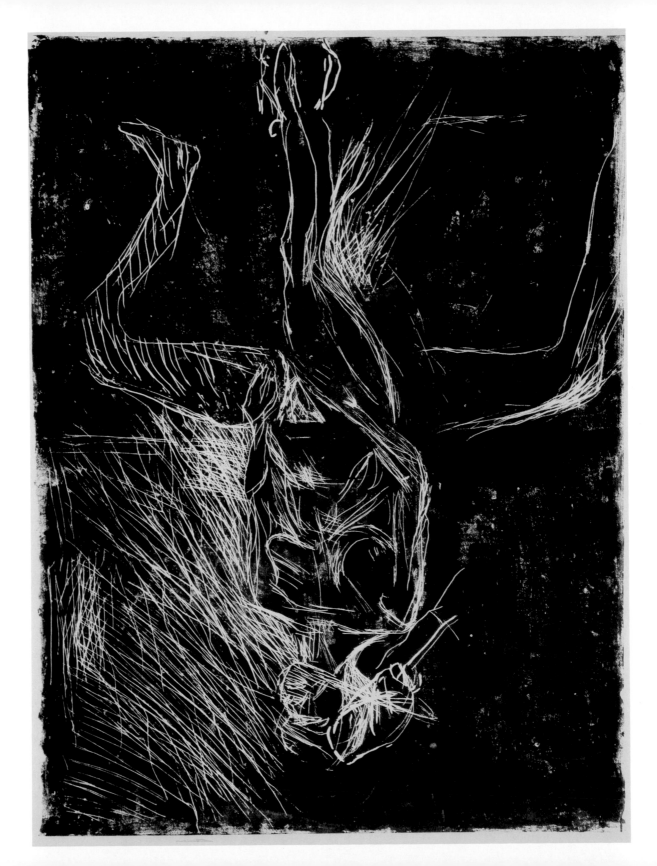

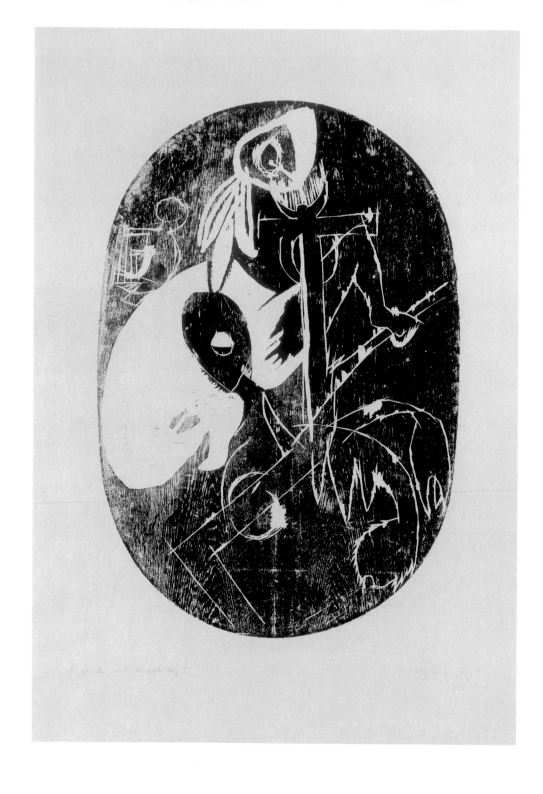

Plate XLIX
Felix Droese (German, born 1950)
Der breite und der schmale Weg I und II (The Wide and Narrow Way I and II), 1981
Woodcuts on Arches paper
Image: 43½ x 29¾ in. (110.5 x 75.5 cm.)
Sheet: 55 x 39⅜ in. (139.8 x 100.0 cm.)
Edition: unique on this paper (other unique printings exist on cloth or on machine-made paper)
Signed and dated: *Felix Droese 1981* in pencil l.r.
Titled: *Der breite und der schmale Weg I and II* l.c.
Inscribed: *Handdruck* in pencil l.l.
Printer: the artist

The son of a North German Old Catholic minister, Felix Droese is intensely concerned with such broad philosophical issues as the artist's role in society and the meaning of human existence. As with his teacher, the influential German postwar sculptor Joseph Beuys, there appears to be in Droese's work a tension between the artist's traditional role of producing objects of beauty for a middle-class market and the making of political and social statements.

Droese's career reveals a complex history of political commitment. A conscientious objector, he did alternative service by working in a mental hospital. He was actively involved in war protests and in a variety of radical political and artistic groups such as the Cologne periodical *Kämpfende Kunst* (Militant Art). In recent years he has given up his membership in some of these organizations and has begun to concentrate more on making works of art.

The pair of woodcuts entitled *The Broad and Narrow Way* are allegorical images that illustrate Droese's concern with larger philosophical issues. The title refers to the passage in the New Testament gospel of Matthew in which Christ speaks of two gateways and two pathways: "..broad is the way, that leadeth to destruction, and many there be which go in thereat" and "...narrow is the way, which leadeth unto life, and few there be that find it" (Matthew 7:13-14, King James version). The immediate source of inspiration for the artist was a nineteeth-century print that showed the two ways — the broad easy one leading to hell and the narrow, difficult one leading to heaven. The print had hung in his parents' home; it is now in the artist's possession. The meaning of Droese's images need not, however, be interpreted in a traditionally religious fashion. A recent catalogue of his work speaks

of the artist's painful experiences along the narrow way between political extremes.[1]

In the second woodcut, the wandering path is bordered with funereal crosses,[2] an expression of the artist's sense of the vulnerability of our endangered society. At the center, a steep-roofed structure and the surrounding landscape are enveloped in flames. The first woodcut, with its cross and hare (the body of the latter resembling the lower body and womb of a woman), is a kind of homage to Droese's teacher Beuys, who has said that the hare has for him an association with women, birth, and menstruation.[3] The hare or rabbit is, of course, a traditional fertility symbol, and the burrowing rabbit is also for Beuys a symbol of revolutionary thought.[4]

The splintery linework of the prints, with its primitivizing character and instinctual gestural qualities, summons up a mood of primal mythology and evokes the woodcuts of Beuys (cat. nos. 16 and 17). Their images are like negative versions of the large allegorical paper cutouts that Droese exhibits casually tacked to the wall.

Droese likes to work with humble or cast-off materials. In the case of *The Broad and Narrow Way*, the block – its ovoid shape suggestive of womb or egg – consists of the two sides of a found tabletop. Later, he recycled the woodblock, using it as components in a sculpture.

S.S.H.

1. Michael Tache, essay in *Felix Droese infelix lignum* (Munich, 1983).

2. An exhibition of 1980 in Düsseldorf consisted of over 700 Droese drawings of crosses (ibid.)

3. The body of a dead hare and crosses are key props in Beuys's 1966 "action" or performance piece "Eurasia." (See Caroline Tisdal, *Joseph Beuys* [Guggenheim Museum, New York, 1979], pp. 105-108.) Another "action" of the preceding year is entitled "How to Explain Pictures to a Dead Hare."

4. Ibid., p. 101.

Grab des unbekannten Malers

Plate L
Anselm Kiefer (German, born 1945)
Grab des unbekannten Malers (Tomb of the
Unknown Painter), 1982
Woodcut, collaged and hand-painted
Image: 68⅛ x 93¼ in. (173.0 x 237.0 cm.)
Edition: unique
Titled: *Grab des unbekannten Malers* in brush l. r.
Printer: the artist

Born before the end of World War II, an inauspicious moment to come into a German inheritance, Anselm Kiefer's art probes and scrutinizes his national heritage – its myths and history – as if he were searching for a positive identity amid its greatness and its sorrow. There is a sense of tragedy as well as a flickering of self-doubt cast over the assertive presence of his work, which is Wagnerian in scope, scale, and emotional tenor.

Such is the case for *Tomb of the Unknown Painter*, in which the strict frontality of the austere classical structure is tempered by an overall untidy and time-worn aspect. The pilasters – unornamented by fluting, volutes, or bases – indicate the most reductive of architectural orders. Yet this is not a Periclean ruin, or even the design of a later classical revivalist such as Schinkel. Rather, it resembles a memorial to fallen soldiers by one of the architects of Hitler's Third Reich such as Troost or Kreis.[1]

The disconcerting effect of appropriating a Nazi design – normally a taboo subject – is made all the more disturbing by its ambiguous treatment, for Kiefer's handling is not simplistic. As Robert Hughes notes, he weaves "a complicated tissue of reflection and atonement laced with numerous levels of irony."

Among the thoughts the image prompts are a meditation upon the birthright of artistic creativity destroyed or corrupted at the hands of Hitler's machine. Along with millions of human victims, a national legacy was charred and turned to ashes. Implied too is the notion that we must confront and not turn away from the tragic misdeeds of our past.

In an ironic way, the imposing monument suggests the mass inflation of current art world reputations. It might seem improbable for an unknown artist to receive the sort of grand entombment traditionally reserved for the military, but, by the same token, Kiefer's reverence for culture and his faith in the redemptive power of art allow one to take seriously the idea that the artist should replace the soldier as the hero of our time. Finally, Kiefer's series of "Monuments to the Unknown Painter" can be viewed as a kind of self-cautionary tale regarding the artist's own new-found fame. A token of his personal identification with the image is provided by the hand print seen at lower center.

The Tomb of the Unknown Painter was fashioned from large sheets and strips of paper glued together. This enormous collage is a one-of-a-kind image, the thickly encrusted ink and rather careless joining giving the print a raw and untamed power. An oversize border, created from inked planks of wood, frames the print and heightens the effect of psychological as well as physical gravity.

D. M.

1. See review by Saskia Bos for Helen van der Meij Gallery, Amsterdam, in *Artforum* 21, no. 5 (January 1983), p. 85.

References
Hughes, Robert. "German Expressionism Lives," in *Time*, August 8, 1983, p. 67.

Exhibition Checklist

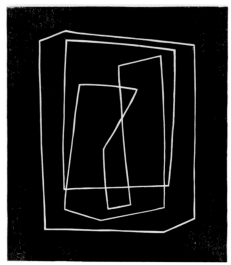

2

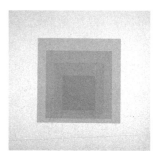

4-6

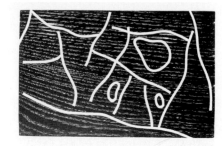

7

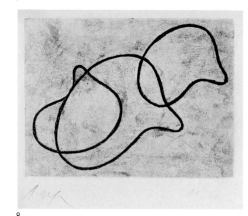

8

Vito Acconci (American, born 1940)
1. See pl. XXXV.
Three Flags for One Space and Six Regions, 1979-1981

Josef Albers (American [born in Germany], 1888-1976)
2.
Showcase, 1934
Linocut
Image: 10⅞ x 9⅜ in. (27.6 x 23.8 cm.)
Edition: 20
Signed and dated: *Albers 34* in pencil l.r.
Titled: *Show-case 2/20* in pencil l.l.
Reference: Miller 45 (See pl. xxiv for full reference.)

3. See pl. XXIV.
Astatic, 1944

4-6.
Grey Instrumentation II, 1975
Three (a, g, j) screenprints (from a portfolio of 12) on Arches paper
Image: 11 x 11 in. (27.9 x 27.9 cm.)
Sheet: 19 x 19 in. (48.2 x 48.2 cm.)
Edition: 36; 10 artist's proofs
Signed: *Albers* in pencil l.r.
Titled: *Grey Instrumentation II (a, g, j)* in pencil l.l.
Printer: Kenneth Tyler
Publisher: Tyler Graphics, Bedford Village, N.Y.

Jean Arp (French [born in Alsace], 1886-1966)
7.
Signes, 1949
Woodcut
Image: 4¾ x 7¼ in. (12.2 x 18.6 cm.)
Sheet: 13¼ x 10⅞ in. (33.5 x 27.5 cm.)
Edition: 50
Signed: *Arp* in pencil l.r.
Reference: Arntz 282, II/III (Wilhelm F. Arntz. *Hans Arp: Das Graphische Werk 1912-66*. The Hague, 1980)

8.
Percursoi, 1960
Etching on BFK Rives paper
Image: 4⅛ x 5⅝ in. (11.0 x 14.3 cm.)
Sheet: 10 x 7½ in. (25.2 x 19.0 cm.)
Edition: 60
Signed: *Arp* in pencil l.l.
Publisher: Atelier Georges Leblanc, Paris
Reference: Arntz 423

Richard Artschwager (American, born 1924)
9.
Cactus Scape II, 1981
Drypoint and solvent on plexiglass on BFK Rives paper
Image: 24½ x 29½ in. (62.2 x 74.0 cm.)
Sheet: 29¼ x 34½ in. (74.3 x 87.6 cm.)
Edition: 1 of 3 trial proofs (The plate broke in printing.)
Signed and dated: *Artschwager '81* in pencil l.r.
Inscribed: *A/P* in pencil l.l.
Printer: Patricia Branstead at Aeropress, N.Y.
Publisher: Multiples, N.Y.

Jennifer Bartlett (American, born 1941)
10. See pl. XXX.
Graceland Mansions, 1978-1979

9

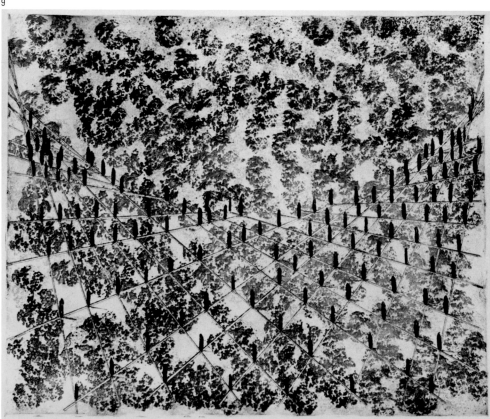

Georg Baselitz (German, born 1938)
11. See pl. XLVIII.
Dreibeiniger Akt (Three-Legged Nude), 1977
12.
Faustkämpfer Nr. 7 (Boxer No. 7), 1977
Linocut on buff paper
Image: 79⅛ x 52 in. (201.0 x 132.1 cm.)
Sheet: 87½ x 56 in. (222.3 x 142.3 cm.)
Edition: 7 variants, each unique
Signed and dated: *G. Baselitz 77* in pencil u.r.
Inscribed: *Nr. 7 I.V. 79*
Printer: the artist
Publisher: the artist

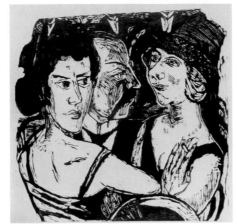

15

Max Beckmann (German, 1884-1950)
13.
Selbstbildnis mit Steifem Hut (Self-Portrait with Bowler), 1921
Drypoint
Image: 12¾ x 10¼ in. (32.3 x 24.7 cm.)
Second state of 4
Signed: *Beckmann* in pencil l.r.
Publisher: J.B. Neumann, Berlin
Reference: Glaser 157; Gallwitz 153, II/IV (See pl. XII for full reference.)
14. See pl. XII.
Zwei Frauen beim Ankleiden (Two Women Dressing) or *Bei der Toilette*, 1923
15.
Gruppenbildnis Edenbar (Group Portrait: Eden Bar), 1923
Woodcut on Japan paper
Image: 19¼ x 19½ in. (49.0 x 49.5 cm.)
Edition: 40
Signed: *Beckmann* in pencil l.r.
Reference: Gallwitz 261 b

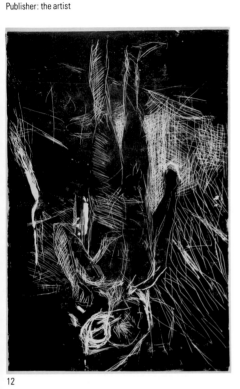

12

13

16

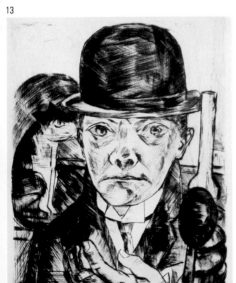

Joseph Beuys (German, born 1921)
16.
Hirschkuh (Doe), 1948
Woodcut (from a portfolio of 5) on BFK Rives paper
Image: 6½ x 13¾ in. (16.5 x 34.9 cm.)
Sheet: 19¾ x 25½ in. (50.2 x 64.6 cm.)
Edition: from Series B of 50 in black (another edition of 50 was printed in brown)
Signed: *Joseph Beuys* in pencil l.r.
Dated: *1948* in pencil l.c.
Publisher: Heiner Bastian, Propyläen Verlag, Berlin
Reference: Schellman and Klüser 92 a (Jörg Schellman and Bernd Klüser, eds. *Joseph Beuys – Multiples*. New York, 1980)
17.
Wattenmeer (Mudflats), 1949
Woodcut (from a portfolio of 5) on BFK Rives paper
Image: 4½ x 14⅝ in. (11.4 x 37.1 cm.)
Sheet: 19⅝ x 25⅝ in. (50.0 x 65.0 cm.)
Edition: from Series B of 50 printed in black (a further edition of 50 was printed in brown)
Signed: *Joseph Beuys* in pencil l.r.
Dated: *1948* in pencil l.c.
Publisher: Heiner Bastian Propyläen Verlag, Berlin
Reference: Schellman and Klüser 92 b

135

17

Umberto Boccioni (Italian, 1882-1916)
20.
Schnelligkeit (Speed) Cyclist Fortbewegung (Forward Movement)
from the fourth Bauhaus portfolio *New European Graphic Art:*
Italian and Russian Artists, 1923
Lithograph from a drawing of 1913 on buff paper
Image: 12⅛ x 10½ in. (30.8 x 26.7 cm.)
Edition: 100
Inscribed: *Bauhaus blind stamp* l.l.
Reference: Wingler IV, 2 (Hans M. Wingler. *Die Kunstlerische*
Graphik des Bauhauses: Die Mappenwerke ''Neue Europäische
Graphik.'' Mainz/Berlin, 1965)

18

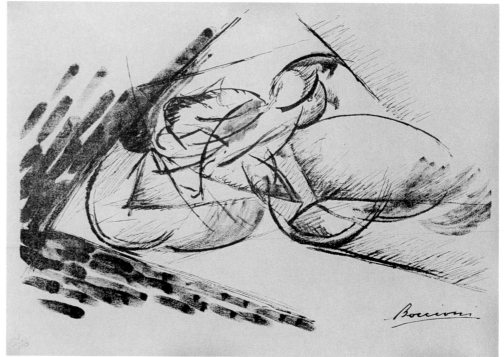

Julius Bissier (German, 1893-1965)
18.
Untitled, 1950
Woodcut
Image: 16½ x 11 in. (41.8 x 28.0 cm.)
Sheet: 18⁹⁄₁₆ x 24¼ in. (48.1 x 61.5 cm.)
Edition: 75 (This is a studio proof outside the edition.)
Signed and dated: *Julius Bissier 50* in pencil u.r.
19.
Untitled, 1950
Woodcut
Image: 15 x 16⅜ in. (38.2 x 41.7 cm.)
Sheet: 24¼ x 18½ in. (61.6 x 47.0 cm.)
Edition: 75 (This is a studio proof outside the edition.)
Signed and dated: *Julius Bissier 50* in pencil l.r.

20

19

21

Mel Bochner (American, born 1940)
21.
Rules of Inference, 1974
Aquatint
Image: 22⅛ x 31 in. (56.2 x 78.7 cm.)
Edition: 34
Signed and dated: *2/35 Mel Bochner 1974* in pencil l.r.
Printer: Patrick Foy
Publisher: Crown Point Press, Oakland

Jonathan Borofsky (American, born 1942)
22.
People Running, 1977-1982
Lithograph on aluminum plate on Exeter paper
Image: 35½ x 69⅜ in. (90.2 x 176.4 cm.)
Sheet: 39¾ x 76⅜ in. (101.0 x 194.2 cm.)
Edition: 40; 7 artist's proofs, 6 others
Signed and dated: *Borofsky 1977-1982* in pencil l.r.
Printer: Serge Lozingot, Anthony Zepeda, and Chris Sukimoto
Publisher: Gemini G.E.L., Los Angeles

23.
Molecule Men, 1979-1982
Screenprint with hand-cut lacquer stencil on Exeter paper
Image and sheet: 96½ x 79¾ in. (245.2 x 202.6 cm.)
Edition: 12 in black; 12 in black and gray
Signed and dated: *Borofsky 1979-1982* in pencil l.r.
Printer: Ron McPherson at Tujunga, Calif.; with Robert Sexton and Ernie Garcia
Publisher: Gemini G.E.L., Los Angeles

22

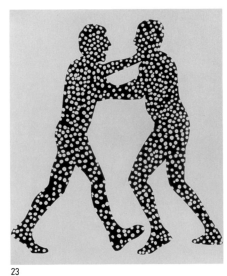

23

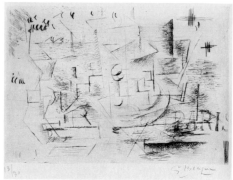

25

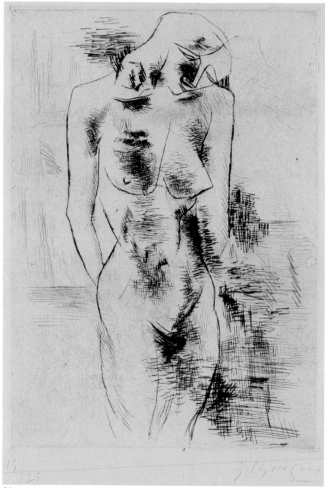

24

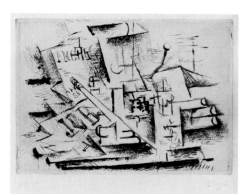

26

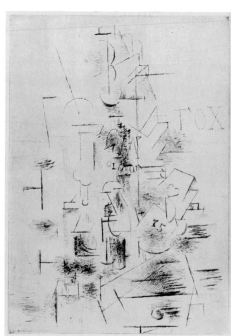

27

Georges Braque (French, 1882-1963)
24.
Etude de Nu (Study of a Nude), 1908
Etching and drypoint on Auvergne paper
Image: 11 x 7⅝ in. (27.8 x 19.8 cm.)
Sheet: 22¼ x 14¾ in. (56.5 x 37.5 cm.)
Edition: 25 in 1953; 30 additional copies on Rives; several proofs
(1908 printing: 3 ?)
Signed: *G. Braque* in pencil l.r.
Printer: Visat
Publisher: Maeght, Paris
Reference: Engelberts 1 (Edwin Engelberts. *Georges Braque,
Catalogue de l'oeuvre graphique original.* Geneva, 1958)
25.
Paris, 1910
Etching and drypoint on tinted Arches paper
Image: 7¾ x 10¾ in. (19.7 x 27.4 cm.)
Sheet: 13¾ x 21⅞ in. (35.0 x 55.8 cm.)
Edition: 30 in 1953 (1910 printing: 1)
Signed: *G. Braque* in pencil l.r.
Printer: Visat
Publisher: Maeght, Paris
Reference: Engelberts 3
26.
Job, 1911
Etching on Arches paper
Image: 5¾ x 7¾ in. (14.3 x 19.7 cm.)

Sheet: 8¼ x 12½ in. (21.0 x 31.8 cm.)
Edition: 100 in 1912, this being a trial proof
Signed: *G. Braque* in pencil l.r.
Inscribed: *H.C.* l.l.
Printer: Delâtre, Paris
Publisher: Kahnweiler, Paris
Reference: Engelberts 4
27.
Fox, 1911
Etching and drypoint on Arches paper
Image: 21½ x 15 in. (55.0 x 38.0 cm.)
Sheet: 25¼ x 19⅝ in. (64.2 x 49.6 cm.)
Edition: 100 in 1912
Signed: *G. Braque* in pencil l.r.
Printer: Delâtre, Paris
Publisher: Kahnweiler, Paris
Reference: Engelberts 5
28.
Bass, 1911
Etching on tinted Arches paper
Image: 18 x 12⅞ in. (45.7 x 32.8 cm.)
Sheet: 25¾ x 19⅝ in. (65.4 x 49.8 cm.)
Edition: 50 in 1950
Signed: *G. Braque* in pencil l.r.
Printer: Visat
Publisher: Maeght, Paris
Reference: Engelberts 6

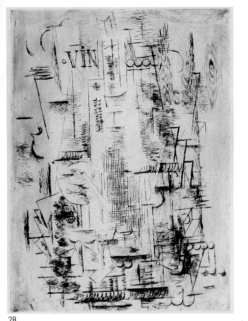

28

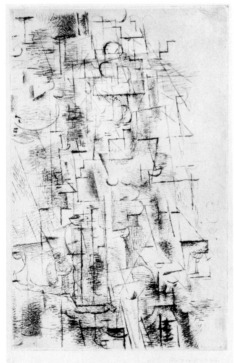

29

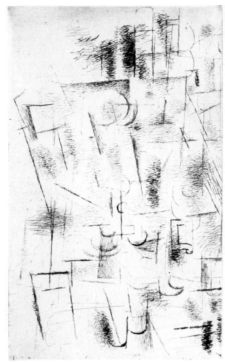

30

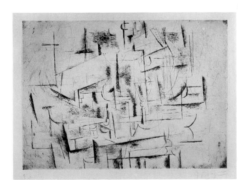

31

Reference: Engelberts 9
This was originally the lefthand side of one horizontal composition (with the foregoing plate, Engelberts 8).

31.
Nature morte II, Cubiste (Cubist Still Life II), 1912
Etching on tinted Arches paper
Image: 12⅞ x 17¾ in. (32.7 x 45.1 cm.)
Sheet: 19⅝ x 25¼ in. (49.7 x 64.2 cm.)
Edition: 50 in 1953
Signed: *G. Braque* in pencil l.r.
Printer: Visat
Publisher: Maeght, Paris
Reference: Engelberts 10

John Buck (American, born 1946)
32.
Untitled (Eclipse), 1982
Color woodcut on Japanese Suzu paper
Image: 77½ x 33¾ in. (196.7 x 85.6 cm.)
Edition: 20; 5 artist's proofs
Signed and dated: *John E. Buck 1982* in black ink l.r.
Inscribed: *Artist's Proof 2-5* in black ink l.l.
Printer: David Holzmann
Publisher: Landfall Press, Chicago

32

29.
Nature Morte I (Still Life I), 1911
Etching and drypoint on tinted Arches paper
Image: 13¾ x 8⅝ in. (35.0 x 22.0 cm.)
Sheet: 22¼ x 14¾ in. (56.5 x 37.5 cm.)
Edition: 50 in 1950
Signed: *G. Braque* in pencil l.r.
Printer: Visat
Publisher: Maeght, Paris
Reference: Engelberts 8

30.
Composition, ou Nature morte aux verres (Composition, or Still Life with Glasses), 1912
Etching and drypoint on Arches paper
Image: 13½ x 8¼ in. (34.3 x 21.0 cm.)
Sheet: 22 x 14¾ in. (55.9 x 37.5 cm.)
Edition: 50 in 1950
Signed: *G. Braque* in pencil l.r.
Printer: Visat
Publisher: Maeght, Paris

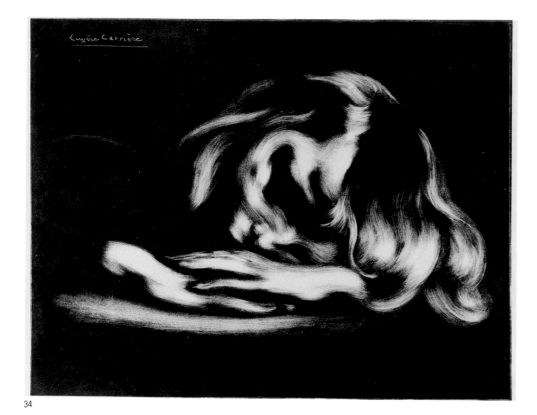

34

Heinrich Campendonk (German, 1889-1957)
33. See pl. VI.
Adam and Eve, ca. 1925

Eugène Carrière (French, 1848-1906)
34.
Le Sommeil (Sleep), 1897
Lithograph on Chine appliqué paper
Image: 13¼ x 16¾ in. (33.7 x 42.7 cm.)
Sheet: 16⁹⁄₁₆ x 22⅛ in. (42.0 x 56.2 cm.)
Edition: unnumbered impression from (or apart from) the 100
published in *L'Album d'estampes originales de la Galerie Vollard*,
1897
Reference: Delteil 36 (Loys Delteil. *Eugène Carrière* [Le Peintre-
Graveur illustré, vol. 8]. Paris, 1913)

Louisa Chase (American, born [in Panama], 1951)
35.
Thicket, 1983
Woodcut
Image and sheet: 29¾ x 36 in. (75.5 x 91.3 cm.)
Edition: 10
Signed: *Louisa Chase* in white crayon l.r.
Titled: *Thicket* in white crayon l.c.
Printer: Chip Elwell Studio, N.Y.
Publisher: Diane Villani Editions, N.Y.

Chuck Close (American, born 1940)
36.
Keith, 1972
Mezzotint on Arches paper
Image: 44⅝ x 35⅛ in. (113.2 x 89.2 cm.)
Sheet: 51 x 41½ in. (129.6 x 105.4 cm.)
Edition: 10
Signed and dated: *Close 1972* in pencil l.r.
Titled: *Keith* in pencil l.l.
Printer: Kathan Brown at Crown Point Press, Oakland
Publisher: Parasol Press, N.Y.

35

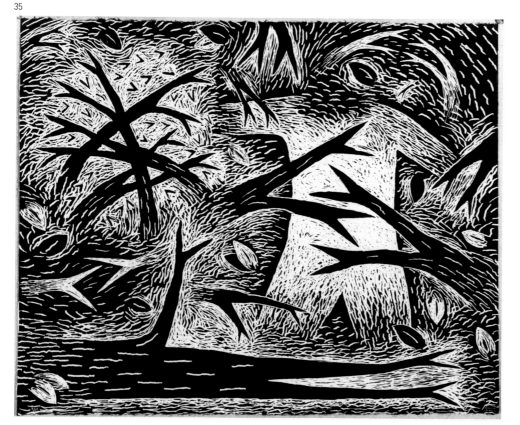

36

Jan Dibbets (Dutch, born 1941)
42.
Untitled II, 1981
Lithograph with photomechanical collage on white board
Image and sheet: 28¾ x 28¾ in. (73.0 x 73.0 cm.)
Edition: 30
Signed: *Jan Dibbets* in pencil l.c.
Printer: Rento Brattingo, Amsterdam
Publisher: Multiples, N.Y.

Richard Diebenkorn (American, born 1922)
43.
Large Bright Blue, 1980
Color etching and aquatint on BFK Rives paper
Image: 24 x 14³⁄₁₆ in. (61.0 x 36.0 cm.)
Sheet: 40 x 26 in. (101.6 x 66.1 cm.)
Edition: 35; 10 artist's proofs
Signed and dated: *RD 80* in pencil l.r.
Printer: Lilah Toland and Nancy Anello
Publisher: Crown Point Press, Oakland

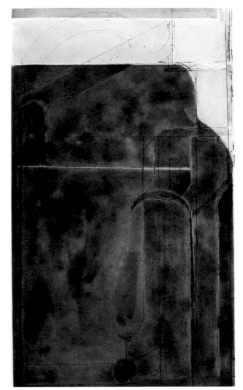

Robert Cottingham (American, born 1935)
37.
F.W., 1975
Etching and aquatint with hand burnishing on Japanese Gasen paper mounted on handmade Twinrocker paper
Image: 10½ x 10½ in. (26.7 x 26.7 cm.)
Sheet: 28 x 22¼ in. (71.2 x 56.3 cm.)
Edition: 50; 12 artist's proofs
Signed and dated: *Cottingham 75* in pencil l.r.
Titled: *A/P II F.W.* in pencil l.l.
Printer: Timothy Berry
Publisher: Landfall Press, Chicago

Enzo Cucchi (Italian, born 1950)
38.
Un' immagine oscura. . . (An Obscure Image. . .), 1982
Etching and aquatint on Fabriano Rosapina paper
Image: 34½ x 54½ in. (87.6 x 137.8 cm.)
Sheet: 47¼ x 69¼ in. (120.0 x 175.9 cm.)

Edition: Arabic-numbered edition of 30, Roman-numbered edition of 6
Signed: *E. Cucchi* in pencil l.r.
Printer: Valter Rossi at Vigna Antoniana Stamperia d'Arte, Rome
Publisher: Peter Blum Edition, N.Y.

Salvador Dali (Spanish [active in France], born 1904)
39. See pl. XVIII.
Mobilier Fantastique (Fantastic Furniture), 1934

Robert Delaunay (French, 1855-1941)
40. See pl. XVI.
Fenêtre sur la ville (Window on the City), 1925

André Derain (French, 1880-1954)
41. See pl. XIII.
Tête de Femme (Head of a Woman), ca. 1910

Jim Dine (American, born 1935)
44.
Self-Portrait: The Landscape, 1969
Color lithograph on Hodgkinson handmade paper
Image and sheet: 53 x 38 in. (134.7 x 96.5 cm.)
Edition: 75; 15 artist's proofs
Signed and dated: *Jim Dine 34/75 1969* in pencil l.l.
Publisher: Petersburg Press, London
Reference: Galerie Mikro 61 (Galerie Mikro. *Jim Dine: Complete Graphics* [essays by John Russell, Tony Towle, and Wieland Schmied]. Berlin, 1970)

45.
Five Paintbrushes, 1972
Etching on Hodgkinson handmade paper
Image: 23¾ x 35⅜ in. (60.2 x 90.0 cm.)
Sheet: 30 x 40 in. (76.2 x 101.6 cm.)
Edition: 75; 15 artist's proofs
Signed and dated: *Jim Dine 1972* in pencil l.l.
Printer: Maurice Payne
Publisher: Petersburg Press, London
Reference: Williams College 135, I/VI (Williams College, *Jim Dine – Prints: 1970-1977*. New York, 1977)

46. See pl. XLI.
Winter Windows on Chapel Street, 1982

45

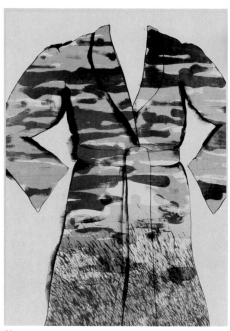

44

47

48

Martin Disler (Swiss, born 1949)
47-48.
Untitled from *Endless Modern Licking of Crashing Globe by Black Doggie – Time Bomb*, 1981
Aquatint, softground, sugarlift drypoint, and photoetching (2 from a portfolio of 8) on Van Gelder paper
Image: 21 x 29 in. (53.2 x 73.7 cm.)
Sheet: 22 x 30 in. (56.0 x 76.0 cm.)
Edition: 49; 10 artist's proofs
Signed: *Martin Disler* in pencil l.r.
Printer: Paul Marcus at Aeropress
Publisher: Peter Blum Edition, N.Y.

Felix Droese (German, born 1950)
49-50. See pl. XLIX.
Der breite und der schmale Weg I & II, 1981

Max Ernst (French, 1891-1976)
51. See pl. XX.
No. 4 from *Fiat modes, pereat ars* (Long Live Fashion, Down with Art), 1919

Richard Estes (American, born 1936)
52.
Roma, from *Urban Landscapes III*, 1981
Color screenprint on Fabriano cotton rag paper
Image: 14 x 20 in. (35.5 x 50.7 cm.)
Sheet: 19¾ x 27½ in. (50.2 x 69.8 cm.)
Edition: 250; 15 artist's proofs
Printer: Domberger Screenprint
Publisher: Parasol Press, N.Y.

Lyonel Feininger (American, 1871-1956)
53. See pl. IX.
Das Tor (The Gate), 1920

52

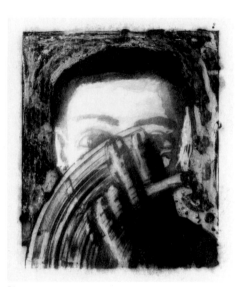

54

Naum Gabo (Russian [active in United States], 1890-1977)
57-77. See pl. XXV.
Opus1-12, 1950-1973, plus 9 variants: *Opus 2, Opus 3* (2 variants),
Opus 4 (2 variants), *Opus 5* (2 variants), *Opus 7, Opus 8*

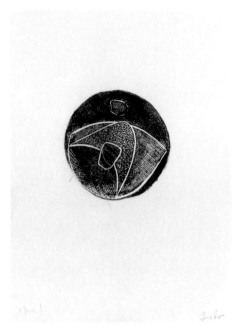

57 (*Opus 1*)

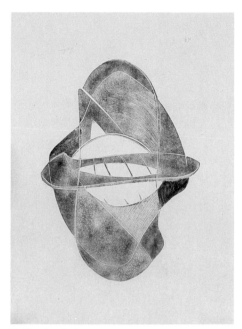

71 (*Opus 3*, variant)

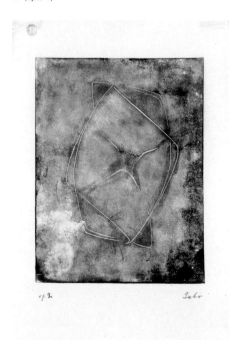

58 (*Opus 2*)

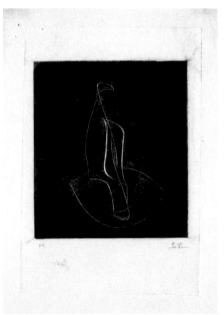

60 (*Opus 4*)

Aaron Fink (American, born 1955)
54.
Smoker with Fan Hand, 1982
Lithograph hand-colored on Tosha-Langa paper
Image: 12 x 10 in. (30.5 x 25.3 cm.)
Sheet: 25½ x 19¼ in. (64.8 x 48.9 cm.)
Edition: 1 of 4 examples, each differently hand-colored
Signed and dated: *Aaron Fink '82* in pencil l.r.
Printer: Herbert Fox, Fox Graphics, Boston
Publisher: the artist

Eric Fischl (American, born 1948)
55. See pl. XL.
The Year of the Drowned Dog, 1983.

Helen Frankenthaler (American, born 1928)
56. See page 29.
Savage Breeze, 1974
Color woodcut from 8 blocks on laminated handmade Nepalese
paper
Image: 24⅝ x 29½ in. (63.2 x 75.0 cm.)
Sheet: 26¾ x 31⅜ in. (68.0 x 79.5 cm.)
Edition: 31; 4 artist's proofs, 25 others
Signed and dated: *Helen Frankenthaler 74* in pencil l.r.
Printer: Bill Goldston and Juda Rosenberg
Publisher: Universal Limited Art Editions, West Islip, N.Y.
Reference: Williams College 51 (Williams College. *Helen
Frankenthaler Prints: 1961-1979*. New York, 1980)

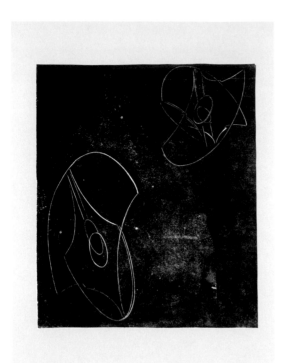

74 (*Opus 5*, variant)

65 (*Opus 9*)

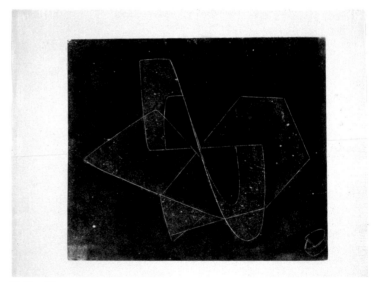

66 (*Opus 10*)

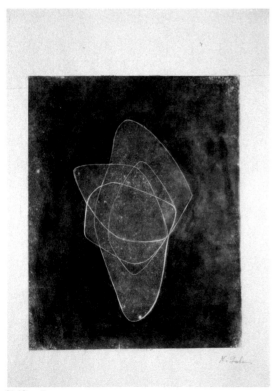

64 (*Opus 8*)

144

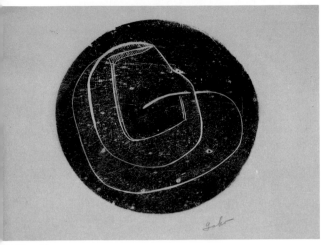

67 (*Opus 11*)

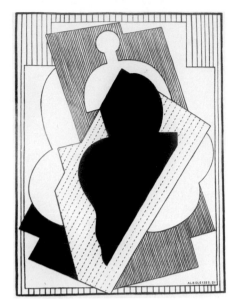

78

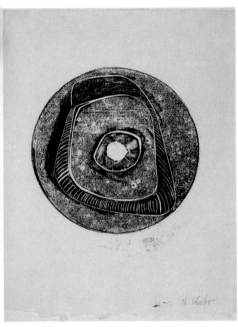

68 (*Opus 12*)

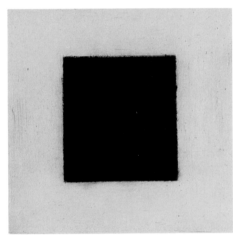

79

Albert Gleizes (French, 1881-1953)
78.
Cubist Composition, from the periodical *Die Schaffenden*, 1921
Woodcut on handmade Japan paper
Image: 10½ x 14¼ in. (26.7 x 36.2 cm.)
Edition : 125, of which this is 1 of 25 deluxe impressions on
handmade Japan paper
Signed: *A.G.* in pencil l.r.
Inscribed: *Die Schaffenden* blindstamp l.l.

Alan Green (British, born 1932)
79.
Centre to Edge, Black-Green (1 of a set of 3), 1979
Color etching
Image: 18⅝ x 18¾ in. (47.4 x 47.7 cm.)
Sheet: 27⅝ x 27⅜ in. (70.1 x 69.6 cm.)
Edition: 25
Signed and dated: *Alan Green 79* in pencil l.r.
Titled: *Centre to Edge Black-Green* in pencil l.c.
Publisher: Annely Juda Fine Arts, London

145

80

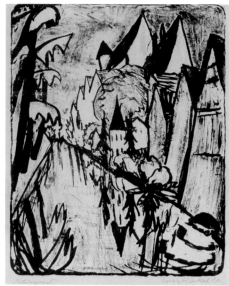

85

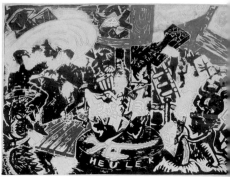

90

82

91

Richard Hamilton (British, born 1922)
80.
Berlin Interior, 1980
Aquatint and etching
Image: 19⁵⁄₁₆ x 27⁹⁄₁₆ in. (49.6 x 69.0 cm.)
Sheet: 22³⁄₈ x 29⁷⁄₈ in. (56.8 x 75.8 cm.)
Edition: 100
Signed: *R. Hamilton* in pencil l.r.
Printer: Aldo Crommelynck, Paris
Publisher: Waddington Graphics, London
81. See pl. XXXI.
In Horne's House, 1982

Mags Harries (Welsh, born 1945)
82.
Glove Series, 1980
Monotype (printer's ink on metal plate with impress of cotton gloves)
Image: 19½ x 16 in. (49.5 x 40.6 cm.)
Sheet: 26¹⁄₈ x 19⁷⁄₈ in. (66.0 x 50.5 cm.)
Edition: unique
Signed and dated: *Mags Harries 1980* in pencil l.r.
Titled: *Glove Series* in pencil l.c.
Publisher: the artist

Erich Heckel (German, 1883-1970)
83. See pl. II.
Weibliche Gesicht (Woman's Face), 1907
84. See pl. VIII.
Parksee (Lake in a Park), 1914
85.
Tübingen, 1920
Lithograph
Image: 19¼ x 15 in. (48.7 x 38.2 cm.)
Signed and dated: *Erich Heckel 20* in pencil l.r.
Titled: *Tübingen II* in pencil l.l.
Reference: Dube 264, II/IV. (See pl. II for full reference.)

Anton Heyboer (Dutch, born [in Indonesia], 1924)
86. See pl. XLVII.
Red Afghan Kazak, 1982

David Hockney (British, born 1937)
87. See pl. XXXIX.
Celia, 1972-1973

Bryan Hunt (American, born 1947)
88-89. See pl. XLV.
Fall and *Fall with Bend*, 1979

Jörg Immendorf (German, born 1945)
90.
Neue Mehrheit (New Majority), number 10 from the series *Café Deutschland gut*, 1983
Linocut with hand coloring
Image: 61½ x 81½ in. (156.1 x 206.9 cm.)
Sheet: 71 x 90 in. (180.0 x 230.0 cm.)
Edition: 10
Signed and dated: *Immendorf '83* in pencil l.r.
Printer: the artist with assistants, Düsseldorf
Publisher: Maximilian Verlag and Sabina Knust, Munich

Rolf Iseli (Swiss, born 1934)
91.
Sous Roches (Under Rocks), 1982
Drypoint on copperplate
Image: 57⁵⁄₈ x 32⁵⁄₈ in. (146.3 x 82.8 cm.)
Sheet: 64³⁄₈ x 34³⁄₈ in. (163.4 x 87.3 cm.)
Edition: 6
Signed and dated: *Iseli '82* in pencil l.r.
Inscribed: *3 Abzug 13.2.82* in pencil l.l.

92

Yvonne Jacquette (American, born 1934)

92.
Northwest View from the Empire State Building, 1982
Lithograph from 2 plates on Transpagra vellum
Sheet: 50⅜ x 34¾ in. (128.0 x 88.3 cm.)
Edition: 60; 12 artist's proofs
Signed: *Y. Jacquette* in pencil l.r.
Dated: *1982* in pencil l.c.
Printer: John C. Erickson at Siena Studio, N.Y.
Publisher: Brooke Alexander, N.Y.

Jasper Johns (American, born 1930)

93.
Coat Hanger I, 1960
Lithograph on German etching paper
Image: 25¼ x 21 in. (64.8 x 53.4 cm.)
Sheet: 36 x 26¾ in. (91.5 x 68.0 cm.)
Edition: 35, plus an undetermined number of proofs
Signed and dated: *J. Johns '60* in pencil l.l.
Inscribed: *artist's proof* in pencil l.l.
Printer: Robert Blackburn
Publisher: Universal Limited Art Editions, West Islip, N.Y.
Reference: Field 2 (See pl. XXVIII for full reference.)

94. See pl. XXVIII.
False Start II, 1962

95.
The Critic Smiles, 1969
Lead relief with cast gold crown and tin leaf
Image and sheet: 22¾ x 16¹³⁄₁₆ in. (57.8 x 42.7 cm.)
Edition: 60; 16 artist's proofs
Signed and dated: *J. Johns 69* with electric stylus image in center
Publisher: Gemini G.E.L., Los Angeles
Reference: Field 119

96.
Untitled (Ruler) II, 1969
Photoetching and aquatint on Barcham Green paper
Image: 29 x 19⅞ in. (73.7 x 50.4 cm.)
Sheet: 41⅜ x 27⅞ in. (105.2 x 70.8 cm.)
Second state of Untitled (Ruler) I
Edition: 15; unrecorded number of proofs
Signed and dated: *J. Johns 1969* in pencil l.r.
Printer: Donn Steward
Publisher: Universal Limited Art Editions, West Islip, N.Y.
Reference: Field 126

97. See pl. XXIX.
Scent, 1975-1976

98.
Usuyuki, 1979
Color offset lithograph from 10 plates on Arches paper
Image: 27½ x 44¼ in. (69.8 x 113.5 cm.)
Sheet: 34¼ x 50¼ in. (87.0 x 127.6 cm.)
Edition: 49; 7 artist's proofs
Signed and dated: *J. Johns '79* in pencil l.r.
Printer: James V. Smith and Thomas Cox
Publisher: Universal Limited Art Editions, West Islip, N.Y.
Reference: Segal Gallery 16 (Thomas Segal Gallery. *Jasper Johns Prints 1977-1981*. Boston, 1981)

99.
Usuyuki, 1979-1981
Color screenprint on handmade Japanese paper
Image: 27⅝ x 45⅝ in. (70.1 x 115.9 cm.)
Sheet: 29½ x 47¼ in. (74.9 x 120.0 cm.)
Edition: 85; 15 artist's proofs
Signed and dated: *J. Johns '81* in pencil l.r.
Printer: Hiroshi Kawanishi, Takeshi Shimada, and Kenjiro Nonaka
Publisher: Simca Print Artists, N.Y., and the artist
Reference: Segal Gallery 35

95

96

93

98

99

Donald Judd (American, born 1928)
100.
Untitled from *Orange Grid Design Series*, 1961-1965
Woodcut, printed from wood sculpture
Sheet: 30½ x 22 in. (77.6 x 55.9 cm.)
Edition: 10
Signed: *Judd* in pencil l.r.
Dated *61-65* in pencil l.l.
Printer: the artist and his father, Roy Clarence Judd
Publisher: the artist
101.
Untitled from *Orange Grid Design Series*, 1961-1965
Woodcut, printed from wood sculpture
Sheet: 30½ x 22 in. (77.5 x 55.9 cm.)
Edition: 10
Signed: *Judd* in pencil l.r.
Dated *61-65* in pencil l.l.
Printer: the artist and his father, Roy Clarence Judd
Publisher: the artist

Wassily Kandinsky (Russian, 1866-1944)
102-113. See pl. XI and page 14.
Kleine Welten (Little Worlds), 1922

Alex Katz (American, born 1927)
114.
Swimmer, 1974
Drypoint and aquatint on German etching paper
Image and sheet: 28 x 36 in. (71.1 x 91.4 cm.)
Edition: 84; 6 artist's proofs
Signed: *Alex Katz* in pencil l.r.
Printer: Prawat Laucharoen
Publisher: Brooke Alexander and Marlborough Graphics, N.Y.

Ellsworth Kelly (American, born 1923)
115.
Wall, 1979
Etching and aquatint on Arches cover paper
Image: 16½ x 13¹⁵⁄₁₆ in. (41.0 x 35.5 cm.)
Sheet: 31½ x 28 in. (80.0 x 71.1 cm.)
Edition: 50; 16 artist's proofs
Signed: *Kelly* in pencil l.r.
Printer: Tyler Graphics
Publisher: Tyler Graphics, Bedford Village, N.Y.

Anselm Kiefer (German, born 1945)
116. See pl. L.
Grab des unbekannten Malers (Tomb of the Unknown Painter), 1982

Ernst Ludwig Kirchner (German, 1880-1938)
117. See pl. IV.
Liebespaar am Morgen (Lovers in the Morning), 1915

Paul Klee (Swiss, 1879-1940)
118. See pl. X.
Drei Köpfe (Three Heads), 1919
119.
Seiltänzer (Tightrope Walker) from the portfolio *Kunst der Gegenwart*, 1923
Color lithograph on handmade paper
Image: 17⅛ x 10⅝ in. (43.5 x 27.0 cm.)
Edition: 220 on handmade paper; an additional 80 on Japan
Signed: *Klee* in pencil l.r.
Inscribed: *23138* in pencil l.r.
Printer: Staatliches Bauhaus, Weimar
Publisher: Márees-Gesellschaft and R. Piper & Co., Munich
Reference: Kornfeld 95 IV c (See pl. X for full reference.)

Willem De Kooning (American [born in Holland], 1904)
120.
Woman with Corset and Long Hair, 1970
Lithograph on Akawara paper
Image: 30 x 23½ in. (76.2 x 59.7 cm.)
Sheet: 37½ x 29¾ in. (94.4 x 75.6 cm.)
Edition: 61; 7 artist's proofs, 9 others
Signed and dated: *de Kooning '70* in pencil l.l.
Printer: Irwin Hollander and Fred Genis at Hollander Workshop, N.Y.
Publisher: M. Knoedler & Co., N.Y.

148

100

101

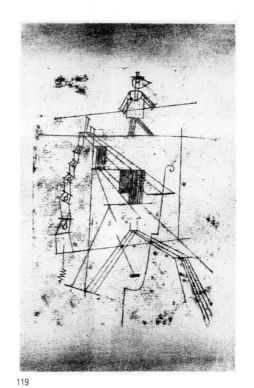

119

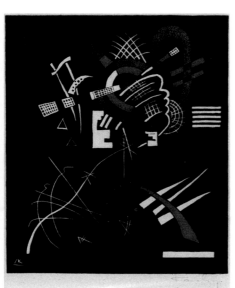

102

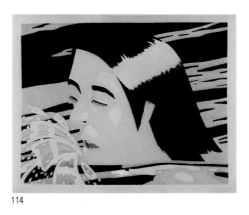

114

115

120

121

132

Lois Lane (American, born 1948)
121.
Snake, 1981
Aquatint, softground, spit bite, and gold leaf (from a portfolio of 4)
Image: 15⅞ x 19⅝ in. (40.3 x 49.7 cm.)
Sheet: 46¼ x 36¼ in. (117.5 x 92.2 cm.)
Edition: 33; 12 artist's proofs
Printer: Aeropress, N.Y.
Publisher: Parasol Press, N.Y.

Sol Lewitt (American, born 1928)
122-131. See pl. XXVII.
Squares with a Different Line Direction in Each Half Square, 1971

Roy Lichtenstein (American, born 1923)
132.
This Must Be the Place, 1965
Color offset lithograph on glazed paper
Image: 21¾ x 16¼ in. (55.2 x 41.3 cm.)

Sheet: 24⅞ x 17¾ in. (63.3 x 45.1 cm.)
Edition: unrecorded (unnumbered)
Signed: *rf Lichtenstein* in pencil l.r.
Publisher: American Cartoonists Society
Reference: Bianchini 13 (*Roy Lichtenstein: Drawings and Prints* [cat. by Paul Bianchini]. New York, 1970)

133. See Frontispiece.
Industry and Melody, 1969
Color screenprint on aluminum foil
Image: 17¼ x 14½ in. (43.9 x 36.8 cm.)
Edition: 100
Signed and dated: *rf Lichtenstein '69* in pencil l.r.
Printer: Gabriele Mazzotta
Publisher: Gabriele Mazzotta, Milan

134. See pl. XXXVIII.
Reclining Nude, 1980

El Lissitzky (Russian, 1890-1941)
135.
Proun 2 B, 1919
Lithograph
Image: 7⅞ x 10¼ in. (20.0 x 26.0 cm.)
Sheet: 13½ x 17⅞ in. (34.3 x 45.3 cm.)
Edition: first edition, Moscow
Signed: *El Lissitzky* in pencil l.r.
Titled: *P 2 B* in pencil l.r.
Reference: Gmurzynska; pp. 27-29. (See pl. XXI for full reference.)

136. See pl. XXI.
Totengräber (Gravedigger), 1923

Robert Longo (American, born 1953)
137.
Frank, 1982-1983
Color lithograph on Arches paper
Image: 59 x 32¼ in. (149.8 x 82.5 cm.)
Sheet: 67½ x 38¾ in. (171.4 x 98.5 cm.)
Edition: 25
Signed and dated: *Robert Longo 83* in pencil l.r.
Printer: Maurice Sanchez at Derrière L'Etoile Studios, N.Y.
Publisher: Brooke Alexander, N.Y.

Robert Mangold (American, born 1937)
138-142. See page 28.
Five aquatints (A-E), 1975
Aquatint on Arches Satine paper
Image: 9¹/₁₆ x 9¹/₁₆ in. (23.0 x 23.0 cm.)
Edition: 50; 15 artist's proofs
Signed: *Robert Mangold* in pencil on verso
Printer: Patrick Foy at Crown Point Press, Oakland
Publisher: Parasol Press, N.Y.

Franz Marc (German, 1880-1916)
143.
Schöpfungsgeschichte II (Creation II), 1914
Woodcut on China paper
Image: 9⁵/₁₆ x 7⅞ in. (23.7 x 20.0 cm.)
Edition: unknown
Reference: Lankheit 843, V/V (Klaus Lankheit. *Franz Marc: Katalog der Werke*. Cologne, 1970)

Louis Marcoussis (French, 1883-1941)
144.
Le Comptoir (The Counter), 1920
Drypoint, etching, and aquatint in brown ink on beige imitation Japan paper
Image: 7⅜ x 5⅝ in. (18.7 x 14.3 cm.)
Fourth and final state
Edition: unnumbered
Signed: *Marcoussis* in pencil l.r.
Publisher: *Die Schaffenden*
Reference: Lafranchis 37 (Jean Lafranchis, *Marcoussis – sa vie, son oeuvre catalogue complet*, Paris [n.d.])

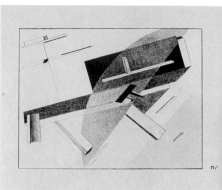

135

137

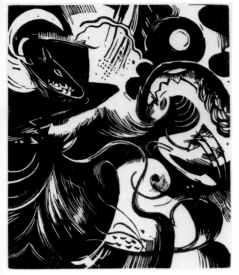

143

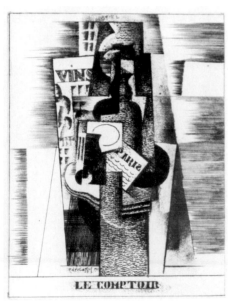

144

145

146

147

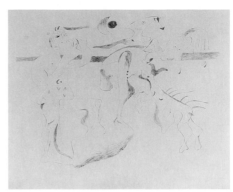

148

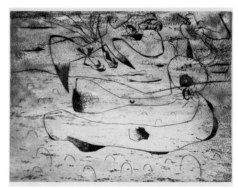

149

Edition: 30 (1-30) and 20 (A-T)
Signed and dated: *B. Marden 71* in pencil l.r.
Printer: Patricia Branstead at Kathan Brown's Workshop, Oakland
Publisher: Parasol Press, N.Y.

Michael Mazur (American, born 1935)
147.
Smoke, 1975
Engraving with electric needle, aquatint, and sanding on Arches cover paper
Image: 17¾ x 35¾ in. (45.1 x 90.8 cm.)
Sheet: 26⅛ x 44 in. (66.5 x 111.8 cm.)
Edition: 25
Signed: *Mazur* in pencil l.r.
Printer: the artist
Publisher: Jane Haslem Gallery, Washington D.C., and the artist
References: (Frank Robinson. *Michael Mazur: Vision of a Draughtsman*. Brockton, Mass.: Brockton Art Center, 1976, no. 94)

Brice Marden (American, born 1938)
145.
10 Days, 1971 or 1972
Hardground etching (from a portfolio of 8) on Arches paper
Image: 12 x 15⅛ in. (30.5 x 38.4 cm.)
Sheet: 22¼ x 30 in. (56.2 x 76.2 cm.)
Edition: 30 (1-30) and 20 (A-T)
Signed and dated: *B. Marden 71* in pencil l.r.
Printer: Patricia Branstead at Kathan Brown's Workshop, Oakland
Publisher: Parasol Press, N.Y.

146.
10 Days, 1971 or 1972
Hardground etching (from a portfolio of 8) on Arches paper
Image: 12 x 15⅛ in. (30.5 x 38.4 cm.)
Sheet: 22¼ x 30 in. (56.2 x 76.2 cm.)

Joan Miró (Spanish, 1893-1983)
148.
Daphnis and Chloe, 1933
Drypoint and etching on Japan paper
Image: 10½ x 12¾ in. (26.7 x 32.4 cm.)
Sheet: 17 x 23½ in. (43.0 x 59.8 cm.)
Edition: 100 on Arches, 10 on Japan
Signed and dated: *Miro 11.33* in pencil l.r.
Printer: Imprimerie Lacourière, Paris
Publisher: Tériade, Paris
Reference: Hunter 4, Benhoura 1 (Sam Hunter. *Joan Miró – His Graphic work*. New York, 1958, and *Miró: L'Oeuvre graphique* [exh. cat. by Marguerite Benhoura, Anne de Rougemont, and Françoise Gillard]. Musée d'art moderne de la ville de Paris, 1974.)

149.
Eagle, Woman, and Night, 1938
Drypoint on Arches paper
Image: 9 x 11⅝ in. (22.9 x 29.5 cm.)
Sheet: 13 x 17½ in. (33.0 x 44.4 cm.)
Edition: 30
Signed: *Miro* in pencil l.r.
Printer: Imprimerie Lacourière, Paris
Publisher: Pierre Loeb, Paris, and Pierre Matisse, N.Y.
Reference: Hunter 14, Benhoura 2

150.
Série I (Series I), 1952-1953
Etching and intaglio on BFK Rives paper
Image: 14⅞ x 14 in. (37.8 x 35.3 cm.)
Sheet: 20⅝ x 20 in. (52.5 x 50.8 cm.)
Edition: 13 (also 7 other editions of 13 each)
Signed and dated: *Miro 1953* in pencil l.r.
Printer: Imprimerie Lacourière, Paris
Publisher: Maeght, Paris
Reference: Benhoura 14, Abrams 77

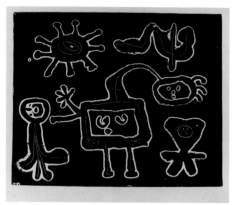

150

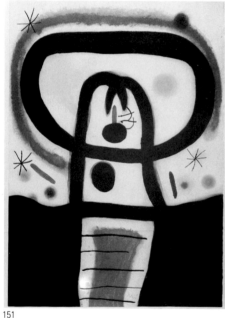

151

151.
L'Equinoxe (The Equinox), 1967
Etching, aquatint, and carborundum in colors on Chiffon de Maudeure
Image and sheet: 41 x 29 in. (104.3 x 73.7 cm.)
Edition: 75
Signed: *Miro* in pencil l.r.
Printer: Arte Adrien Maeght, Paris
Publisher: Maeght, Paris
Reference: Benhoura 91

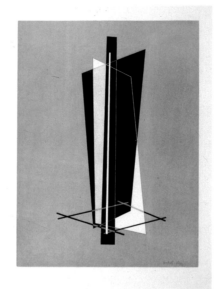

152

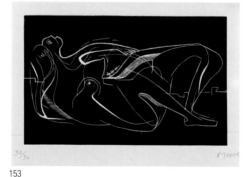

153

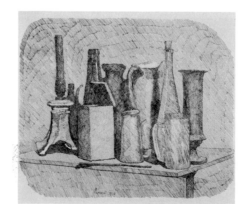

154

László Moholy-Nagy (Hungarian [active in Germany], 1895-1946)
152.
Konstruction (Construction), 1923
Lithograph on gray-green paper
Image: 20⅛ x 10⅜ in. (51.1 x 26.3 cm.)
Sheet: 23⅞ x 17⅜ in. (60.6 x 44.2 cm.)
Edition: 50
Signed: *Moholy-Nagy* in pencil l.r.
Publisher: Verlag Ludwig, Hanover

Henry Moore (British, born 1898)
153.
Reclining Nude, 1931 (published 1966)
Woodengraving on tinted Japan paper
Image: 4 x 6⅜ in. (10.2 x 16.2 cm.)
Edition: 50; 10 artist's proofs, 6 others
Signed: *Moore* in pencil l.r.
Printer: Feguet and Baudier, Paris
Publisher: Gérald Cramer, Geneva
Reference: Cramer 2 (Gérald Cramer, Alistair Grant, and David Mitchinson. *Henry Moore – Catalogue of Graphic Work, 1931-1972.* Geneva, 1973)

Giorgio Morandi (Italian, 1890-1964)
154.
Grande natura morta con la lampada a petrolio (Large Still Life with Oil Lamp), 1930
Etching
Image: 14¼ x 12 in. (36.2 x 30.5 cm.)
Edition: 40
Signed and dated: *Morandi 1930* in pencil l.r.
Reference: Vitali 75, V/VI (Lamberto Vitali. *L'Opera grafica di Giorgio Morandi*, 2nd ed. Turin, 1964).

Malcolm Morley (British, born 1931)
155.
Train Wreck (red version), 1981
Hardground etching and aquatint on Stonehenge Roll Stock paper
Image: 32¾ x 44¼ in. (83.2 x 112.1 cm.)
Sheet: 37½ x 49¼ in. (95.3 x 125.1 cm.)
Edition: 12; 5 artist's proofs
Signed: *Malcolm Morley* in pencil l.r.
Printer: Styria Studio, N.Y.
Publisher: Xavier Fourcade, N.Y.

Robert Motherwell (American, born 1915)
156.
Automatism A, 1965-1966
Lithograph (zinc plate) on BFK Rives paper
Image and sheet: 28 x 21 in. (71.0 x 53.3 cm.)
Edition: 100; unrecorded number of proofs
Signed: *Robert Motherwell* in brown crayon l.l.
Inscribed: *Artist's Proof* in crayon l.l.
Printer: Irwin Hollander
Publisher: Hollander Workshop, N.Y.
Reference: Belknap 6 (See pl. XLIII for full reference.)
157. See pl. XLIII.
Red Open with White Line, 1979

Edvard Munch (Norwegian, 1863-1944)
158. See pl. I.
Vampyr (Vampire), 1895
159.
Mädchenporträt (Portrait of a Young Girl), 1912
Woodcut on Japan paper
Image: 21¾ x 13¾ in. (55.2 x 35.0 cm.)
Sheet: 23⅜ x 15½ in. (59.5 x 39.4 cm.)
Signed: *Edv Munch* in pencil l.r.
Printer: probably the artist
Reference: Schiefler 388 (See pl. I for full reference.)

Gabriele Münter (German, 1877-1962)
160. See pl. VII.
Herbstabend - Sèvres (Autumn Evening - Sèvres), ca. 1907

Kenneth Noland (American, born 1924)
161. See pl. XLII.
Handmade Paper: Horizontal Stripe Series III, 1978

155

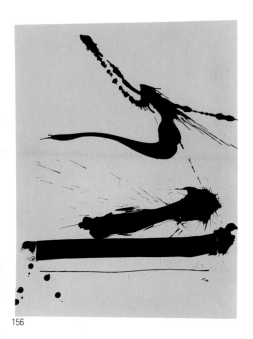

156

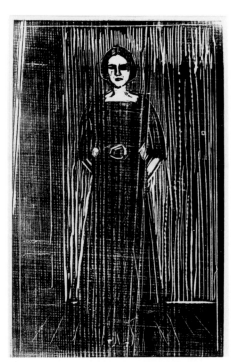

159

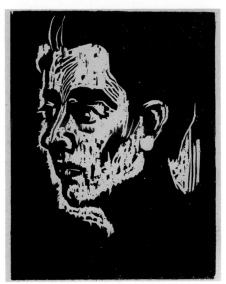

162

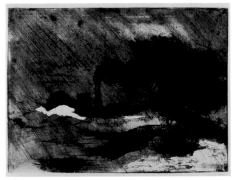

163

Emil Nolde (German, 1867-1956)
162.
Junger Priester (Young Priest), 1906
Woodcut
Image: 11¹³⁄₁₆ x 9 in. (30.0 x 22.9 cm.)
Signed: *Emil Nolde* in pencil l.r.
References: Schiefler 27 I/III (See pl. III for full reference.)
163.
Dampfer (Tugboat), 1910
Etching
Image: 12 x 15¹⁵⁄₁₆ in. (30.5 x 40.5 cm.)
Edition: 1 of 5
Signed: *Emil Nolde* in pencil l.r.
Printer: Genthe, Sabo
Reference: Schiefler 135, II/IV
164.
Hamburg Innenhafen (Hamburg – Inner Harbor), 1910
Etching
Image: 12¼ x 16³⁄₁₆ in. (31.1 x 41.1 cm.)
Sheet: 15 x 19 in. (38.0 x 48.3 cm.)
Edition: at least 12 examples of this state
Signed: *Emil Nolde* in pencil l.r.
Printer: Genthe, Sabo
Reference: Schiefler 144 II/II
165. See pl. III.
Junge Dänin (Young Danish Woman), 1913

153

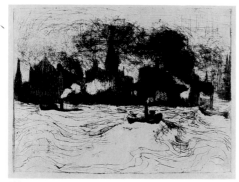

164

169

170

Claes Oldenburg (American, born [in Sweden]1929)
166-167. See pl. XXXVI.
Double Screwarch Bridge, II and III, 1980-1981

Max Pechstein (German, 1881-1955)
168. See pl. V.
Erlegung des Festbratens (Hunting of the Roast for the Feast), 1911

A. R. Penck (Ralf Winkler) (German, born 1939)
169.
Number 1 from *8 Erfahrungen* (8 Experiences), 1981
Woodcut on handmade paper
Image: 23½ x 19¼ in. (59.7 x 48.9 cm.)
Sheet: 30⅛ x 23 in. (76.5 x 58.4 cm.)
Edition: 50; 10 proofs
Signed: *a. Y. (ar penck)* in pencil l.r.
Printer: François Lafranca, Locarno, Switzerland
Publisher: Peter Blum Edition, N.Y.

170.
Number 4 from *8 Erfahrungen* (8 Experiences), 1981
Woodcut on handmade paper
Image: 23¼ x 19⅜ in. (59.1 x 49.2 cm.)
Sheet: 30¼ x 22¾ in. (76.5 x 57.8 cm.)
Edition: 50
Signed: *a. Y (ar penck)* l.r.
Printer: François Lafranca, Locarno, Switzerland
Publisher: Peter Blum Edition, N.Y.

Pablo Picasso (Spanish [active in France], 1881-1973)
171.
Deux Figures nues (Two Nude Figures), 1909
Drypoint on Arches paper
Image: 5⅛ x 4⁵⁄₁₆ in. (13.0 x 11.0 cm.)
Edition: 100
Signed: *Picasso* in pencil l.r.
Reference: Geiser 21; Bloch 17 (See pls. XIV and XVII for full references.)

172.
Nature Morte, Compotier (Still Life, Compote), 1909
Drypoint
Image: 5½ x 4½ in. (13.1 x 10.9 cm.)
Edition: 100
Signed: *Picasso* in pencil l.r.
Reference: Geiser 22; Bloch 18

173.
Mademoiselle Léonie, 1910
Etching
Image: 7⅞ x 5⁹⁄₁₆ in. (20.0 x 14.2 cm.)
Reference: Geiser 23; Bloch 19

174. See pl. XIV.
Nature Morte: Trousseau de Clefs (Still Life, Bunch of Keys), 1912

175.
L'Homme à la Guitare (Man with Guitar), 1915
Engraving
Image: 5⅜ x 4⅜ in. (15.3 x 11.5 cm.)
Edition: 100
Signed: *Picasso* in pencil l.r.
Reference: Geiser 51; Bloch 30

176.
La Source (The Spring), 1921
Drypoint on Montval paper
Image: 7 x 9⅜ in. (17.8 x 23.8 cm.)
Edition: 100
Signed: *Picasso* in pencil l.r.
Reference: Geiser 61; Bloch 45

177.
Figures, 1927
Etching
Image: 7¾ x 11 in. (19.4 x 27.7 cm.)
Edition: 50 (printed in 1960)
Signed: *Picasso* in pencil l.r.
References: Geiser 122; Bloch 81

178. See pl. XVII.
Visage, 1928

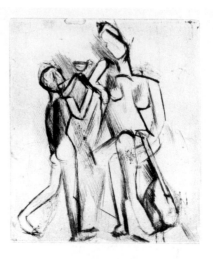

171

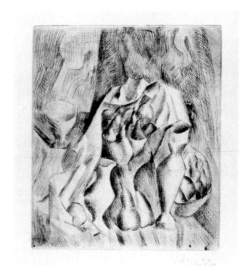

172

179.
Le Sauvetage II (The Rescue II), 1932
Etching on vergé d'Auvergne Richard de Bas paper
Image: 6¼ x 7⅞ in. (15.9 x 20.0 cm.)
Edition: 50 (printed in 1961)
Signed: *Picasso* in pencil l.r.
Publisher: Edition Galérie Louise Leiris, Paris
References: Geiser 273; Bloch 245

180.
Tête (Head), 1933
Etching with grease crayon resist
Image: 7 x 6⅛ in. (17.6 x 15.5 cm.)
Edition: 50; plus additional proofs pulled in 1961
Signed: *Picasso* in pencil l.r.
Reference: Geiser 295; Bloch 256

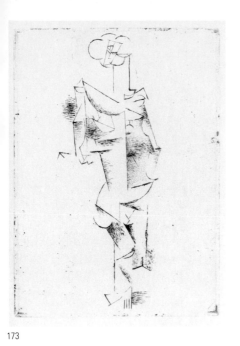

173

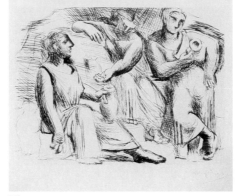

176

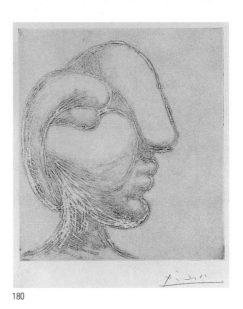

180

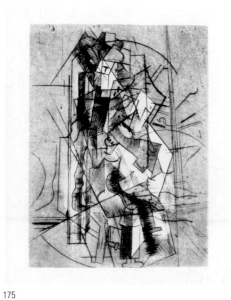

175

177

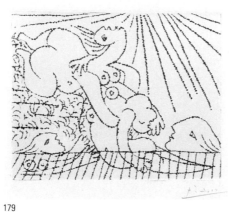

179

181

181.
Sculpteur et Modèle debout (Sculptor and Standing Model) from
Vollard Suite, 1933
Etching on Montval paper
Image: 14½ x 11¾ in. (36.8 x 29.7 cm.)
Sheet: 17⅝ x 13½ in. (45.0 x 34.5 cm.)
Edition: 250 on Montval paper watermarked "Vollard" or
"Picasso," 50 on larger Montval paper watermarked "Papeterie
Montgolfier à Montval" (note: occasional impressions from these
50 have "Maillol" watermark with a figure of a woman), 3 on
parchment
Signed: *Picasso* in pencil l.r.
Printer: Roger Lacourière, Paris
Reference: Geiser 330; Bloch 177

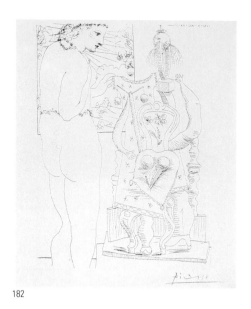

182

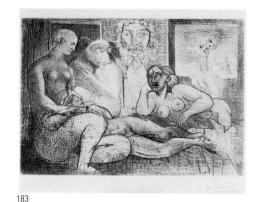

183

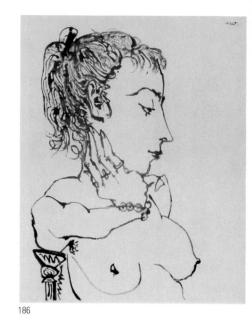

186

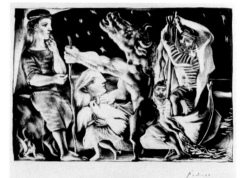

184

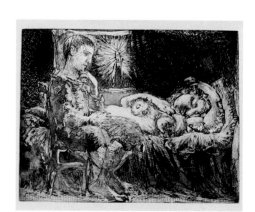

185

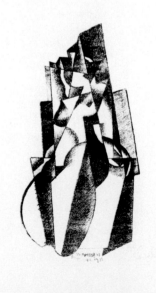

188

182.
Modèle et Sculpture surréaliste (Model and Surrealist Sculpture) from Vollard Suite, 1933
Etching on Montval paper
Image: 10⅝ x 7⅝ in. (26.8 x 19.3 cm.)
Sheet: 17⅝ x 13½ in. (45.0 x 34.5 cm.)
Edition: See cat. 181.
Signed: *Picasso* in pencil l.r.
Reference: Geiser 346, II; Bloch 187

183.
Quatre Femmes nues et tête sculptée (Four Nude Women and Sculpted Head) from Vollard Suite, 1934
Etching and engraving on Montval paper
Image: 8¾ x 12⅜ in. (22.2 x 31.4 cm.)
Edition: See cat. 181.
Signed: *Picasso* in pencil l.r.
Reference: Geiser 424, V; Bloch 219

184.
Minotaure aveugle guidé par une fille dans la nuit (Blind Minotaur Guided by a Young Girl in the Night) from Vollard Suite, 1934
Aquatint on Montval paper
Image: 9¾ x 13⅝ in. (24.7 x 34.7 cm.)
Edition: See cat. 181.
Signed: *Picasso* in pencil l.r.
Reference: Geiser 437, IV; Bloch 225

185.
Garçon et Dormeuse à la Chandelle (Boy and Sleeper by Candlelight) from Vollard Suite, 1934
Etching and aquatint on Montval paper
Image: 9⅜ x 11⅞ in. (23.7 x 30.0 cm.)
Sheet: 17⅝ x 13½ in. (45.0 x 34.5 cm.)
Edition: See cat. 181.
Signed: *Picasso* in pencil l.r.
Reference: Geiser 440; Bloch 226

186.
Buste de Femme (Bust of a Woman), 1955
Aquatint and engraving
Image: 25½ x 19½ in. (64.7 x 49.5 cm.)
Edition: 50
Signed: *Picasso* in pencil l.r.
Reference: Bloch 771

187. See pl. XIX.
Pique (Rouge et Jaune) (The *Pic*: Red and Yellow), 1959

Enrico Prampolini (Italian, 1894-1956)
188.
Figurliches Motiv (Figural Motif), 1921, from the fourth Bauhaus portfolio: *New European Graphic Art – Italian and Russian Artists* (1923)
Lithograph
Image: 9⅝ x 4¹⁵⁄₁₆ in. (24.4 x 12.5 cm.)
Edition: 110
Signed: *119 Enrico Prampolini* in pen l.r.
Publisher: Bauhaus, Weimar
Reference: Wingler IV, 10 (See cat. no. 20 for full reference.)

Robert Rauschenberg (American, born 1925)
189.
Breakthrough I, 1964
Lithograph from 1 stone on BFK Rives paper
Image and sheet: 41½ x 29⅞ in. (105.4 x 75.9 cm.)
Edition: 20; plus unrecorded number of proofs
Signed and dated: *5/20 Rauschenberg 1964* in pencil l.l.
Publisher: Universal Limited Art Editions, West Islip, N.Y.
Reference: Foster 26 (Edward A. Foster. *Robert Rauschenberg: Prints 1948-1970* (exh. cat.). Minneapolis Institute of Arts, 1970)

190. See page 24.
Booster, 1967
Color lithograph and screenprint on Curtis Ray 100% cotton paper
Image and sheet: 72 x 35½ in. (182.8 x 90.2 cm.)
Edition: 38; 12 artist's proofs and 13 other proofs
Signed and dated: *Rauschenberg '67* l.r.
Printer: Kenneth Tyler assisted by Robert Bigelow
Publisher: Gemini G.E.L., Los Angeles
Reference: Foster 47

191. See pl. XXXII.
Scrape, 1974

Dorothea Rockburne (Canadian [active in United States])
192. See pl. XXVI.
Locus Series #4, 1972-1975

Alexander Rodchenko (Russian, 1891-1956)
193. See pl. XXIII.
Composition, 1919

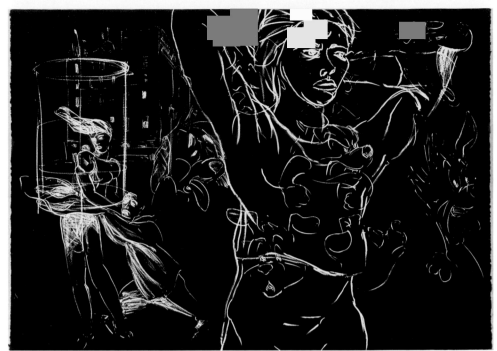

196

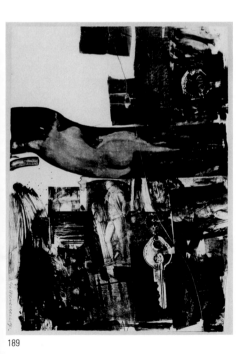

189

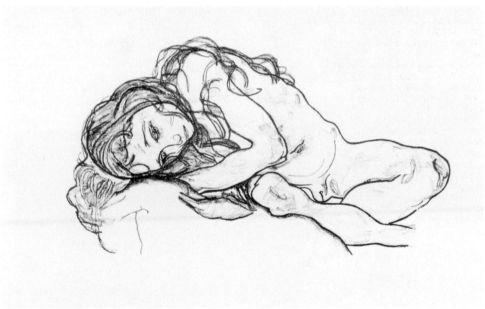

197

James Rosenquist (American, born 1933)
194. See pl. XXXIV.
Chambers, 1980

Susan Rothenberg (American, born 1945)
195. See pl. XLVI.
Untitled, 1983

David Salle (American, born 1952)
196.
Untitled from *Until Photographs Could be Taken from Earth Satellites*, 1981
Aquatint (from a portfolio of 8) on BFK Rives paper
Image and sheet: 30 x 41 in. (76.2 x 104.2 cm.)
Edition: 10; 10 artist's proofs
Signed: *David Salle* in pencil l.r.
Printer: Brenda Zlamany at Jerry Parker Editions, N.Y.
Publisher: Parasol Press, N.Y.

Egon Schiele (Austrian, 1890-1918)
197.
Mädchen (Girl), 1918
Lithograph on buff wove paper
Image: 8¼ x 14¾ in. (21.1 x 37.3 cm.)
Reference: Kallir 17 (Otto Kallir. *Egon Schiele, The Graphic Work.* New York, 1970)

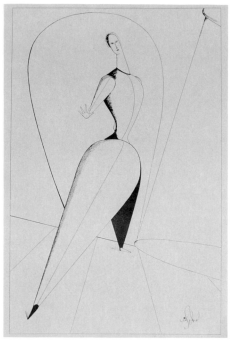

198

199

Oskar Schlemmer (German, 1888-1943)
198.
Die Geste (The Gesture), 1922
Lithograph
Image: 23¾ x 15⅝ in. (60.4 x 39.6 cm.)
Sheet: 25⅜ x 17¾ in. (64.5 x 45.1 cm.)
Edition: only a few impressions
Signed: *Oskar Schlemmer* in pencil l.r.
Titled: *Lithographie Die Geste* in pencil l.r.
Reference: Schlemmer G19 (*Oskar Schlemmer: Zeichnungen und Graphik; Oeuvre-katalog* [cat. by Tut Schlemmer], Stuttgart, 1965)

Karl Schmidt-Rottluff (German, 1884-1976)
199.
Elbchausee bei Hamburg (Elbe Road near Hamburg), 1911
Woodcut
Image: 19⅜ x 23¾ in. (49.3 x 60.4 cm.)
Signed and dated: *S. Rottluff Hamburg 1911* in pencil l.r.
Reference: Schapire 64 (Rosa Schapire. *Karl Schmidt-Rottluffs graphisches Werk bis 1923.* Berlin, 1924)

Kurt Schwitters and **Theo van Doesburg** (German, 1887-1948, and Dutch, 1883-1931)
200. See page 20.
Kleine Dada Soirée, 1922
Offset lithograph in black and red on machine-made paper
Image and sheet: 11¹³⁄₁₆ x 11¹³⁄₁₆ in. (300.0 x 300.0 cm.)
Edition: undetermined (used as a poster)
Unsigned

201. See pl. XXII.
Untitled Number 2 from *Merz 3: Merzmappe: 6 lithos*, 1923

Richard Serra (American, born 1939)
202.
Robeson, 1983
Silkscreen and paintstick through stencil on screen
Image and sheet: 102 x 66 in. (259.0 x 167.6 cm.)
Edition: (edition in process) several artist's proofs
Signed and dated: *R. Serra 83* in pencil l.r.
Titled: *a.p. III Robeson* in pencil l.c.
Publisher: Gemini G.E.L., Los Angeles

202

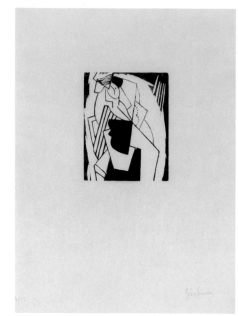

203

Gino Severini (Italian, 1883-1966)
203.
Cubist Figure: Woman, ca. 1915
Linocut on Japan paper
Image: 4⅛ x 3⅜ in. (10.5 x 8.5 cm.)
Edition: 15
Signed: *Gino Severini* in pencil l.r.

Joel Shapiro (American, born 1941)
204.
Untitled, 1981
Two-color, 5-screen, 8-pull screenprint on handmade Japanese paper
Image: 36¼ x 46 in. (92.1 x 116.8 cm.)
Sheet: 38¼ x 50½ in. (97.2 x 128.3 cm.)
Edition: 24
Signed and dated: *Shapiro 1981* in pencil l.l.
Publisher: Simca Print Artists, N.Y.

Alan Shields (American, born 1944)
205.
Angel Scrim, 1977
Color screenprint (double-sided) on dyed handmade Japanese mesh paper
Image: 25 x 38 in. (63.5 x 96.5 cm.)
Edition: 9
Signed and dated: *Alan J. Shields 77* in pencil l.r.
Titled: *Angel Scrim* in pencil l.c.
Printer: William Weege
Publisher: Jones Road Print Shop and Stable, Barneveld, Wisconsin

204

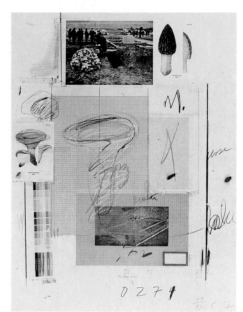

208-211

205

Steven Sorman (American, born 1948)
206. See page 25.
Which (A Partial Memory), 1981
Color lithograph, woodcut, and collage on Japan paper
Image and sheet: 39½ x 31½ in. (100.3 x 77.5 cm.)
Edition: 30
Signed: *Steven Sorman* in pencil l.r.
Dated: *on 3.6.81* in pencil u.c.
Titled: *Which (a partial memory)*, printed in type top center
Publisher: Vermillion Editions, Minneapolis

Frank Stella (American, born 1936)
207. See pl. XLIV.
Talladega Three I, 1982, from *Circuits*

Cy Twombly (American, born 1929)
208-211. See pl. XXXIII.
Natural History Part I: Mushrooms, 1974

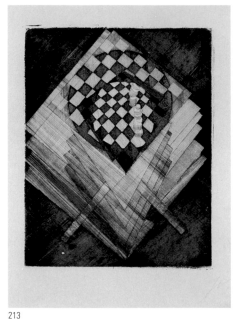

213

215

216

Jacques Villon (French, 1875-1963)
212. See pl. XV.
Portrait de Jeune Fille (Portrait of a Young Woman), 1913
213.
Table d'Echecs (Chessboard), 1920
Etching
Image: 7⅞ x 6¼ in. (20.0 x 16.0 cm.)
Edition: 125; some artist's proofs
Signed: *J. V.* in pencil l.r.
Publisher: Gustav Kiepenheuer, Potsdam, for the periodical *Die Schaffenden*
Reference: Ginestet and Pouillon E292 (See pl. XV for full reference.)

Andy Warhol (American, born 1928)
214. See pl. XXXVII.
Marilyn, 1967

Tom Wesselmann (American, born 1931)
215.
Smoker, 1976
Color lithograph with embossing in 20 colors from 9 aluminum plates, 4 litho plates, and 1 embossing plate on Arches cover paper
Image: 14⅝ x 23 in. (37.2 x 58.4 cm.)
Sheet: 22 x 30 in. (55.9 x 76.2 cm.)
Edition: 75
Signed and dated: *Wesselmann 76 9/75* in pencil l.c.
Printer: Styria Press, N.Y.
Publisher: Multiples, N.Y.

William T. Wiley (American, born 1937)
216.
Now Here's That Blame Treaty, 1982
Aquatint, soft-ground, and drypoint on Arches buff paper
Image: 48 x 36 in. (121.9 x 91.4 cm.)
Sheet: 55 x 42 in. (139.7 x 106.7 cm.)
Edition: 50; 10 artist's proofs
Signed and dated: *Wiley 83* in pencil l.r.
Printer: Hidekatsu Takada
Publisher: Crown Point Press, Oakland